Rituals of War

Rituals of War

The Body and Violence in Mesopotamia

2008

Zainab Bahrani

ZONE BOOKS · NEW YORK

2008

© 2008 Zainab Bahrani

ZONE BOOKS

1226 Prospect Avenue

Brooklyn, NY 11218

Printed in the United States of America.

Distributed by The MIT Press,
Cambridge, Massachusetts, and London, England

Library of Congress Cataloging-in-Publication Data

Bahrani, Zainab
 Rituals of war : the body and violence in Mesopotamia /
Zainab Bahrani
 p. cm.
 Includes bibliographical references and index.
 ISBN 978-1-890951-84-9
 1. War – Iraq – History – To 634. 2. Military history, Ancient.
3. History, Ancient. I. Title.
U31.B34 2007
935–dc22

 2007061960

Contents

Acknowledgments

I would like to thank the John Simon Guggenheim Foundation for the generous grant that made the greater part of the research and writing of this book possible; Columbia University for providing two summer research grants; and Corpus Christi College, Oxford for giving me a visiting fellowship and a place to work in the spring and summer of 2006.

Many thanks to those who read and commented on chapters of the manuscript or the entire text: John Baines, Jonathan Crary, Donald P. Hansen, Natalie Kampen, Günter Kopcke, R.R.R. Smith, and Marc Van De Mieroop. I am also grateful to Dominik Bonatz, Paul Collins, and David O'Conner for sharing the manuscripts of their articles on war reliefs in Assyria and Egypt; Harvey Weiss, Eckart Frahm, and Kathryn Slanski for their insightful comments when I presented some of this work at Yale University in 2005; and Benjamin R. Foster for his thoughts and expert views on Akkadian kingship and the stele of Narmasin. I would also like to thank Irene Winter and Elizabeth Simpson for their kind permission to publish the reconstruction drawing of the stele of Eannatum, James Conlon for help with the images, and Scott Horton for the Immanuel Kant quote on war that appears as the epigraph

to Chapter Five. I offer my sincere thanks to Meighan Gale of Zone Books for her careful editing and her patience. As always, I could not have written this book without my boys, Marc and Kenan.

An Archaeology of Violence

War is organized violence. As such, war might be viewed in the same way as some other institutions and rituals of civilized people. War was first defined as a form of controlled, organized, and even ritualized violence some time ago, in the first part of the twentieth century, in the works of authors such as Georges Bataille and Roger Caillois, and slightly earlier, in the psychoanalytic writings of Sigmund Freud. Carl von Clausewitz's 1832 treatise *On War*, which describes war as an act of rational violence and a political instrument of the nation, is widely regarded as the first modern philosophical work that considers the "true nature" or, in Platonic terms, originary essence of war. For Clausewitz, this essence is certainly organized and civilized aggression. It is "violence that arms itself with the inventions of art and science."[1] The ancient Mesopotamians, whose forms and representations of violence are the focus of this book, seem to have been already aware of such a philosophical definition of war. In the Sumerian myth "Enki and the World Order," the Mesopotamians counted the art of war among the MEs of civilization. The ME is a category in the Sumerian taxonomy of the world that Assyriologists usually translate as "the arts of civilization."[2] This category is comprised

of a long list of the achievements of this early complex society, from kingship and rule to metallurgy and writing.

For the Mesopotamians, the arts of war, plunder, and taking booty were all aspects of civilized behavior. These are the forms of behavior of people who have become urbanized, that is, settled into urban communities interacting within urban social structures. Scholars of Antiquity have sometimes been baffled by the idea that such unpleasant forms of behavior might be considered MEs, or arts. The inclusion of sexuality and its various manifestations, including prostitution, and war and its practices in the grouping of "arts of civilization," along with such commendable occupations as music and craftwork, has been something of a mystery to modern readers. Ancient Mesopotamian culture is described in the grand narratives of world history as the ancestor to the Western tradition yet it remains, in this traditional view, rather unlike the later West in such civilized areas as ethics and aesthetics.

Perhaps the word *art* as a translation of ME is slightly off the mark. No word in contemporary sociological, anthropological, or archaeological theories is the equivalent of Sumerian ME. War, as organized violence, is indeed a form of civilized behavior, as abhorrent as that thought may be. The Mesopotamians recognized this behavior as a ritualized organization, distinctive of complex societies; they linked it directly to the existence of the city and later, as it came into its own, the state. In the list of the MEs, they seem to have attempted to draw a taxonomic difference between the behavior of civilized people and animals or the barbaric non-urbanized nomads. The categorization of the MEs reveals an early contemplation of the place of human behaviors and the order of things in the world.[3]

According to Bataille, war exists because the taboo on violence in daily life relegates violence to areas of existence confined

in space and time and that follow their own rules.[4] Today, a number of such rules exist, many of which have recently become issues of concern and subjects of contemporary debates and analyses. For example, the international laws that regulate war and occupation such as the Geneva Conventions and the Hague Convention, the accepted treatment of prisoners of war, the concept of war crimes, the legality of torture and its relationship to a specific national terrain, and the legitimacy of the nation-state are issues that are being redefined by politicians and contested by military commanders. The latter discussions indicate that even within war some forms of violence are acceptable (what is called conventional warfare), some are questionable or vaguely defined (such as the torture of prisoners of war and "collateral damage"), and some are categorized as criminal (rape and deliberate attacks on civilians during war and occupation). These divisions of violence fall into the Western philosophical categories of *jus ad bellum* and *jus in bello*, the two areas of just war. The first is just cause to go to war; and the second, just behavior in war (as in the treatment of civilians and prisoners of war). In the Middle Eastern tradition, the term *jihad* (although it is currently used to mean terrorist or suicidal war) is more or less similar to the idea of *jus ad bellum*, in that it defines in which cases going to war is justified. Ibn Khaldûn (AD 1332–1406), a Muslim jurist and historian, discussed the definitions of just and unjust wars in his *Muqqadimah*; centuries later, Michael Walzer, an American scholar of government and philosopher of war, analyzed wars, and behavior within them, in his 1980 book *Just and Unjust Wars*.[5] Discussions and treatises from China and the Indian subcontinent about correct behavior in war and reasons to go to war are also well known. Sunzi's *Art of War*, from the fifth century BC, and the *Arthasastra*, a late fourth-century-BC Sanskrit treatise on diplomacy and war attributed to Kautilya, are two early texts

11

concerned with the realm described in the Western tradition as just war.

These discussions fall under the ethics of war. The concept of just and unjust war means that war is not generally thought of as an impetuous activity. It involves a choice made at a particular moment, when violence is sanctioned as an accepted, correct, even valorized form of behavior. War, then, is the collective organization of aggressive urges. It is the controlled practice of group violence on a large scale, and as such it has to adhere to certain forms: its own rules and regulations. Clausewitz was certainly not the first to contemplate the notion of war. War and its causes have been analyzed from the earliest historical records. In recent scholarship, scholars of government and historians of war are not alone in studying the forms of war and their justifications. Sociologists and anthropologists have also attempted to frame the act of war within human behavior and within theories of war. War, state violence, and the law are now the focus of some of the most incisive contemporary philosophical writing. And "war studies" has now become an independent academic field at a number of universities.[6]

The art of war — the forms and images of violence that both support and justify wars, enabling as well as representing them — has received far less attention. A number of studies of images of violence and war have recently emerged from the fields of art history and visual cultural studies, but the uses and functions of such images in Antiquity remains largely untheorized.[7] What was the place of images of war and violence in Antiquity? Did such images aim to be objective historical records? Were they coercive or propagandistic? How was the notion of just war formulated in the images of war? How were works of art, historical monuments, and artifacts treated in war? And how did the monument of war (that much-revered type of monument) come to be invented in Mesopotamian Antiquity?

A history or an archaeology of forms and monuments of vio-
lence can consider how such conventions of war, its represen-
tations, and its underlying activating rituals were practiced in
Antiquity.[8] Art, visual displays, representations, and war have a
long, interrelated history. War, one can argue, is already a narra-
tive as it is acted out on the battlefield. Assyrian and Babylonian
accounts of battle make war's narrative aspect clear. Furthermore,
war, victory, and royal or imperial power do not appear as narra-
tives only in the visual arts. Central to the aims of the economy of
violence (in Bataille's broadest sense of economy as the circula-
tion of energies) and of power and geopolitics is the technology
of war, a militaristic complex that is sometimes described as the
war machine.[9] This war machine depends on technologies of vio-
lence in every sense of the word *technology*. Aspects of war such
as the supernatural, rituals of divination, and performative repre-
sentations are all integral parts of the war machine. But the war
machine is not reducible to the military. It is a complex appropri-
ated by state violence but by definition outside the normative
day-to-day affairs of the city and the internal laws of the state.[10]

War is a strictly organized activity that at the same time allows
for forms of behavior that are non-normative and taboo. Like the
festival and some religious rituals, war occupies a place outside; it
is a phenomenon that stirs and interrupts.[11] In Bataille's words,
"the unleashed desire to kill that we call war goes far beyond the
realm of religious activity. It is a suspension of the taboo sur-
rounding death and killing."[12] The contemplation of war in this
way, as organized and sanctioned violence, appropriated or chan-
neled by the urbanized city-state, limited in time and place, was a
source of anxiety for the peoples of ancient Mesopotamia. Not
unlike today's state records and dominant representations, Meso-
potamian records and rituals of war and images of violence sought
to rationalize war as a just aggression in each case. There is no

extant Sumerian or Akkadian treatise on just war. However, the large corpus of textual and visual representations of violence and war allows an analysis of the subject of violence in Mesopotamian Antiquity. This book, therefore, investigates aspects of war that might not today be considered within the realm of military logistics and strategies but that the ancients clearly understood as crucial and logical aspects of war and sovereignty.

The Mesopotamian discussion of war, its justifications, and its rituals spans the period between the third and the first millennia BC. As such, it predates all other discussions of war and traditions of justified wars. The Assyrians of northern Mesopotamia are perhaps thought of in relation to war and violence more often than most other ancient cultures, especially in the first millennium BC, when the Assyrian kings expanded their empire into the surrounding territories. These kings conquered lands, moved populations, plundered cities, cut down and burned forests, and destroyed monuments. The expansion of power of the Assyrian kings of the first millennium BC constitutes what can be firmly defined as an imperial mission. The Assyrian kings were remarkable perhaps not so much because they were aggressive imperialists, since other periods of imperial expansion and force have existed in history, as because they chose to record the events of war, torture, and conquest in detail, sparing us from no gruesome act of violence in their glorification of war and empire — either in their written annals or in the visual images of empire.

War, imperialism, and power in Mesopotamia have been discussed from the point of view of political history in numerous publications. In fact, the political-historical approach is now standard in the field of Mesopotamian studies, especially in works on the Akkadian and Neo-Assyrian periods. Materialist economic reasons, and geopolitical reasons of power and control, spurred the Mesopotamians into the act of war for imperial expansion at

various times, but these territorial wars relied on rituals and representations of power and rituals of battle. These were the ideological methods that enabled the processes to work.

This book, therefore, is not a chronological survey of specific historical wars and technologies of weaponry or vehicles of war in Mesopotamia; a number of useful, concise studies already exist on that subject.[13] Instead, this study considers what underlies war and violence. It examines philosophical beliefs about war and ideologies of war in Mesopotamian tradition; conceptions of violence and power that were inseparable from conceptions of the body and its control; and the processes and rituals of war that these formulations of the body and power made possible. These developments of ideas of power, rule, dominion, and authority cannot be separated from visual images or representation broadly defined. These formulations and representations, technologies in the rituals of war and in displays of violence and power, are an inevitable part of every imperial process. The present study thus considers facets of war and domination that fall under the categories of representation and display, the ritualistic, the ideological, and the supernatural. These might be described as the magical technologies of war, and as such they are not usually discussed in the standard political narratives of Mesopotamian history books.

Being among the world's earliest imperial forces, the Mesopotamians developed a system of expansion that relied on the machinations of war and the sophisticated development of weaponry and technology. But military technology included a number of aspects that today would be regarded as unscientific: the reading of omens, the movement of prisoners, the display of acts of torture. These practices and the beliefs behind them were the parameters of war for the Assyrians. They defined the reasons for war; they justified war, even if war was primarily a process of imperial expansion and the resulting control of natural resources,

15

land, and wealth. Magical technologies and rituals can be described as a semiotics of war that delineates the parameters for correct and incorrect behavior in war. They define certain acts as appropriate and other acts as enabling, empowering, or, in fact, actually leading to victory.

For the Assyrian imperial war machine, for example, the processes of war were clearly linked to the supernatural, but amid the detailed Assyrian accounts of the need for imperial expansion, an incredible anxiety about the outcome of war, about life, death, and memory, can be glimpsed. In fact, these accounts display the extraordinary historical consciousness that is characteristic of early Mesopotamian Antiquity. It is here that images and monuments, in my assessment, have a social role beyond the depiction of historical events.

Formulations of the body and power are made, defined, and become reified through monuments, representations of war, and images of violence. Underlying the discussions of these rituals and representations of war is the premise that the body is a principal factor in the political economy of power. In *Discipline and Punish*, Michel Foucault argues that the art of punishing must rest on a whole technology of representation.[14] This kind of reliance on technologies of representation in the broadest semiotic sense, in relation to violence and control, can be seen clearly in the ancient Mesopotamian record. This study, therefore, is focused on the interrelationship of power, the body, and violence in Assyro-Babylonian society and its representations, a semiotics of war that was an integral part of the mechanics of warfare. In other words, it combines three lines of inquiry that are not generally seen or studied together: war, the body, and representation.

Chapter One, "The King's Head," opens with a study of a particular sculpted relief from Ashurbanipal's palace at Nineveh (c. 650 BC). This is a wall panel usually referred to as the Battle of

Til-Tuba relief and now found in the collection of the British Museum in London. Focusing on this work of art, the chapter follows the movement of the defeated Elamite king's severed head on the relief and in the parallel and contemporaneous historical annals of this battle, to assess the significance of the head's repeated and cryptic appearance in the composition. A close reading of the image in its relationship to the historical annals of the same campaign demonstrates that the narrative of war is woven around the main subject, which is the decapitation of the Elamite king as an act in itself, an act that is contingent but described as a supernatural event decreed by the gods, and that is in some sense pivotal in that theatre of war.

Chapter Two discusses Babylonian semiotics and the relationship of representation to reality in Mesopotamian speculative thought, a relationship that is essential to an understanding of the function of images such as the Battle of Til-Tuba relief. The Mesopotamian scholarly tradition conceived of the division between artifice and reality in rather different terms from the later classical Greek concept of mimesis. Instead of imitating the natural world, representation (writing, visual images, and other forms) was thought to participate in the world and to produce effects in the world in magical or supernatural ways. The world was saturated with signs, and Babylonian scholars were the first to develop a rigorous system of reading visual signs according to a method that would now be described as semiotic. Taking up Carlo Ginzburg's suggestion that the origins of semiotics are to be found in Babylonian divination, the chapter delineates the links between these methods of divination and Mesopotamian concepts of representation and the real.[15] Building on earlier work on this subject, especially my book *The Graven Image,* the chapter considers the relationship of ideology to the concept of images in Assyro-Babylonian culture.

In Chapter Three, what I have described as the "mantic body"

is discussed in some detail as a distinctive Mesopotamian conception. In Mesopotamia, the body and body parts signified omens in ways that were considered very real and serious. This was no marginal superstition. The semiotic code of the body and body parts was a crucial part of the Mesopotamian cultural understanding of the world and its movements and was therefore central to notions of history and time.

The Assyro-Babylonian practice of divination by means of reading parts of the body is analyzed in some detail in Chapter Three, since divination through extispicy (reading a sacrificial animal's entrails) and hepatoscopy (inspection of the liver) were fundamental to the strategies of war. The Babylonian and Assyrian practice of reading omens from the liver of a sacrificial animal is well known, but this type of manticism ought to be seen within the broader context of the Mesopotamian conception of the mantic body. While recent research in theories of the body has often focused on the organic body as a locus of existential identity, for the Mesopotamians the body, especially the human body, was by definition a semiotic entity. Body parts were believed to signify; they contained universally relevant signs that made reference to aspects of the world, history, and lived experience well beyond personal identity. They could also portend future events in messages that could be deciphered through divination, a system that worked as an exegetical reading of the parts of the body according to preestablished codes, recorded in treatises that span from the third through the first millennium BC. Finally, the argument for the semiosis of the organic body leads to a reconsideration of the boundaries between the organic body and its representations in Mesopotamian thought.

Chapter Four, "Death and the Ruler," takes up the notion of violence and the body in public art as an expression of sovereign power and the power over life and death. In focusing on the rela-

tionship between death and the ruler, the chapter explores explicit and public violence in historical images of war as political technologies of the body. The new formulation of the king's power over life and death is drawn up through new visual images of sovereignty, as well as relying on the more standard rituals and political rhetoric. These changes come to be crystallized in the famous victory stele of the Akkadian ruler Naramsin (2254–2218 BC).

Chapter Five, "Image of My Valor," continues the investigation begun in Chapter Four into the formulation of sovereign power in public monuments, shifting the focus to the historical development of and changes in images of heroism, victory, and explicit physical violence. It begins with a close analysis of the iconography and text of an Old Babylonian public monument that dates to the beginning of the second millennium BC, and is described in the text written on the monument as "Image of My Valor." It considers earlier Sumerian and Akkadian images and later Neo-Assyrian depictions of victories in battle. The latter are particularly well known as images that are brutally direct in their portrayal of violence.

The Assyrians depicted and recorded their rise to political power, their defeat and subjugation of enemy lands, and their control of the entire Middle East in the first millennium BC via the bodies of the defeated. Such depictions did not simply record the events of battle but also narrated the identity of the empire. Images of forced exile and mass deportation, war prisoners' pleas for mercy, and enemy rulers' homage to the Assyrian king all celebrated Assyria's victory through the body of the vanquished enemy. Torture, as opposed to execution and immediate death, became a common subject in scenes of war. Decapitation, flaying, impaling, and other forms of physical torture appear in the battle scenes of Assyria. In the Neo-Assyrian era, these images of slow violence to the enemy's body became so common in scenes of

19

victory that torture itself can be read as a narrative means of signaling the conquest of the other.

Chapter Six, "The Art of War," considers the place of art in war and the art of war as military strategies. Rituals of making images, wars fought over cult statues and public monuments, the abduction of images, the use of images as human substitutes, and the human substitute as a form of image are aspects of the place of art in war. The uses of images in war, the treatment of images during battles, and battles fought specifically over images — in sum, the treatment of images in war — communicate more about the representation of war itself as image. A discussion of the practices of deportation and exile of populations follows. Both of these practices had to do with the reconfiguration of space in the vision of the imperial power and were (as they continue to be today) strategies of warfare.

Chapter Seven, "Omens of Terror," is a study of the relationship between religious rituals and war — specifically, the place of divination and manticism in wars and images of war, using texts and the archaeological record. This chapter brings together my earlier argument regarding the power of images, relating it to the function of image making and image magic in Babylonian and Assyrian traditions, as evidenced by textual records.

The Mesopotamians were the first to develop medical semiotics or symptomology. They used protasis and apodosis in all scientific formulations and in logic. The Codex Hammurabi, for example, uses the same scientifically inextricable link between symptom and cause. The same was true for the reading of omens. The signs of war could then be read logically, in a similar way to the signs of justice or somatic signs. They were embedded naturally into the world. This system of signification and how it functioned enabled the semiotics of the body and violence to be part of the mechanism of war.

The concluding chapter explores the relentless nature of the war machine and its relationship to the arts. Art glorifies war and terrorizes through the explicit images of violence. But an ancient Babylonian poet wrote a passionate epic account of the relentless horrors of the war machine.

We may believe that Mesopotamian practices of violence and rituals of war are far removed from our own civilized time, yet even today, rituals of war, the parameters of accepted levels of torture and violence, and the treatment of prisoners of war and enemy combatants are redefined through visual displays in the media and through the rhetoric of justice and enlightenment. In the end, this ought to be a reminder that the usual statements of abhorrence of the Assyrian displays of violence fit neatly into Tzvetan Todorov's observation that a description of the uncivilized sign (that of others) is an uncivilized description of the symbol (our own).[16] For the ancients, religion was not separate from the ideology of sovereignty. Instead, the supernatural served to facilitate the ground rules of war. Expansion and empire and physical violence against the bodies of the enemy were just activities approved by the gods, although never directly ordered by them. The ideological belief that one's own was the correct system of rule justified war, violence, the torture of enemy bodies. It justified imperialism, and a tyrannical reign, but ancient authors also worried about the excesses of power and hubris and left numerous warnings and laments about the sorrows and horrors of war.

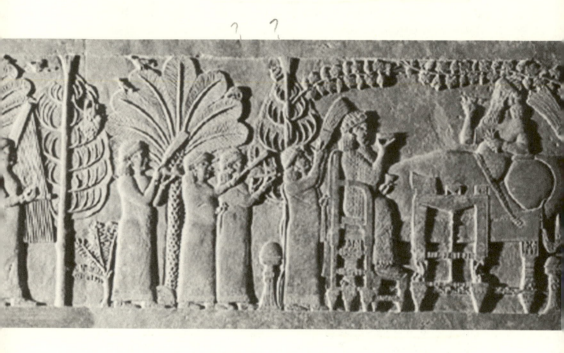

Figure 1.1. Ashurbanipal's banquet, Nineveh, c. 645 BC. British Museum, London.
Photo: Zainab Bahrani.

Til-Tuba panels
excavated 1840s

CHAPTER ONE

The King's Head

If a Severed Head Laughs: Conquest of the Army.*

Meaning is not "at the end" of the narrative, it runs
across it; just as conspicuous as the purloined letter,
meaning eludes all unilateral investigation.
— Roland Barthes†

The king's head hangs in the tree before the banquet of the Assyr-
ian king, Ashurbanipal, and his wife, Ashursharrat, in the gardens
of Nineveh. The scene depicted in this relief is idyllic. After the
battle is over, the royal couple feasts in the garden, surrounded
by attendants and musicians, while the head of the Elamite king,
Teumman, hangs like an ornamental trinket in the pine tree be-
fore the Assyrian king. Nearby, birds and a cricket rest on the
branches of the neighboring palms (fig. 1.1).

The Assyrian historical annals relate that Teumman had been
beheaded in the midst of the Battle of Til-Tuba, in 653 BC, and
that the head was carried in a triumphal chariot to the Assyrian
city of Arbil and from there to the royal palace at Nineveh, where
it was finally displayed. That Elamite campaign and the following
triumphal march and victory were the subject of a series of Assyr-
ian palace sculptures from Nineveh, specifically a marble wall

* From the omen series *Šumma ālu*, translated in Guinan, "A Severed Head
Laughs," p. 425.
† Barthes, *Image, Music, Text*, p. 87.

23

revetment of the royal palace (now exhibited at the British Museum in London). The act of the beheading of the enemy, Teumman, King of Elam, amid the Battle of Til-Tuba is depicted as part of a cycle of a historical narrative of war, yet, as a decapitation, it is a subject that seems to transcend the actual and contingent events of the specific battle.[1] To be precise, it is not the battle, or even the act of decapitation, that the composition takes as its focus. It is the severed head, a body part that emerges inadvertently here and there across the surface of the relief — a body part that becomes a terrorizing sign of violence and victory at the same time. The severed head emerges in a way that is almost disruptive to the scene of the battle, as if the battle were only a backdrop for the decapitation. It becomes a point that interrupts the textured chaotic surface that is the depiction of a war. The war is portrayed as real and historical, but it is the head that firmly fixes that narrative of a specific historical battle across the surface of the relief.

The relief cycle represents a campaign that culminated in a battle at the river Ulai in 653 BC at which the Assyrians defeated the Elamites. A scholar of Antiquity comes to this relief with expectations, with certain preconceptions regarding the Assyrian empire, Assyrian art and ideology, and the function of their images of war. For one, the Assyrians are always represented as victorious in their war reliefs; there are no images of Assyrian defeats. Second, the Assyrians clearly preferred an aesthetic of violence, in which enemies were depicted as enduring the most gruesome sorts of bodily torture. Still, something more draws the viewer to this particular relief, pulls one in, and forces one to look more closely. What is the lure of this image? The composition's complexity, which draws the viewer to the scene and the fascinating details of the narrative is at the same time an obstacle. A viewer can survey the relief numerous times and yet there is always a bar-

24

rier. One cannot enter the scene, so to speak. One cannot take in the whole composition at a glance. The complexity of the image is slightly overwhelming, and the numerous details strewn and scattered across the surface of the relief are somewhat alarming.

Austen Henry Layard found the Til-Tuba panels during his excavations in the 1840s and brought them back to the British Museum in London at that time.[2] The scene, which is surely embedded into the ideology of empire, has been discussed quite thoroughly from that point of view. Is it true to the historical event? Is it an exaggeration? Did the Assyrians really do these things? How close or how distant is this depiction of the battle to the real, historical event of war?

To view this artifact as a work of visual art, one ought not, in the first instance, to look at it as a document of a historical battle or statecraft. Of course, it is also these things, albeit in an indirect and nonmimetic manner. The subject matter of the composition of the Til-Tuba reliefs is certainly that specific battle and Assyrian war in general, and since all art is infused with ideology, these aspects must be taken into account. But what exactly is the meaning of this narrative and its use as a wall revetment in Room 33 of the Southwest Palace?

There are three adjoining panels of fossiliferous limestone (that were put together in the museum) and further panels and fragments bearing images of the same historical campaign (figs. 1.2–1.4). Because of the relief's size, its function as a palace wall revetment, and the minute details of the scene, no photograph can represent the totality of what remains of the composition in one image, so it is always depicted only in parts. Even if what exists is already incomplete, one certainly gets a better idea of the work when viewing all three remaining panels together in the museum. At first glance, the three panels appear to depict a chaotic mass of bodies strewn across the pictorial space with little

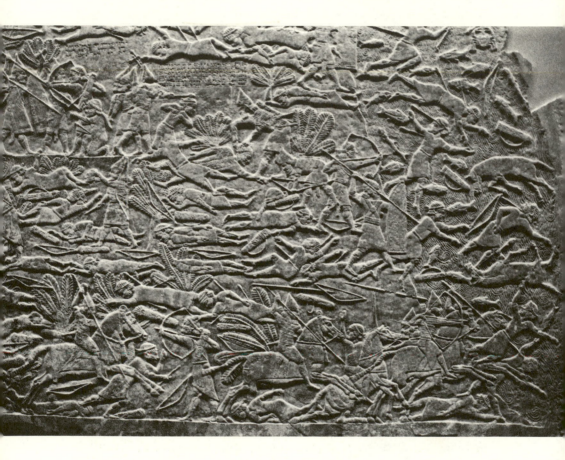

Figure 1.2. Right panel of the Battle of Til-Tuba, Nineveh, c. 650 BC. British Museum, London. Photo: Zainab Bahrani.

Figure 1.3. Central panel of the Battle of Til-Tuba, Nineveh, c. 650 BC. British Museum, London. Photo: Zainab Bahrani.

Figure 1.4. Left panel of the Battle of Til-Tuba, Nineveh, c. 650 BC. British Museum, London. Photo: Zainab Bahrani.

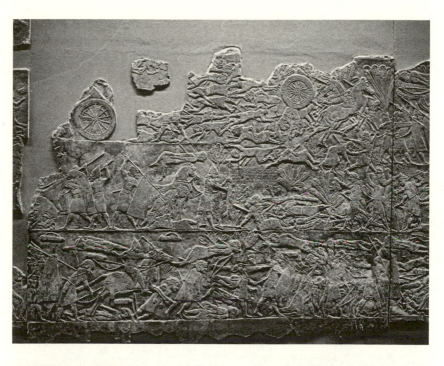

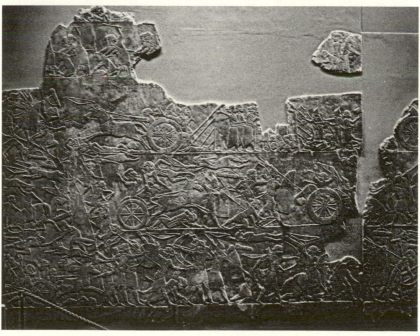

consideration for composition. The surface is densely covered with a mélange of horses, asses, chariots, and human bodies moving in all directions. Perspective is nonexistent or, at best, seems to change arbitrarily from one section to the next. There seems to be no focal point. Everything about the composition seems to be the opposite of what we are trained to see as "a composition." It is a clutter seemingly born of *horror vacui*. The trees that appear here and there in the background seem to have no function other than to fill open spaces between figures. Randomly strewn bows and quivers seem to float about the scene.

At the edge of the right panel is the river Ulai, a vertical band of swirling threads of patterned water (see fig. 1.2). The bodies of dead and wounded Elamites, their weapons and horses strewn among fish and crabs, appear to be suspended over the water. The river is seen from above, its distance tilted up and brought to the surface of the picture plane, so its entirety can be absorbed at a glance. This treatment of space is unique in these panels. Elsewhere, the chaos is subdivided into registers, according to the ancient Mesopotamian tradition of relief carving, beginning as early as the famous Uruk vase from around 3200 BC. In the extant Til-Tuba scene, five registers loosely defined across the scene can be discerned.

At the top, on the right side, are two registers of defeated Babylonians standing in an orderly single-file line; the repetition of their bodies, which are all of the same height and positioning, creates a horizontal movement that probably continued across the top of the relief. At the far left remains a fragment of an enigmatic scene. Assyrian soldiers stand above kneeling prisoners, who are busily grinding something with stones, possibly the bones of their own ancestors (see fig. 1.5).

The main action of the battle is distributed across three indistinctly defined registers. The far-left scene is cut off at the hill

and was clearly meant to continue onto another panel (see fig. 1.4). In the area that remains, four horizontal registers are clear, and the fragmentary remains of a fifth at the top indicates that the composition was once larger. In each remaining register, a ground line, on which the soldiers and chariots are placed, can be distinguished. In each case, figures and weapons are also scattered above the first group of ground-line figures, indicating distance. The registers are loosely defined, and the figures are not confined within each register's boundaries.

Feet and wheels cross the slight relief ledge everywhere. In some places, the action spills from one register into the next without regard for linear boundaries or the relationship between one figural group and the next. For example, in the center, Teumman (Teptihuban-inshushinak) and his son, Tammaritu, are running away from the chariot scene (see fig. 1.6). The heads of the soldiers below form their stepping-stones. Is this simply the result of a miscalculation on the part of the ancient sculptor? This spilling over from one scene or level into the next leads the viewer's eye to the next scene. This is seen on the first two panels but not on the left one. In fact, it is not entirely clear that the last two panels toward the hill were originally joined. There is only one area at the bottom where the leg of a soldier crosses diagonally into the next.

The Severed Head

Certain main events across the reliefs can be read as forming the narrative: Teumman's overturned chariot, his escape with his son (see fig. 1.6), his submission, his decapitation (see fig. 1.9), the Elamite pleading to the Assyrian soldier for a beheading (see fig. 1.10), and the transportation of the severed head. In the central row on the right, under Teumman's chariot, an Elamite is cutting his bow as an act of submission that is well known from literature

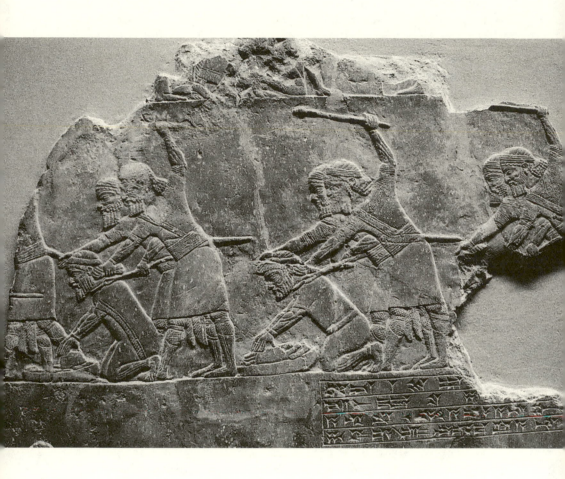

Figure 1.5. Grinding the bones of ancestors. Detail of fig. 1.4.

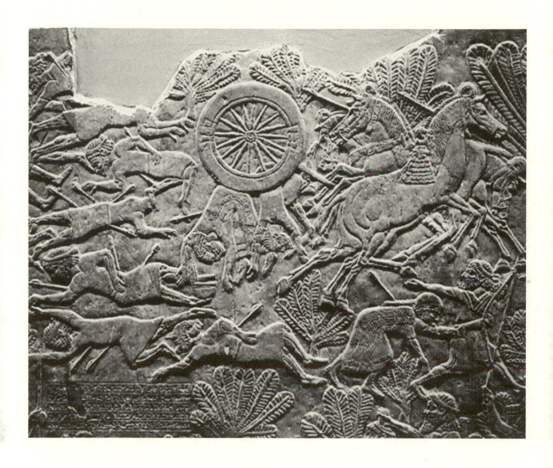

Figure 1.6. Teumman and Tammaritu running away. Detail of fig. 1.3.

(see fig. 1.3). Other details are worthy of discussion and ought to be analyzed carefully, but let us consider the focal point of the Til-Tuba relief: the severed head and the events leading up to the decapitation. The severed head reappears across the surface of the relief, as conspicuous as the purloined letter.

Moving from the macrodepiction to the microdepiction, the overall composition of the Til-Tuba panels is configured to create a sense of chaos, the tumult of war, and the mass of dead Elamites, and yes, this is clearly an Assyrian victory, since no Assyrians are ever shown being killed or wounded. At the same time, accurate historical and ethnographic specificity is of the utmost importance. The horses and asses are beautifully carved in a linear, decorative, yet realistic style, whereas the Elamites are somewhat awkwardly proportioned, with smaller bodies and larger heads than the Assyrian soldiers. Realism is of great concern in some areas and less in others. Realism is suspended, just as it is utilized, for the sake of the narrative.

The relationship between the depiction of one moment in time and that of another is not obvious. There is no linear movement across space in an orderly chronological sequence. This relief cannot be read from left to right or from bottom to top or in any other direction that we might expect according to the rules of narrative representation.[3] Time is not depicted as a linear progression. But this should not be surprising, given more familiar works of art, such as Masaccio's fresco cycle devoted to the life of St. Peter in the Brancacci Chapel of the Santa Maria del Carmine in Florence (fig. 1.7). Masaccio uses continuous pictorial narrative, but the direction of the passage of time is not always clear. In *The Tribute Money*, for example, there are three moments in time, and the later points of the narrative flank the central scene, in which the Roman tax collector approaches Jesus and the apostles. If there is no orderly linear progression in time on the Til-Tuba

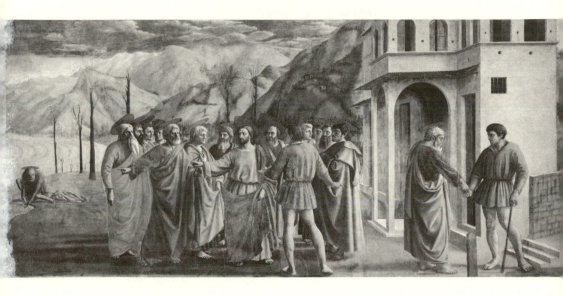

Figure 1.7. Masaccio, *The Tribute Money*, Brancacci Chapel of the Santa Maria del Carmine, Florence, 1427. Photo: Scala/Art Resource, New York.

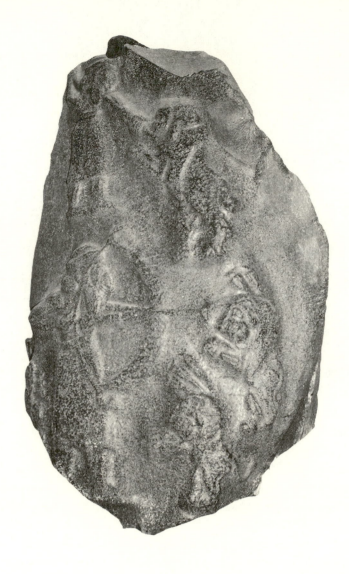

Figure 1.8. The Priest-King Stele, Uruk, c. 3200 BC. Iraq Museum, Baghdad.
Photo: Zainab Bahrani.

relief, we must also consider what this means for other works of Assyrian art, works we often try to read according to some predetermined idea of narrative progression. This disregard for a direct or clear linear progression can be seen as a deliberate choice.

There is no focal symmetry in the composition of the Til-Tuba relief. In the narrative, the same characters appear at different moments in time — but this is not new for Mesopotamia. The earliest works already treated time this way. For instance, the Priest-King basalt stele of the fourth millennium BC from Uruk is such a work (fig. 1.8). What we have here is repetition. The priest-king is depicted twice in the lion hunt. Below, larger and closer to the foreground, the ruler is shown hunting lions with a bow and arrow. Above, on a much smaller scale, the same figure is depicted spearing a lion at another moment in time. It is irrelevant whether one moment is earlier or later. It is the double occurrence of the king that matters here.

The focus of the Til-Tuba composition is not some fixed perspectival point or linear progression. Instead, the meaning is underscored through repetition. The focal points are multiple, and all are images of the severed head. The depictions of the event of the royal deaths of Teumman and his son are precise (fig. 1.9). The Assyrian soldiers first strike with a mace, then sever the head with a blade.[4] This event is of paramount importance: the death of a king is not the same as the death or execution of an anonymous soldier. The execution of a king is an extraordinary act in any political theology. Because the king is consecrated and outside the law, the death of a king is always exceptional. In his discussion of *homo sacer*, Agamben points out that the defining characteristic of homo sacer, "his unsacrificeability according to the forms prescribed by the rite of the law," is also applicable to the sovereign, and that some trace of this unsacrificeability of the sovereign's life is still to be found in the principle of the laws

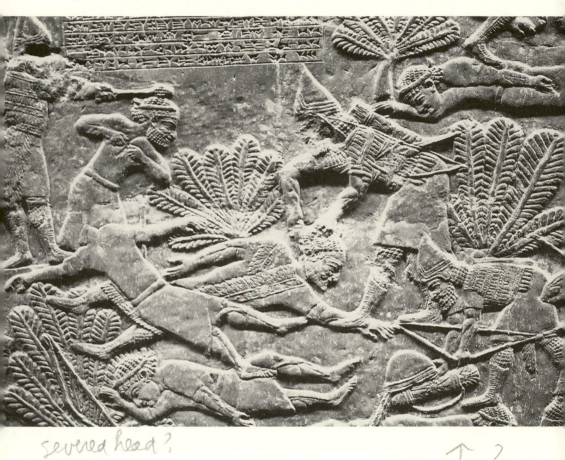

mace

severed head?

↑ ?

Figure 1.9. Beheading of Teumman. Detail of fig. 1.2.

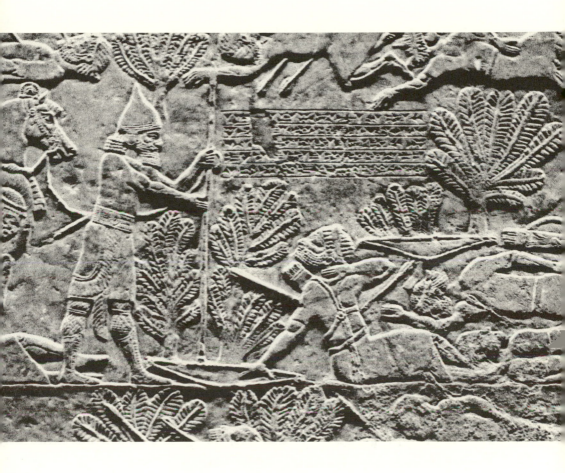

Figure 1.10. A wounded Elamite pleading with an Assyrian soldier to kill him. Detail of fig. 1.3.

which exempt the head of state from submission to ordinary legal trials.[5]

The one clearly distinctive factor in the Til-Tuba composition is the repetition of the severed head. In this scene, as in all Assyrian art, repetition must be confronted as a compositional element in its own right, not lamented as an example of the artist's lack of originality, as has been too often done in past assessments of the arts of the ancient Near East. Why is the king's head repeated across the relief? Why is it almost cryptically concealed in the details of the representation's *horror vacui*? What is the meaning of these compositional choices — crowding, repetition, haphazard overlapping of figures — a compositional and stylistic method that is quite unlike that of other sculpture from the reign of Ashurbanipal?

Several formal elements are identifiable in royal Assyrian art and composition: the treatment of space includes the reduction of space to the plane of the foreground; forms are flattened and brought forward; and a gradual movement toward repetition is interrupted by symmetrical scenes. The choice between repetition and symmetry is always interesting, for these compositional elements are not merely a question of abstract lines.

But the rules of aesthetics and the choice of formal elements cannot lead to a direct explanation of the scene and its meanings. How, then, can such an image be understood? There is a barrage of clues from the past and in the work itself. The head is one of them. The head in the relief is significant by the very fact of its being hidden within the chaos of battle. Like the purloined letter in the Edgar Allan Poe story, it is, so to speak, hidden in full view.

Confronted with the riddle of the repetition of the severed head embedded in the tumult of battle, let us look at the account of this episode in the historical annals for more than just the factual record of the war as the primary source of this narrative. What is the account of this event trying to say? How is the just

Ishtar

cause of Assyrian war conveyed? In fact, a similar repetitive focus on the severed head can also be found in the historical annals. That is, there is a literary parallel to the motif of the head's repetition. But let us first consider the inscriptions on the relief. They do not tell the story of the Battle of Til-Tuba, despite the title that we have given to this work of art. The epigraphs carved on the relief tell the story through an emphasis on severed heads. They read as follows:

Epigraph on the upper part of the right panel, above the scene depicting Teumman and Tammaritu engaged in a bow-and-arrow battle with Assyrian soldiers:

> Teumman, who, in the collapse of his reason, said to his son, "Shoot me with the bow."

Epigraph to the middle right of the right panel, above the beheading scene:

> Teumman, king of Elam, who was wounded in the great battle, and Tammaritu, his oldest son, who held him by the hand, fled to save their lives and hid themselves in the woods. With the aid of Aššur and Ishtar, I slew them and cut off their heads, one in front of the other.

Epigraph in the central panel:

> Urtaku, the son-in-law of Teumman, who was wounded by an arrow but did not die, called out to an Assyrian for his own beheading, saying: "Come, cut off my head, take it before the king, your lord, and let him have mercy."

Epigraph on the upper left panel, over the chariot:

> The head of Teumman, king of Elam, which a follower of my army, a common soldier, had cut off in the midst of the battle, they are bringing in haste to Assyria, to announce the news of victory.[6]

The viewer can see Teumman and Tammaritu fall out of the over-turned chariot, then run away (see fig. 1.6). At the same time, the headless body of Tammaritu, already dead before his father appears to the right, as well as Teumman's decapitation, while below, an Assyrian holds up the head in triumph (see fig. 1.9). The viewer can then see its final hanging in the tree in the banquet scene, in which Ashurbanipal reclines on his ivory couch with the head in the distance before him (see fig. 1.1). The viewer can follow the movement of Teumman's head across the reliefs, but not without some difficulty. In the chaos of battle, the figures of Teumman and Tammaritu are just a minor part of the generally unruly scene. This effect of chaos is created by a variety of diagonals, produced by the bodies of people falling or bodies sprawled out in a seemingly random manner. But, in fact, there is a great deal of repetition of figures, which creates a kind of organizational registration through the positioning of bodies and weapons. In this composition, Teumman is not easily located. He can be recognized by his fringed garment, but his figure does not otherwise stand out. One has to search the surface of the reliefs carefully in order to trace his movements. Nevertheless, the movement of the king's head across the composition is the major event of the narrative.

In the Assyrian annals as in the epigraphs on the relief, the emphasis is on the fate of the severed head.[7] In the historical Cylinder Texts that describe Ashurbanipal's campaigns we have a record of the Elamite wars on several clay cuneiform texts, multi-faceted in shape, which Assyriologists call prisms or cylinders. In one account on the Rassam Cylinder, the first thing mentioned — after a list of the names of the gods who commanded it — is the beheading of Teumman.[8] The earlier account of Cylinder B goes into great detail about the fate of Teumman's head throughout the historical account.[9]

Elsewhere, texts state that Ashurbanipal took the road to Arbil

Ishtar

with the head of Teumman and made his entrance into the city of Arbil with this king's head, and that Ishtar had given it to him: "With the decapitated head of Teumman, king of Elam, I took the road to Arbela amid rejoicing."[10]

An epigraph seemingly intended for another sculpture and recorded in a text reads: "I, Ashurbanipal, king of Assyria, displayed publicly the head of Teumman, king of Elam, in front of the gate inside the city, where from of old it had been said by the oracle: 'The head of thy foes thou shalt cut off.'"[11]

The king's head is the most important element in the Til-Tuba relief. It is not merely a display of violence for the sake of coercive propaganda through the terror of a violent act. It is a fulfillment of an oracle, the destiny of Ashurbanipal's victory as decreed by the gods. In other words, in this composition, both the justification for war and the Assyrian victory are signaled through the king's head. The severed head becomes at once the sign of just war and its inevitable victory.

The proposition here that the king's head should be read as a message-sign is consistent with the account of the Battle of Til-Tuba as it is written in the historical annals. The relief image does not copy, in visual form, the written narrative of the battle, but the two versions are nevertheless connected. In the written narrative account of the annals, the outcome of the battle was predicted through a series of omens.

The most complete version of Ashurbanipal's Seventh campaign is described in Cylinder B, an eight-sided prism written in 648 BC. This prism is a historical-building inscription that was never publicly displayed but was written in order to be interred as a foundation deposit in the palace. In other words, the reader was construed as belonging to the future (see Chapter Four). The message was relayed across time. And there is no question that the Assyrians were acutely aware of the passing of centuries, of

41

earlier cities and kings, and of the rise and fall of dynasties, since most of their inscriptions make this historical consciousness clear. In the medium of the narrative there is already an indication of an Assyrian historical consciousness, one that I believe to be of considerable importance in the function of the war reliefs and linking texts and images.

The text of Cylinder B begins with a description of Ashurbanipal as the great king, relates who his father and grandfather were, and then declares that the gods had decreed a favorable destiny for him and, more importantly, that the gods had given him the intelligence to grasp the scribal arts and the ability to read the complex system of cuneiform signs with their many layers of meaning. Ashurbanipal himself boasts that he is able to read the signs. He possesses a good knowledge of hermeneutics and the semiotic system of Assyro-Babylonian scholarship:

> I am Ashurbanipal, the great king, the mighty king, King of the universe, King of Assyria, King of the four regions, offspring of Esarhaddon, King of Assyria, Governor of Babylon, King of the Land of Sumer and Akkad, grandson of Sennacherib, King of the Universe, King of Assyria. When the great gods in their council decreed my fate, they destined me for a favorable destiny. They gave me a broad comprehension, caused my mind to grasp all of the philological scribal art, exalted the utterance of my name before princes, and magnified my rule.[12]

The description of Ashurbanipal as a wise and learned king, justified in his rule by lineage and the gods, and destined for greatness, is followed by the description of his campaigns. The seventh campaign concerns Til-Tuba. The following is an excerpt from the account:

On my seventh campaign, I marched against Teumman, king of the
land of Elam, who, concerning Ummanigaš, Ummanappa, Tammar-
itu, sons of Urtaku, King of Elam, Kudurru, Paru, sons of Ummanal-
daše, brother of Urtaku, King of Elam, had sent his messengers to
me to secure their extradition. These people, who had fled and
grasped my royal feet, their extradition I did not grant him, on
account of the insolent messages that, by the hand of Umbadara and
Nabudamiq, he had been sending me monthly. In Elam, he boasted
before the assembly of his troops.

I trusted in Ishtar, who had helped me, did not grant him the
request of his impudent mouth or give him those refugees. Teumman
planned evil, and Sin (the moon god) planned portents of evil for
him. In the month of Tammuz, there was an eclipse of the moon.
From daybreak until daylight it rested. The moon god went into
eclipse, so Šamaš (the sun god) saw this and, like him, darkened and
rested, presaging the end of the dynasty of the King of Elam and the
destruction of his land. He (Sin) revealed to me the fruit of his deci-
sion, which does not alter. At the time, an event befell him (Teum-
man). His lip darkened and became stiff; his eye twisted, and a
gabasu grew in it. By these things that Aššur, Sin, Šamaš, Nabu,
Ishtar, Ishtar of Nineveh, Ishtar of Arbil, Ninurta, Nusku, and Nergal
did to him, he was not confounded. He mustered his troops.[13]

The text goes on to say that not only did Teumman not heed the
portents of evil — the sign of the eclipse that marked a destruction
of Elam and the body omens that afflicted his lips and eye — but,
to make matters worse, he persisted in ignoring those portents,
and the gods continued to send signs to Ashurbanipal. In the fol-
lowing month, Ab, the month of the feast of the goddess, a dream
came to the oneiromancer at the temple of Ishtar, constituting
another mantic sign for Ashurbanipal:

In Ab, the month of the rise of the Bow Star, during the feast of the
revered Queen, the daughter of Enlil, when I stopped in Arbil, the
city beloved of her heart, to worship her great divinity, they brought
me intelligence of the advance of the Elamite, who had gone forth
without the gods' consent. Thus spoke Teumman, whose reason
Ishtar had unseated: "I will not give up until I have come and fought
a battle with him."[14]

According to the text, Ashurbanipal then went to the temple of
Ishtar of Arbil and prayed to her to defeat Teumman. Later, dur-
ing the night, a certain seer lay down and had a dream-vision.
When he awoke, he recounted the dream to Ashurbanipal, first
describing the appearance of Ishtar, the goddess of love and war:
"Ishtar who dwells in Arbil entered, and right and left she bore
quivers. She held a bow in her hand. She unsheathed a sword for
battle." In the dream, Ishtar embraced the king, a flame burst forth
before her, and she said she would side with him in his victory.

Ashurbanipal continues that in the following month, Elul, the
month of the greatest effectiveness of the goddess, "I put my trust
in the oracle of Glittering Sin and the message of Ishtar and mus-
tered my warriors against Teumman, king of Elam." But these
were not the last portents. During the Battle of Til-Tuba, Aššur
and Marduk revealed more favorable omens to the oracle priest
through the signs of a word-dream: "At the command of Aššur
and Marduk, the great gods, who strengthened me through the
favorable omens of a revelation, the work of an oracle priest, I
accomplished his defeat at Til-Tuba."[15]

To summarize, the chronicle of the seventh campaign men-
tions the following omens:

1. A lunar eclipse occurred, followed by a darkened sun.
2. Body omens grew on Teumman.

44

3. A dream of Ishtar came to the oneiromancer at the temple of Ishtar.
4. Marduk, during the Battle of Til-Tuba, came to the assistance of Ashurbanipal through the signs of a word-dream. Ashurbanipal cuts off the head of Teumman at the command of Aššur and Marduk.

In the first omen, a lunar eclipse predicted the death of kings, the end of rule, or defeat. This defeat could be for any king, but in the case of a partial eclipse, such as the one that occurred in July 653 BC, the part affected was read geographically by the astronomers (ṭupšar Enūma Anu Enlil) as referring to Akkad, Subartu, Elam, or Amurru. It so happened that in 653 BC, the Elamite sector of the moon became occluded.

Lunar eclipses are among the oldest known type of celestial omen. In the Old Babylonian period, in the first part of the second millennium BC, aspects of lunar eclipses — such as date, time, duration, and direction of the motion of the shadow — were recorded for future reference. An old Babylonian text explains:

An eclipse in the evening watch is for plagues.

An eclipse in the middle watch is for diminished economy.

An eclipse in the morning watch is for [the curing of illness].

The right side of the eclipse was crossed; nothing was left: there will be a devastating flood everywhere.

An eclipse in the middle part; it became dark all over and cleared all over: the King will die. Destruction of Elam.

An eclipse began in the south and cleared: downfall of the Subarians and Akkad.

An eclipse in the west: downfall of the Amorites.

An eclipse in the north: downfall of the Akkadians.

An eclipse in the east: downfall of the Subarians.

The moon rose dark and cleared: omen of the destruction of Elam and Gutium.[16]

This tradition continued into the first millennium BC and well into the Hellenistic era, during the Seleucid dynasty. The compilation of these omens in an earlier Babylonian text known as the *Enūma Anu Enlil* includes the following in a long list of meanings for lunar eclipses:

If the moon is dark in the region of the stars to the west of Cancer: the decision is for the Tigris: The Tigris will diminish its flood-waters.

If the moon is dark in the region of the stars to the east of Cancer: the decision is for the Euphrates: The Euphrates will diminish its floodwaters.

If the moon is dark in the region of Pisces: the decision is for the Tigris, and Akkad, and a decision for the sea, and Dilmun.

If the moon is dark in the region of Aries: the decision is for Uruk and (the sanctuary of) Kullaba.[17]

The area of the moon that is darkened in an eclipse, the ecliptic stars in the path of the moon, and the zodiac signs were all correlated with geographical places.[18]

In the narrative of events leading up to the seventh Elamite campaign, after the first omen of the eclipse, a series of physiognomic omens appeared on Teumman's body. His lips darkened and became stiff, and his eye was afflicted with a growth. Such

46

changes of the shape and color of body parts are listed in the series of omens known as *Alamdimmû*, "if a form/shape," a lengthy catalog of physiognomic omens. The *Alamdimmû* omens are closely related to the SA.GIG texts (the medical texts that list the *sakikku*, or symptoms on the body of a patient; these will be discussed at length in Chapter Three). In addition, an omen is provoked. Ashurbanipal asks Ishtar a direct, specific question, through the oneiromancer, and requests an answer.

The first omen was celestial and public. It could be observed by the *ṭupšarru* (the celestial diviner) and explained to the king. The physiognomic signs on Teumman were also unprovoked terrestrial and personal omens. He did not heed them, and he apparently did not perform the necessary apotropaic rituals to avoid the predicted outcome. They are presented in the narrative as Teumman's personal fate, his destiny (*šimtu*). The third omen was solicited by Ashurbanipal. In the fourth, during the Battle of Til-Tuba itself, Marduk sent a cryptic message to Ashurbanipal in a word-dream. Aššur and Marduk commanded the defeat and decapitation of Teumman. The text describes how Teumman's head was severed, an Elamite emissary was made to carry the head around his neck, and it was eventually borne through the city gates in triumph:

> The head of Teumman, King of Elam, I hung around the neck of Dunanu, and around the neck of Samgunu, I hung the head of Ištar-nandi. With the loot of Elam, the spoil of Gambulu that at the command of Aššur my hands had captured, with singers to make music, I entered Nineveh with joy. Umbadara and Nabudamiq, nobles of Teumman, King of Elam, by whose hands Teumman had dispatched his insolent message, whom I detained in my presence, and who awaited my decision, saw the severed head of Teumman, their master, in Nineveh, and insanity seized hold of them; Umbadara tore his

beard; Nabudamiq pierced his abdomen with his girdle dagger. The severed head of Teumman I displayed conspicuously in front of the gate at the center of the city of Nineveh, so that the severed head of Teumman, King of Elam, might show forth the might of Aššur and Ishtar, my lords, to the people.[19]

In the images of the Til-Tuba relief, as in the historical annals, the decapitation is of central importance. It is the message of the work of art, just as it dominates the textual account. The king's head is a sign that is more than the severed head itself. It is a body-sign that works as a message. In the *Alamdimmû* series, signs that appear on a person's body are omens of destiny for the person in question but can also have relevance for society as a whole. That is how we can understand the body omens that Teumman suffered right before his defeat — the growth in his eye and problems with his lips. These somatic omens were both portents of his individual destiny and the signs of the Assyrian victory to come. Teumman's physiognomic omens were narrated into the account of the campaign against Elam literally as portents of Assyrian victory, written by the gods onto the body of the Elamite king. Afterward, his head became a sign, a message through a body part indicating the kingdom's defeat, its figurative decapitation. This reading of the head as a message-sign is corroborated by the written account of the head's being borne through the city gates of Arbil as a sign of triumph and its subsequent exhibition in Nineveh.

However, there are also ancient omens of terror. The king's head on the relief signals the Assyrian victory, yet it is also a metonymic omen of terror itself, a sign that is more than a severed head of a defeated king. It becomes a message of a predominant Assyrian ideology of terror embedded into the visual narrative of war. The use of body parts as a message is known from narrative accounts of other times and places in the ancient

Near East. One late example is Plutarch's *Crassus*, in which Crassus and his seven legions are surrounded by the Parthian army while marching through the Syrian desert near Carrhae (Harran). Twenty thousand men were killed and ten thousand taken prisoner, and seven eagle standards were lost. Crassus was decapitated; his severed head was sent to the Parthian King of Kings who was at the court of Armenia. At the time, Euripides's *Bacchae* was being performed at the palace, and the head of Crassus was used in the play as the head of Pentheus:

> Now when the head of Crassus had been removed, and a tragic actor, Jason by name, of Tralles, was singing the part of the *Bacchae* of Euripides where Agave is about to appear. While he was receiving his applause, Sillaces stood at the door of the banquet hall, and after a low obeisance, he cast the head of Crassus into the center of the company. The Parthian lifted it up with clapping of the hands and shouts of joy, and at the king's bidding his servant gave Sillaces a seat at the banquet. Then Jason handed his costume of Pentheus to one of the chorus, seized the head of Crassus, and, assuming the role of the frenzied Agave, sang the verses through as if inspired.[20]

After describing the treatment of the severed head of Crassus, the biography ends with these words: "With such a farce as this, the expedition of Crassus is said to have closed, just like a tragedy."

There are clear indications in Plutarch's life of Crassus that Crassus's life, especially the expedition into Mesopotamia that ended it, was predetermined from the start, and that Crassus proceeded toward a tragic end as if in a play. The defeat of Crassus and the Romans, his beheading, and the subsequent use of the severed head are features of a moral tale of arrogance and avarice. The story of Crassus's decapitation in Mesopotamia is woven into the larger narrative of his inability to read the signs and his

49

improper conduct in war. The story of the Roman expedition's failure and defeat in Mesopotamia is very close to the narrative of Ashurbanipal's seventh Elamite campaign, in which Teumman is beheaded and his head brought back as a trophy. Teumman's head, like that of Crassus, is a sign. It is the element that holds the narrative together and pins it into place as a predetermined text.

In effect, the head becomes more than the mimetic and historical head of Teumman in the symbolic order; it is part of the political economy of death. The head is the focus and message of the relief in both the work of art and the text of the historical annals. The device of Teumman's head in the composition of the Battle of Til-Tuba relief can be illuminated by the Roland Barthes quote at the beginning of this chapter: "Meaning is not 'at the end' of the narrative, it runs across it; just as conspicuous as the purloined letter, meaning eludes all unilateral investigation."[21]

However, it is not just the head, but perhaps also the very act of decapitation that is at issue. Both the visual and the written accounts evince a desire to focus on head-hunting as an activity. If the head-hunt is a specific act of war, then let us consider how it relates to other known Assyrian rituals — controlled lion hunts, sacrifice, substitution, and the magic of the state — all issues discussed in Chapter Eight. The Assyrian lion hunt is in some respects enacted as a parallel to war.[22] In sum, the severed head is a body omen, and the subject of the Til-Tuba relief is the head. In the Assyrian conception of just war, omens both legitimated and motivated the war and predicted victory.

Performative Images

In my previous work, I have attempted to make a case for the Assyrian belief in the animistic power of images and the relationship of image making to forms of manticism. These aspects of the response to images had not been addressed in modern accounts of

Assyria, because Assyrian art is usually studied as a source of information for empire and for the depiction of specific historical battles. But in relation to this attribution of power to images, we might see that at least one aspect of narrative imagery the Assyrians used functions differently from later forms of narrative art. This is what I have called the performative image.[23] This concept problematizes ideas of narrative and representation traditionally applied to Mesopotamian art and opens up the genre of narrative into another dimension.

Much Assyrian scholarship has been focused on the relationship between the historical annals and the images of war in the reliefs. While the text and the images must certainly be studied together, a simple reading of the reliefs as visual copies of historical texts misses the mark. When they are evaluated according to their historical accuracy, the Assyrian reliefs are read as if they were mimetic representations that nevertheless falsified things, or failed in their mimesis.

But in Assyria the visual image was not seen as a copy of the real. Instead, its nature is better described as indexical, because it functioned through a relationship of contiguity to the signified. Thus portraits of kings functioned as something more than mere representations; they were substitutes. This thinking led to the practices of abducting images of gods and kings during battles and carrying off monuments. For instance, the Codex Hammurabi and the Victory Stele of Naramsin were both taken by the Elamites to their capital at Susa, in Iran.

This conception of the image as substitute also led to the destruction of the representations of certain kings in Assyrian palaces, such as the faces of Sennacherib at Lachish (see fig. 6.3) and Ashurbanipal in his Nineveh banquet scene (see fig. 1.1), and the placement of protective curses on images of kings.[24]

The study of the destruction of images must lead to a reconsider-

ation of the function of war reliefs. If the argument that the Assyrians saw images as powerful indexical forms of presence is correct, how does that relate to the function of the reliefs?

First, let us begin with the basic identification of the genre. Assyrian palace reliefs are architectural sculpture. They are an element of the wall revetment of the palace; they form part of the fabric of the palace wall. The creation of a sculpted palace was considered an exceptional event. Written accounts describe the importance of all the materials used, their place of origin, their positioning within the structure, and so on. A committee of officials under royal supervision seems to have been in charge of the construction. At least one of these officials must have been experienced in magic, since various parts of the palace had to be protected by apotropaic rituals using images.

The protective clay figurines, the *lahmu* and *apkallu*, buried under the floors, in corners of rooms, in courtyards, and so on, have been uncovered by archaeologists. The famous colossal winged bulls and lions bear inscriptions clearly stating that their function is apotropaic and suggesting that the colossi had the potential to become animate beings and walk off.[25] There is also ample evidence that the image of the king, whether in relief or in the round, was a form of his presence, even after death; his essence was somehow still within the image, and harm could come to him through it, as the curses placed on royal sculptures depicting the king clearly state.[26]

The imagery on the palace reliefs must be understood in this context of image power. It is part of the fabric of the structure of the palace. Like the colossi and the foundation figures, it could be effective in ways that were not simply propaganda; it could make things happen. This imagery was at least in part a means of effecting an apotropaic and invocational magic. It could construct Assyrian power and make the Assyrian victory inevitable and en-

52

during. In that sense, it can be defined as a performative imagery, an imagery that creates through the act of representation.

Performative statements were used as a standard form in Assyro-Babylonian incantations. The performative statement is not mimetic, because it does not simply repeat a preexisting reality; it works to create a reality by means of the utterance. Ritual texts provide ample proof that words had a performative function and that imagery in the Mesopotamian tradition also worked in this way, at least in some situations. Assyrian ideas about representation and reality were linked, in that it was possible to destroy something by destroying an image of it. The reverse was also true. Representation was thought to make things happen, not simply to depict. The making of images had a performative and indexical relation to the thing portrayed, rather than being a mimetic copy of the real world, although it incorporated details of the real, especially in the art of the Neo-Assyrian Empire.

The Assyrian method of representing the regions of the empire was generally attentive to minute details and concerned with ethnographic accuracy, even when the composition was hierarchical and representations of the body were stylized into abstract patterns. In studying Assyrian reliefs of war campaigns, scholars have most often looked for historical accuracy: this Assyrian soldier wears that type of gear, Elamites look different from Assyrians, and so on. Most such studies have considered them documents through which to visualize the real historical event of the battle, the terrain where the battle took place, and how the propagandistic message of the Assyrian victory is conveyed through the image. That is, the Assyrian relief is, paradoxically, taken as a reflection of both ideology and historical events. Realism is certainly a distinctive aspect of Assyrian narrative art. Accurate details of dress and landscape were used to create what Barthes would have called the reality effect.

53

Historical records and ideology are two important aspects of the study of Assyrian art. However, one might also look at this particular depiction of the Battle of Til-Tuba as an aesthetic composition — in other words, as a work of visual art. This may seem like a somewhat reactionary or conservative return to a Morellian connoisseurship, however, this approach simply calls for a close visual analysis of the works of art of Near Eastern Antiquity. If those interested in context and contextualized readings are to consider seriously what this means for ancient works of visual representation, they must begin this consideration with the depiction itself. In other words, it is not sufficient to analyze aspects such as local ideologies and social uses of the visual arts from outside the work. We ought to consider closely the work, in and of itself, and attend to it seriously as a work of representation.

In formal terms, the narrative of the Til-Tuba battle seems to reveal what might justifiably be described as a fascination with repetition. The narrative multiplies the profusion of violence by means of repetition that creates a sense of order through its use of symmetry, in the repetition of bodily shapes of the dead and wounded bodies, weaponry, and the constantly reappearing head of the king. But such repetition is out of keeping with the otherwise realistic narrative details. What, then, is its pictorial purpose here?

The relief also treats space distinctively. Assyrian reliefs do not favor optical illusionistic space but a tilted construction with a close horizon or background, a reduction of the space to the plane of the foreground. In images such as the Til-Tuba relief and in other Assyrian reliefs, repetition has power. Repetition on the reliefs is not limited to a realist representation of processions of soldiers or tribute bearers or a barrage of troops in the military siege of an enemy city. Repetition is often a formal element free of any iconographic or narrative links. This infinite movement in

repetition becomes a mechanical force, a relentless movement that decenters the composition and makes impossible the existence of any central focal point.

Perhaps we can think about this compositional element given what we know about repetition in texts or incantations. In other words, we ought to regard repetition in and of itself as a representational device that works to make something happen, just as it does in the performative ritual statements in incantations. The king's head is a sign underscored by repetition in the relief. The severing of the head and its subsequent transport and triumphal display are rituals of war; they are visual and theatrical performances of victory. The decapitation in itself is the primary subject of both the relief and the chronicle of this war. There is a ritual side to the Battle of Til-Tuba that is recorded in the relief and replays itself into eternity.

Chapter Two

Babylonian Semiotics

> I learnt the craft of Adapa the sage, the hidden
> mystery of the scribal art. I used to watch the signs
> of heaven and earth and to study them in the assembly
> of the scholars.
>
> — Ashurbanipal*

Babylonian scholars were the first to develop a rigorous system of reading visual signs according to a method that would now be called semiotic. This intellectual development came out of the Babylonian and Assyrian speculative scholarly tradition, which conceived of the division between artifice and reality in entirely different terms from the concept of mimesis. The latter, an ancient Greek concept that we have learned to take as equivalent to representation, essentially functions as a division between the original and the copy or representation. And although recent theoretical writing on aesthetics and philosophies of representation has pointed out the limitations of thinking of mimesis in terms of original and copy and has greatly problematized the imitative concept, there is still the essential basis of a duality in representation. In Mesopotamia, however, representation (writing, visual images, and other forms) was thought of not as imitating the natural world but as participating in it and affecting it in supernatural, even magical ways. For the Mesopotamians, the world was saturated with

*Frahm, "Royal Hermeneutics," p. 45.

signs in a very real sense. The universe of things and the world of
signs, which Walter Benjamin tries to bring closer together, was
already, logically and metaphysically, all one universe in Mesopo-
tamian speculative thought.[1] It was a commonly accepted schol-
arly position in Mesopotamia that everything in the universe could
be deciphered. By the Neo-Assyrian period, in the first millen-
nium BC, the idea that the universe consisted of signs that had to
be read or interpreted was standard among specialists in ṭupšarutu,
an area of expertise that can be described as philology.[2]

In an essay on scientific method and the rise of semiological
modes of interpretation in the nineteenth century in Europe,
Carlo Ginzburg made the intriguing suggestion that the origins of
semiotics are to be found in Babylonian divination.[3] The essay
focuses on the methods of Freudian psychoanalysis, the reading of
clues by Arthur Conan Doyle's fictitious detective Sherlock Holmes,
and the art critic Giovanni Morelli's methods of connoisseurship,
according to which an artist's work can be recognized by details in
the painting that function as a trace of handwriting or a signature.
Freud had already pointed out the similarity among these methods
of inquiry in "The Moses of Michelangelo," in which he states that
the underlying method of all of these endeavors is "accustomed to
divine secret and concealed things from despised or unnoticed fea-
tures."[4] Ginzburg explains that this method means reading minute
details as clues and argues that all three cases evoke the model of
medical semiotics or symptomatology.

In Ginzburg's assessment, divination — like symptomatology —
consists of reading signs in an indexical manner; therefore, a
symptomatic or divinatory paradigm is used for scientific inquiry
in all these cases. Similarly, in Mesopotamia, signs, representa-
tions, and images were understood according to this kind of semi-
otic system.

Indeed, the links between methods of divination and Mesopo-

tamian concepts of representation and the real can be demon-
strated through numerous narrative genres and visual images. In
the visual arts — for instance, in images of war and violence — that
complication of the relationship between representation and the
real comes into play. There is usually the historical event of a war,
real and documentable according to contemporary notions of his-
tory, and there is the ideological message of justification, glory,
and victory, but if Mesopotamian conceptions of representation
did not function according to a standard system of mimesis, then
these are not the only two aspects of the image of war. Therefore,
Assyro-Babylonian images of war or violence contain a kernel of a
historical record of an event, but their essence is the ideological
component regarding the message of a just war or justified war.
At the same time, the images of war have a link to the realm of the
divine in a more direct, if supernatural, way. The supernatural
aspect of the image is still linked to ideology, but not a simply
propagandistic or epiphenomenal ideology, in the sense of a delib-
erate manipulation of the masses.[5] In the following chapters, I
shall analyze these aspects of images of bodily violence, war, and
sovereign power by considering the correspondence and, indeed,
interplay between the political and the supernatural, but first I
shall outline what the link between divination and representation
means and how to consider the ideology of rule in conjunction
with the realm of the supernatural.

Representation, Divination, Reality

In ancient Mesopotamian scholarly thought, there was a collapse
of any clear distinction between the real and representation or, at
least, the boundary between the two became blurred. For the
ancient Babylonians and Assyrians, this certainly was the case.
This metaphysical system can be interpreted as a primitive attri-
bution of life to images or a belief in the supernatural, but it can

also be read as a realization of the complex relationship between representation and the real. For the Mesopotamians, representation and the supernatural were not separate spheres; they were both directly linked to things that happened in daily life. Or rather, representation was a medium through which this link was made manifest. In this sense, Benjamin's suggestion that the wholeness of the universe is sustained by natural correspondences that urge men to analogies is not far from Babylonian scholarly thought. For Benjamin, the mimetic faculty has decayed or been transformed in modern man, so that these magical correspondences have been lost. The ancients were more aware of this "nonsensuous similarity" among things in the world.[6]

To return to semiotics and Babylonian speculative thought: the place where the ancient concepts of representation and the sign-laden world clearly came together is the realm of divination. Divination worked through an interpretation of signs in the universe. In the Mesopotamian context, Jean Bottéro has argued that the invention of writing had a great effect on the development of divination.[7] One might take that observation further and say that the entire system of divination became influenced by the logic of the script. For the ancient Mesopotamians, the world was saturated with signs; the world was a text. All these signs could be submitted to a certain type of textual reading: the interpretive reading that is an integral part of the process of reading cuneiform script.

The Mesopotamians believed that the gods wrote into the universe, and that is why the world could be read hermeneutically by those who were wise enough. The world was inscribed (the Akkadian word is *šaṭāru*). The world was thus quite literally laden with signs. These signs could then be deciphered through the science of divination, which depended on a form of textual and interpretive reading of things in the world, as this verse from a Neo-Assyrian hymn to Šamaš, a god of divination, makes clear:

O radiance of the great gods, light of the earth
Illuminator of the world regions
Lofty judge, creator of heaven and earth
O Šamaš, by your light you scan the totality of lands as if they were
cuneiform signs
You never weary of divination.[8]

This hymn from Ashurbanipal's reign is quoted by Jacques Der-
rida at the beginning of *Of Grammatology,* the founding text of
what is now known as Derridean deconstruction.[9] I have else-
where discussed the similarities between some aspects of Der-
ridean deconstruction, semiotic theories, and Assyro-Babylonian
logic.[10] But Assyro-Babylonian speculative thought has still not
received the attention it merits. Ginzburg (who was spurred to
his conclusion by the Assyriologist Bottéro's essay "Symptômes,
signes, écritures en Mésopotamie ancienne") is no doubt correct
that the first development of semiotics emerged from this Baby-
lonian divination. The divinatory system of Babylonia and Assyria
used tropes, rhetoric, and the logic of the script. The reading of
signs in omens and in dream interpretation can very often be
explained through the tropical functions of rhetoric and the spe-
cific values of cuneiform script. The divinatory system was deeply
steeped in writing; it was the product of a literate culture.

It is possible to speak of "Babylonian semiotics," as opposed to
what early anthropologists like James George Frazer called "sym-
pathetic magic" or "vague emanations,"[11] because this Babylonian
system relies on rhetorical analogies and semantics and grammar
derived from the written language. In other words, it appears to
be based largely on the logic of script. The power of writing, rec-
ognizable in the ability to convey an original piece of information
in a record that can be consulted and retrieved later, can be seen
as a power that imbues other parts of existence and the world.[12] It

is not a simple recording instrument but a "technology of intellect," and as such it is intertwined with people's lives, cognitively as well as organizationally.[13] Jack Goody has made a convincing argument for the influence of writing in literate societies, even on illiterate people. He differentiates between nonliterate societies that make no use of written script at all, and societies that have writing but in which a large segment of the population is illiterate.[14] Nonliterate societies can and do use divinatory practices, but not all forms of divination function according to the literate hermeneutical system of the Babylonians and Assyrians.

When writing was invented in the fourth millennium BC, an entirely new system of representation that could signify real things on two-dimensional clay tablets was formed. An inventory of signs was created that was logical and upon which users had to agree. In the system that the Mesopotamians devised, phonetic value and pictographic value coexisted. From the very beginning, the system was polysemous. Moreover, as Mario Liverani has pointed out in relation to the Uruk phenomenon in Mesopotamia, the invention of writing was not merely a technological change but a change that eventually brought about an alteration in the entire perception of the world.[15] Liverani describes how the sexagesimal system of accounting came to influence perceptions of the economic and agricultural domains. But following Goody's account of writing as a cognitive and intellectual technology, the point can be taken further. As all forms of manticism clearly demonstrate, the script cannot be separated from Babylonian ontology. While some scholars of early Mesopotamian script, such Robert K. Englund and Hans J. Nissen, have primarily been interested in the economic and administrative basis and use of writing, others, such as Liverani, Jean-Jacques Glassner, and, in a fundamental and seminal way, Bottéro, have looked more deeply into how writing affects cognitive and intellectual operations and

how people in Mesopotamia came to relate to the world surrounding them after writing was invented.[16] John Baines makes a similar intellectual case for Egypt where a contemporaneous development of writing took place.[17]

Cuneiform script, however, is by its very nature multivalent and resists any possibility of a simple and direct reading. No wonder, then, that hermeneutics was a Babylonian development. Since the separation of phonetic signs from iconic signs never fully occurred in Mesopotamia, the signs of the script can always potentially be read according to ideographical or phonetic values, as well as the values of homophony, metonymy, synecdoche, and metaphor. Reading cuneiform script became even more complicated when one could read the sign in two languages, Sumerian or Akkadian. In order to read a sign correctly, the reader had to consider each possible value in relation to the text as a whole. Yet for the Babylonian and Assyrian scholars who amassed the lists of signs and their readings, and who recognized the infinite play of possible meanings, all these values, whether present or absent from the surface of the sign, were part of each sign's essential meaning. In other words, as in Derridean *différance*, meanings differ and are deferred, creating an endless play of signification. The attempt to amass all these meanings reveals what at times appears to be an almost pathological anxiety; the same might be said for the science of divination itself.

Clearly, then, this system of script and its method of readings gave rise to Babylonian hermeneutics. In Akkadian, *pašāru* is a multilayered reading or decipherment of texts, in the broadest sense of the word. *Pašāru*, a form of what I would call textual exegesis, was closely linked to divination (*barûtu*) which was, in turn, related to vision as an act of seeing. A *barû* was a type of priest who was also a diviner; the noun *barû*, which is derived from the verb to see, literally means observer or seer. The *barû* was an

expert in *barûtu*, the observation of signs in the world. "*Barû ša mati*," the epithet for the god Šamaš, the sun god and the patron of divination, is written with the *dingir* sign (which is a determinative for a god) and thus reads, "Divine seer of the land." Šamaš is also said to inscribe omens into the world, for example into the body of the sacrificial animal, to read in a type of divination that will be discussed in Chapter Three. Ancient texts say that Šamaš "inscribes the omens in the entrails of the lamb."[18] The perception and investigation of truth were the sun god's special domain. Another epithet is also used for Šamaš: *pāšir šamê u erṣetum*, the "exegetical reader of heaven and earth."[19]

In Assyro-Babylonian ontology, omens are written into the real. Omens could be solicited from the livers of sacrificial animals by priests, for example, but they were also inscribed by the gods into the common, everyday world. An observant person could read these messages anytime or anywhere. Catalogs of omens listed vast amounts of possible patterns of flights of birds, birth deformities, chance occurrences in cities, and aspects of human physiognomy. By the seventh century BC, at least ten thousand omens had been cataloged. Thus hair-growth patterns, moles, and other physical characteristics were considered not accidental but linked to an individual's fate. For the Mesopotamians, semantic codes in physiognomy belonged to the real. They were not in any way metaphorical or allegorical. The difference between material reality and semiosis, which is based on scientific reason in the modern view, was an intertwined area in Assyro-Babylonian thought. This connection cannot be easily explained as a blurring of the real and the imaginary. Instead, the real contains what we might call the imaginary within it.

But what is the difference between reading the past and the future, reading portents and omens, and reading the traces of already existing or past things or of semata? Ginzburg says that the

difficulty with comparing semiotics and divination is that tracking clues, as in detective work, is a process of finding traces of the past in the signs of the present, whereas divination involves looking for traces of the future in signs. However, in consulting the ancient Mesopotamian record one sees that this is not the case. Divination is a reading of a previously written sign in the real. In other words, it is, to some extent at least, in the past. In Mesopotamian thought, the past and future were directly linked; this conception of time can be demonstrated by numerous types of divinatory texts. In fact, there appears to have been a perceived circulation of past and present, the one having an effect on the other, inseparably and continuously. I will return to this point in Chapter Three, in relation to the class of Mesopotamian predictive textual records known as historical omens.

The forms of representation of history, wars, and sovereign power in Babylonian and Assyrian Antiquity thus emerge from a tradition in which representation, broadly defined, is a multi-layered system of signification that interacts with historical time and supernatural mantic signs. Ideology is never simply political manipulation. It consists of the entire apparatus of representation and bases itself upon the supernatural. In Babylonia and Assyria, the semiotics of power was simultaneously relied upon and feared by the sovereign. It was never simply under his control, so throughout the millennia of absolute power the anxieties of the office of kingship remain discernible.

Ideology and Ritual

Ideology has been an important working concept in Near Eastern archaeology since the 1970s. It has been a convention of Mesopotamian scholarship to think that any serious study of the ancient Near East will focus on the ideology of kingship or the empire. While varying definitions or notions of ideology are utilized in

archaeological or art historical theories, in Near Eastern archaeology the concept of ideology has generally been used in the sense of either false consciousness or false image — in both cases, it is an untruth about a true situation. Although this theoretical position is not argued or discussed explicitly in all cases, it is often taken as common sense that ideology is emitted by the person of the king. This belief in the king as the source of ideology is more or less an adherence to the early Enlightenment notion of ideology as the false notion of reality promoted by disparate interests, particularly "priests and despots," as Louis Althusser, referring to Karl Marx and Friedrich Engels's *German Ideology*, put it.[20] Thus, it has been the standard theoretical position that the ruling political ideology can be read directly in images of Antiquity, since their production was controlled by the king or by the ruling dynasty. For Near Eastern archaeology, ideology is typically thought of as directly reflected in representations.

But there is a fundamental paradox in this interpretation of the ideological image. On the one hand, Near Eastern art is ideological in the sense of being a manipulated, untruthful message, an ideology promoted by the dominant class (in this case, the despot himself) as a means of concealing a reality. On the other hand, these propagandistic messages are taken as a window through which historians and archaeologists can access historical events. The latter theory reduces the image to an object in the service of political history, rather than acknowledging it as a complex representation. Obviously, such a view of representation as a tool of political history is both reductive and contradictory and has numerous theoretical problems that cannot all be disentangled here, but some major stumbling blocks to this use of images and notions of iconographic ideology should be pointed out before the present investigation can proceed.

Added to the difficulties of the dichotomy of representation

66

and ideology is the description of images directly and unproblematically as iconography. The word "iconography" is commonly used by archaeologists to refer to the visual arts, but the term has a specific meaning in visual theory and art history. The problematics of representation ought to be addressed within archaeology, because imagery is not a value-free system of recording reality, and one cannot, as some maintain, read the ideology of the past as reflected directly in iconography. Nevertheless, even if one wishes to adhere to the opposition of false ideology versus truthful image, one ought to think about how that falsehood is produced in representation. The distinction between truthful and false images depends on a conception of representation as an enterprise that sets out to imitate mimetically everything in the society that produced it. But that is not a sustainable definition of representation for any culture.

On the theoretical level, it is difficult to sustain the equation of ideology with falsehood. In many images, the event depicted is factually true but nonetheless ideological, rendering the dichotomy of ideology and representation untenable. Examples of narrative images from Antiquity that have been taken as ideological are the Assyrian reliefs and the narrative of militaristic events on Trajan's Column, but it is certain that these narratives are based on actual historical events. But the idea that ideology must be based on a truth is also problematic. Consider a statement as common as "Ideology must be experienced as truth in order to function." In the substantial study of ideology that he has carried out for several years, Slavoj Žižek makes the point that ideology is not necessarily always experienced as truth.[21] Žižek returns to the theoretical writings of the Frankfurt School philosopher Theodor Adorno, who in his "Beitrage zur Ideologienlehre" argued that Fascist ideology worked as a lie experienced not as truth but as a lie, even by its promoters. According to Adorno, no one took

67

Fascist ideology seriously, not even Fascists. Its status, in Žižek's words, "is purely instrumental, and in fact, ultimately relies on external coercion and repressive state apparatuses."[22] In other words, if in the Althusserian model ideology is separate from Repressive State Apparatuses and functions within, as well as creates, Ideological State Apparatuses, or the ideological edifice itself, then Fascist ideology is not ideology. But if ideology regulates the relationship between the visible and the nonvisible, as well as the changes in this relationship, then representation is at the very heart of any theory of ideology.

Regardless of Adorno's observation regarding Fascism, it is clear that a fundamental stratagem of ideology is the reference to "self-evidence." Roland Barthes believed that ideology worked through the naturalization of the symbolic order into reality.[23] In the 1970s, Louis Marin argued at length that the relationship between ideology and representation ought to be defined as a *chiasmus*.[24] If we accept these arguments, then theories of ideology, no matter how varied politically, should nevertheless address representation as being the cog in the wheel of ideology itself. That is, representation does not represent ideology, since ideology can exist only in and through representation. So when addressing the issue of ideology and representation as if it were a subsection of ideology in the past, it is difficult to set representation apart as a distinct place where ideology can occur, or in which ideology can manifest itself, or use representation for its own goals. In other words, to see representation as a place where ideology can be accessed is problematic, since theories of ideology and representation are fundamentally linked.

Representation is taken in its broadest sense here. It encompasses the main areas that we are concerned with in the present work: the visual, the textual, and ritualistic performance. We have studied the ideology of, for example, the Assyrian empire by

68

means of the carved images or written annals that paint a false or distorted picture of the true situation. But since it is this very despotic situation that is represented, how is this image false? If ideology is, as theorists from Marx to Žižek maintain, a mystification, how do we read the Mesopotamian visual and textual records of kings and their wars? If we take Mesopotamian studies as an example, it becomes clear that the critique of ideology must be released from this discussion of truth and falsehood if it is to be of any use to studies of Antiquity. Instead, theories of representation can become a place to think through theories of ideology.

Assyria's domination of the Near East in the first millennium BC relied on the might of an army, a military power that was invincible at the time. However, representation and ritual played a strategic and supernatural role in the Assyrian war machine. Ritual was not simply used in the service of propaganda, nor was it even "fundamentally political," as some maintain.[25] Ritual permeates the war machine well beyond the overt and institutionalized forms of religion. It cannot be explained as the coercive display of the king.[26]

Žižek's Hegelian model of ideology, which derives from Marx's statement that religion is ideology *par excellence*, is useful for thinking about the location of ideology in different representational cultural practices. In this model, based on the example of religion, ideology works through the tripartite division of doctrine, belief, and ritual. To take this further, performative ritual generates its own ideological foundation. That is, the generative matrix of ideology is produced through external behavior, through ritual in its broadest sense, as through performative behavior that is not acknowledged as performative or ritualistic but simply seen as the activity of natural daily life. I have developed this point elsewhere in relation to Assyro-Babylonian ideology and representation, which, in my assessment, worked on the level of the

performative.[27] In other words, it worked through embodied action and through vocal performative utterance, as well as in a notion of representation as performative utterance. The ideas in Blaise Pascal's *Pensées* are ultimately behind this conception of ideology's performative nature. Pascal observed that ideology's mystical authority functions through unquestioned custom and pointed out that reason is for the crowds, while law is based only in the performative act of its own enunciation.[28]

This concept of ideology as active is different from either a Foucauldian or post-structuralist notion of reality as simply a discursive formation, misperceived as extra discursive fact. And it is different from the more boldly delineated truth-and-ideology divide to which Jürgen Habermas and Seyla Benhabib adhere.[29] It is also fundamental for understanding ritual and its dependence on representations. While Maurice Bloch developed a thesis that ritual may be ideological in nature or have ideological functions, in his theory, ideological ritual is seen as a distortion rather than as a performative and representational act.[30] A notion of ideology as inseparable from representation allows for a critique that does not simply compare truthful and distorted messages but attempts to address the workings of ideological mystification. Consequently, this notion would mean also that contemporary scholarship acknowledges its own political stance as the point of departure, rather than arguing from a point of no ideology or an ideology-free area of scholarship.

This point is important, since, as several neo-Marxist theorists have argued, one is never so much within ideology as when one claims to be on the outside and immune to any ideological belief. There is thus no outside of ideology, no zero point from which to begin.[31] So if there is no nonideological image that can be juxtaposed to the ideological false image, is it impossible to discern ideologies in the past?

For Althusserian Marxism, the materialization of ideology can be found in Ideological State Apparatuses and even in Repressive State Apparatuses to some extent. In terms of practice (if we accept the Althusserian notion), for Mesopotamian archaeology this means that we can analyze ideologies in the past. But this is a more difficult and convoluted path, because ideologies are not simply found reflected in representations, archaeological remains, or historical accounts. To disentangle ancient ideology's message from the truth of the past is no easy matter. We cannot point out ancient ideology as falsehood in opposition to our own truthful reconstructions of the past. What this amounts to is an unstated argument for a (very ideological) binary of self and other, ancient and modern.

Adorno's statement about Fascist ideology's being a deliberate falsehood meant to be taken as falsehood is an insight that immediately makes sense to those of us who have lived under totalitarian dictatorship. In my own background of living under dictatorships of one form or another, I learned at a very early age that no one takes seriously the dictatorship's overt statements, or any newspaper or television account, but pointing this out was out of the question. To use a personal version of ethno-archaeological methodology: take the well-known poster of Saddam Hussein that represents him as Nebuchadnezzar in his chariot, wearing Babylonian attire, winning a victory with a modern arsenal (fig. 2.1). Other posters represented him as Salah-al-din at the Crusades or as an ancient Muslim warrior fighting in the Battle of al-Qadissiyah. In considering these posters' role in the Iraq ruled by Saddam, I am reminded of Adorno's statement regarding fascist ideology. No one in Iraq ever believed that Saddam was the reincarnation of Hammurabi, Ashurnasirpal II, or Salah-al-din, not even Saddam himself. That was not the ideological message. It was not even that Saddam was believed to be *like* those heroes or analogous

71

Figure 2.1. Saddam Hussein poster, Baghdad, Iraq, c. 1991.

to them. The underlying ideology at that time was actually the unconditional submission of the people to the Saddam-ruled Iraq. It is what Žižek refers to as the syndrome of "Yes, we know, but all the same . . ." To make his point about ideology, Žižek uses the example of the parable of the Emperor's new clothes. He describes this as a story that relates the irrational sacrifice to the state, a parable that was most certainly applicable to Saddam's Iraq.[32] This system can actually bypass ideology. It relies to a great extent on coercion, police repression, censorship, silencing through severe laws, and the like. A poster of Saddam as Nebuchadnezzar or Hammurabi presented itself as the ideology of the regime, but that is not what it was. It was simply a lure, a detour from what was actually the ideology of silence. How, then, can we extrapolate from such insights that we have learned from more contemporary situations? On a theoretical level, this means that just as what is presented or argued as being outside ideology, or nonideology, can be shown to be ideological, so too the reverse is possible: something can be presented as official ideology when it is simply a detour. We can look for a method to analyze ideology in the past, but such a method necessarily remains between past and present; even when we read ideology in the past through material culture, images, or texts, that direct reading of ideology as ideology is often a mimetic reading that may actually be luring us into the trap of the surface message.

Consider what the scholarship of the ancient Near East usually says about the Assyrian Empire. We often simply repeat the ideological message, the dictates of the Assyrian reliefs and annals, and then refer to them as ideological. In that sense, we become puppets for the Assyrian Empire, repeating or echoing its statements over the millennia. This can be described as the trap of mimesis, of believing the image or representation to be a real and accurate reflection. The reverse, thinking of ideology as false image, is also

73

derived from the same belief in the mimetic process. It is simply
the other side of the coin. Acknowledging this dilemma should
not lead to the nihilistic view that we can never analyze ideologies
in the past, but that in order to do so it is necessary to come to
terms with the problematics of representation. For archaeology,
this means that theories of representation must be taken seriously
within the field rather than being dismissed as the lightweight
concern of the fine arts. Reading images is no more direct or
unproblematic than reading texts or material remains. If repre-
sentation is at the heart of ideology, then discussions of ideology
in the past must begin to address theories of representation.

The Mantic Body

SA.GIG (handbook which concerns) all disease and
all distress; *Alamdimmû* (handbook which concerns)
external form and appearance, the fate of man which
Ea and Marduk ordained in heaven. [Let the *āšipu*-
magician] who reads the decision and who watches
over people's lives, who comprehensively knows
SA.GIG and *Alamdimmû*, inspect and check, [let him
ponder], and let him put his diagnosis at the disposal
of the king.

— SA.GIG Text.*

The emission of signs by human and animal bodies was a central
concern of Babylonian scholarship and thought in the second and
first millennia BC. It formed the focus of meditations and contem-
plations of daily life, the order of things in the world, the past, and
the future. For the Mesopotamians, the essential nature of the or-
ganic body was that it was laden with signs; as a signifier, it not
only subsumed the signified identity but also became the locus of
production of signs that were relevant to the world beyond the
body. That process of signification, like later forms of physiognomy,
had to do with the present and with the life and identity of the
individual, but in the Babylonian view the signs of the body had to
do with the future as much as the present. The Mesopotamian

* SA. GIG or *sakikku* means "symptoms." Finkel, "Adad-apla-iddina," p. 193
(translation emended).

75

conception of time was linked to the notion of divination and manticism, and this link can be seen clearly in the specific practices of body divination. Like medical semiology, these practices worked as prognostic as well as diagnostic methods.

In some sense, for the Mesopotamians, *man* himself was a proleptic category. The legend of Atrahasis establishes a time frame by beginning with the words, "When god was man": the gods were then what they afterward created man to be.[1] Unlike the Egyptian notion of time in which the cyclical nature is clear, the Mesopotamian conception of time was to a great extent focused on the worldly future. In Babylonian and Assyrian thought, things that are to come are a most important category of thought. These future events could take on tangible and material manifestations, in portents or even in specific identities and in the physical bodies of the gods. In the realm of the Babylonian gods, Nabu, who is always to come as the successor of Marduk, exemplifies this idea. Nabu never takes the place of Marduk. His entire role is anticipatory. Signs written into the bodies of animals and humans, beneath the skin and on the surface, were always there and could be read by those wise enough to decipher them. Their portents were both essential and direct.

The human body was fragmentary and could signify through its parts as well as the whole. Parts could mean the organic body or aspects of the body that today would not necessarily be considered integral to bodily identities, such as exuviae: hair, nails, body parts, and bodily fluids separate from the body. Parts could also include artifactual bodies or bodily representations in the visual arts.

The total organic body was seen as a text. Perhaps this statement will seem commonplace, since the metaphor of bodily inscription has become a postmodern maxim. But the declaration should not be understood in metaphorical terms; in Mesopotamian Antiquity, the body was quite literally conceived of as a

textual entity. That textuality was considered logical, and the text of the body could be accessed as a form of serious empirical knowledge.

For the Babylonians and the Assyrians, the body's semiotic qualities were not simply a matter of effective gestures in action or motion, in ceremonies or performances in which meaning could be found. Semiotically, the body was not simply an entity that worked as a supplement to the voice as a means of communication — for example, through smiles, gestures, or external and cultivated aspects such as clothing. The body's narrative through movement and gesture was taken into account in social contexts, but that narration through gesture or expression was not the semiosis of the body that was at the forefront of Mesopotamian thought in Antiquity. The body was neither simply the medium of movement nor the medium of, or supplement to, the voice in communication.

In the theories of the body currently circulating in the fields of archaeology, art history, and anthropology, the body is the locus of existential identity. For the ancient Mesopotamians, that conception of the body would no doubt have appeared far too limiting. The endless possibilities of semiosis that the Mesopotamians believed the body contained went far beyond individual identity. From ancient texts, images, and rituals relating to the body, body parts, and anatomy in general, a conception of the mantic body emerges that might be defined as a distinctive Mesopotamian conception of the body-text. This body-text is further complicated by the fact that as an entity it related directly to the Mesopotamian conception of time, of reading a past into the future through the omens of the body. Identity was therefore not seen in terms of a Cartesian duality of mind/body, or body/soul. Perhaps even more distinctively for Mesopotamia, the body was not limited by its own boundaries in expressing subjectivity. This extension of subjectivity meant that the body was seen as an assemblage

of parts, or as a network; the corporeal was extended by means of organic body parts such as hair, nails, and fluids. These parts of the body were considered effective as extensions of identity beyond the limits of the body because they were thought to contain the greater sum of elements of the body within them, like fractals. The diffusion of agency was therefore possible.

It was due to this conception of the extension and diffusion of identity through bodily parts that representation through a part for the whole was possible and this conception led to a profound anxiety regarding the body and its possibilities for extension. The essence of identity was not limited to the body as we might see it today but inhered in these detachable parts. It must be stressed, therefore, that the body was not simply a medium of signification of the sex-gender dyad. Identity was a form of presence that could take on numerous manifestations.

The Mesopotamians' belief that certain elements of the body, such as nails, hair, and bodily fluids, contained identity within them may make sense today given recent research into DNA as a marker or trace of identity. For the Mesopotamians, however, identity did not inhere only in the organic parts of the body. Inorganic objects such as garments, jewelry, and other decorations and belongings, such as cylinder seals, were all associated with the body and identity and could stand in for the person in a very real sense. They could become objects with agency. Numerous texts testify to ritual and legal practices in which a person could be represented by the hem of a garment or by a personal cylinder seal.[2] Such forms of extensions or diffusions of identity worked through association or a form of transmission. Similar to contagion, they worked through contact with the body. They were indexically linked to the person in more than a metaphorical or metonymic way. Such forms of bodily extension and diffusion of agency were the basis for the possibility of identification or representation by

means of a seal or an image in a legal situation, but they could also permit volt sorcery. There was a belief in a causality between what may happen to the diffused part and the person in question.

In Charles Sanders Peirce's semiology, the index is a natural sign because a causal inference can be made and there is what he describes as a material correspondence or a direct link. The index as a category is thus more applicable to the Mesopotamian notion of the use of personal material objects to represent the individual than a metaphorical relationship in which one thing takes the place of and stands in for another. The association was natural because there was a transfer involved in the essence of identity into these things. The person was diffused and therefore present in these exuviae and objects. For the Mesopotamians, such indexical representations were not seen as a marginal religious practice or limited to sorcery; rather, they were fundamental to the logic of representation itself. In addition to exuviae or personal extensions, representations in visual arts, sculpture, and even the written name were all considered sites for the manifestation of identity.[3]

Alfred Gell made the case that the index in art works through the "abduction of agency."[4] In that sense, the work of art or representation becomes directly linked to the essence of the thing represented. Similarly, it is important that the indexical nature of these things in Mesopotamia was not a matter of agency being attributed to personal belongings, as in the practice of animism described by Freud in his essay, *The Uncanny*.[5] The difference is that the things themselves have agency; they have the ability to become social agents in their own right. This belief can be seen clearly in the treatment of sculpture in war. In battles, monuments, images of gods, and portraits of kings were abducted or mutilated in order to achieve victory. They were also concentrated in one location in order to amass power. The monuments

and portraits could effect a defeat or destruction by means of (nonmanipulated or unprovoked) portents appearing on their surfaces: in that way the objects had the agency to effect change. While this belief may be dismissed as the workings of primitive minds, ultimately the images did indeed have agency, since their removal prompted ancient political powers and armies to go to war specifically in order to retrieve them.

Anatomical Texts and Mantic Body Parts

For the Mesopotamians, the body's originary condition was textual. At its creation, in clay, the same medium as the writing tablet, the body inherently had similar qualities to a text, of inscription into clay. Body parts — especially marks on the body, changes that occurred on the surface of the body during one's lifetime — could therefore be read as signs. Body parts were believed to signify; they contained universally relevant signs that made reference to aspects of the world, history, and lived experience well beyond personal identity. The signs on the body could certainly be relevant to the person in question, but they could also portend future events more generally. These physical messages could be deciphered through divination, a system that literally worked as an exegetical reading of the parts of the body according to preestablished codes. These codes are recorded in treatises that span in time from the third through the first millennium BC. The body, then, was both a semiotic and a mantic entity — or rather, in Mesopotamia, these two aspects of communication, semiosis and manticism, were inextricably linked and considered to be made manifest and material in anatomy.

Nowhere is this conception of anatomical signs more clear than in the well-known and distinctive Babylonian practices of hepatoscopy and extispicy (reading the future from the sacrificial animals' livers and entrails, respectively). The Babylonians and

the Assyrians believed that the sun god, Šamaš, used this code as a system of communication, usually reserved for questions of major events relating to king and country. Šamaš, as noted in the previous chapter's discussion of Babylonian semiotics, is said to have written omens into the entrails of the lamb. As the sun god, he could see from above. His epithet was "divine seer": *barû ša mati*.[6] The *barû* priest, a term that literally means seer or observer, was able to recognize these signs. These divinatory practices are important not only to the present study because of the semiotic logic on which they relied (which will be illustrated below) but also because the taking of omens was vital to the strategies of war.

An haruspex and several *barû*-priests were part of the royal court. They also went into battle with the troops.[7] Records were kept and the condition of a liver was compared to previous instances of omen taking when certain events had taken place. The *barû* priest could then consult a record of previous omens for a code of meaning of signs inscribed in the liver or entrails. Even when astronomical omens became most prevalent in the courts of the Assyrian kings of the first millennium BC, these omens were submitted to an haruspex for confirmation through hepatoscopy.[8] Prophecies by ecstatics also had to be submitted to hepatoscopy in order to be validated. For this process to take place, a hair from the ecstatic's head and a clipping from the fringe of his garment were sent to represent him in the ritual.[9] In the second millennium BC, in the city of Mari, in northern Mesopotamia (modern Syria), an archive records how a haruspex used extispicy to confirm prophecies and dreams and even the prediction of a lunar eclipse.[10] Hepatoscopy and extispicy clearly dominated other forms of manticism in Mesopotamian divination.

Medical Semiotics and Symptomatology

The mode of interpretation used for these forms of manticism in Mesopotamia, most visibly in extispicy and hepatoscopy, is similar to the model of medical semiotics or symptomatology. Carlo Ginzburg, who draws a parallel between divination and symptomatology (discussed in Chapter Two), sees one difference: in medical symptomatology one deals with tracking the past, whereas in divination one deals with the signs of the future.[11] Nevertheless, an investigation of divinatory practices and texts reveals that this is not the case. Divination, as a mode of reading, is also about the present and the past, just as symptomatology is not just concerned with the trace of the illness, the past of the organism as revealed by the signals of the body, but also predicts the patient's future behavior by means of these very signs. Divination is a reading of a previously written sign in the real. In other words, it is the past, or the present condition of the body, the place, or the heavens.

Divination not only points to the future but is linked to the past as well, just as the symptom in medicine can trace the past and predict the future course of an illness. Erica Reiner suggests that the ancient phrase stating that Šamaš inscribed the omens into the entrails has its origins in a lost myth about the sun god.[12] Such a reconstruction may be correct, but it is not necessary to explain the logic of the preexistence of the writing in the entrails. In a myth dating from the first millennium BC, found in Ashurbanipal's library, Enmeduranki, an antediluvian king of Sippar, learned oil and liver divination directly from the gods Šamaš and Adad, who were responsible for divination and the secrets of heaven and earth. In turn, Enmeduranki taught people in Sippar, Nippur, and Babylon these methods of reading. Portents are already written, and many of them have to do with events that took place in the past that are then repeated in the future. This link between the past and the future, which could be read through

82

divination, will be discussed below, after a clarification of the underlying logic of the divinatory system.

To return to the point made in Chapter Two regarding the influence of writing on Mesopotamian culture: Jean Bottéro has argued that the invention of writing had a great effect on divination. One can take this argument farther and say that the system of divination is fundamentally and extensively based on the logic of script. Semiotics and rhetoric often appear to be at the basis of Mesopotamian divinatory interpretation. The formulation of written texts on divination is similar to those of medicine and law, both of which are prominent in the Mesopotamian record. In the texts, written formulae are made up of two parts: protasis and apodosis. As in the laws listed on the stele of the laws of Hammurabi, the formulation reads, "If X, then Y," with Y being a direct result of X (more on this in Chapter Four). This paradigm can be summed up as one of cause and effect.

Scientific inquiry and legal texts both use a symptomatic divinatory paradigm. In Hippocratic medicine, for example, one analyzes the symptom (*semeion*) in a similar way to the Mesopotamian practices. This method, too, also involves retrospective predictions, in that the body emits signs that reveal not just a preexisting condition but also that condition's future state. In Mesopotamian speculative scholarship, though, the emission of signs is in the entire world. These emissions are phenomenal in that they are a manifestation or an appearance. But they also involve time and history, because they carry a trace of the past and portend the future.

In medical semiology, the symptom is organized into a physician's discourse. To read a disease's signs, to give it a name is to make it exist in the discursive realm. This process is diagnostic. The point of diagnostic observation is to name and thereby categorize and organize the world. In Barthes's words, it is the physician who,

through the act of reading transforms the symptom into a sign. [13] In medical discourse, a disease does not exist until it is named. The sign refers to an illness, but there can be several signifiers, in that there may be a number of symptoms that must be read in that somatic context. The physician attempts to identify the illness based on a reading of signs and transformations in the body. These signs must be contextualized, and the possibilities are narrowed through an empirical process of observation and elimination.

Extispicy is an empirical system of what could be called historical omens. It seems to have been fully developed by the last quarter of the third millennium BC, making it the most ancient recorded form of divination. In a nocturnal ritual, an animal is sacrificed and its entrails removed and studied for their visual appearance. Specific questions could be asked before the sacrifice, such as whether the king should send his troops or envoy to this or that city or whether the army should march against a certain city. The answers listed in the compendium appear to have been very specific. For instance, a description of some Babylonian omens dating to the reign of Ammiṣaduqa (1646–1626 BC) reads:

> If the diaphragm is shifted towards the apex of the heart: the army will not reach its destination.

> If the apex of the heart is covered in mildew and it is black: terror will come to the prince.

> If the apex of the heart is covered with mildew and a white patch lies on it: an envoy telling dangerous lies will arrive; secondly, among your auxiliaries, a city will be conquered. [14]

The animal's body emits signs. The signs are already there, hidden under the skin, and come to be revealed and deciphered in the ritual. As in medical symptomatology (for example, in the SA.GIG

texts), it is the diviner's discourse that reads the ominous message in the exta.

Hepatoscopy is similar to extispicy. Inspecting the liver of the sacrificial animal required a learned form of reading that cannot be understood outside the context of the technologies of writing and medical semiology. When a veterinary toxicologist and a veterinary physiologist at Tufts University were consulted on the descriptions of the condition of the sheep liver, they explained that the variations in shape, color, and so on apparent in the omens are commonly the result of disease, malnutrition, or naturally occurring local minerals.[15] It is possible, then, that a particular formation of the liver may be a sign, indexical of drought or famine and be scientifically correct. That is, such an observation can be described as empirical. From such logical symptoms, other linkages that today might seem less empirical or scientific may have been observed. While omens might be read on the surface of things and bodies, in the case of extispicy and hepatoscopy what we have in effect, is a reading of hidden signs that remained under the skin and were revealed by exposing the entrails in the ritual of divination.

Different possibilities of reading the signs on the liver are listed in a seemingly exhaustive manner in treatises on extispicy. While not all the omens clearly refer to historical events that can be recognized from or corroborated by other textual sources, the early liver omens can be described as historical in nature because the prognosis usually deals with the past as a means of seeing the future. Reading an omen in historical terms meant that the signs emitted from the liver pointed to a certain turn of events that had already been experienced at an earlier moment in time. An ancient event in the history of Mesopotamia could thus repeat itself in the present. The event could have been one of major significance in Mesopotamian history, although that was not always the case.

A tablet from the Assyrian library of Nineveh of the seventh century BC concerns a part of the liver, called the "path": referring to a groove that runs horizontally below the vertical groove on the left lobe of the liver, which is called the "presence." A number of liver omens concerning the path and the presence are listed in the compendia of interpretations. For example,

> If there is a cross between the presence and the path: the king, his courtiers will kill him.

> If a weapon is placed in between the presence and the path and it points to the narrowing to the right: he who is not the occupant of the throne will seize the throne.[16]

The historical omens read conditions that had been previously observed in a slaughtered animal at the time of a particular event in the past considered greatly significant. One liver omen reads: "The army will go on campaign and will be beset by thirst. They will drink bad water and die." This means that at some point when the path of the liver was in a specific condition, soldiers in the army were reported to have died from drinking bad water. [17]

Other earlier omens are also quite specific about the event that was about to take place being a repetition of history, presaged by a shape in the entrails or the color of the liver. Some such omens involved the segment called "the well-being," a groove between the umbilical fissure and the bladder.

> If there is a Hal sign at the emplacement of the "well-being": the reign of Akkad is over.

> If the entire liver is anomalous: omen of the king of Akkad regarding catastrophe.[18]

These omens are from the Babylonian king Samsuiluna's reign (1749–1712 BC), but they refer to the Akkadian dynasty, which fell about four hundred years earlier.

The following examples of prognostication also involve clearly historical omens that refer to presaged repetitions of history:

> If on the right side of the liver of the sacrificial sheep there are two finger-shaped outgrowths: it is the omen of a period of anarchy.
>
> If in the liver, the part called the gate of the palace (the umbilical incision) is double, if there are three kidneys, and if on the right-hand side of the gallbladder two clearly marked perforations are pierced: this is the omen of the inhabitants of Apishal whom Naram-sin made prisoner by means of a breach in the wall.[19]

Some of this omen's logic seems to derive from homonyms or synonyms. For example, the word for breach in the wall is the same as that for the perforations in the gall bladder. Therefore, while the historical event that occurred at the same time as the condition of the sacrificial entrails was central, other factors clearly contributed to their correct decipherment.

This meant that during particularly eventful moments in Mesopotamian history, the condition of the entrails or liver of the sacrificial sheep had to be carefully recorded so that should something similar reappear in a sacrificial liver in the future, one could read the possibility of the recurrence of such an event. At times, when a particularly crucial event took place, the liver of the animal was extracted after the event to record the condition of the liver in relation to that event. These conditions were recorded in the compendia in order to be available for later consultation and for this purpose there were also sculpted liver models (see fig. 3.1).

Terra-cotta models of livers from the city of Mari are inscribed,

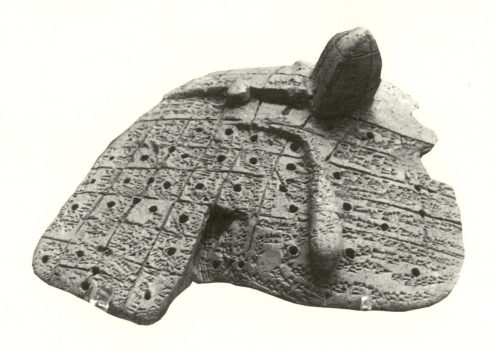

Figure 3.1. Liver model for omen readings, early second millennium BC. British Museum, London. Photo: Zainab Bahrani.

"This is what the liver looked like when the country rebelled against the ruler Ibbi-Sin (c. 2000 BC)." This rebellion was the catastrophe that ended the third dynasty of Ur, and the priests obviously considered it important enough to warrant a careful record of the condition of the livers right before it occurred.[20] The liver models are annotated with descriptions of specific conditions of the different parts of the liver; the notes are made on the model of the liver itself so it can be referenced directly for parallel signs.

In some cases, descriptions of the entrails' condition were carefully recorded in texts and images. For example, in one case the condition is described as "If the entrails resemble the head of (the monster) Humbaba." Terra-cotta heads of this monster made of entrails (see fig. 3.2) are known from the archaeological record.

The Babylonian practices of extispicy and hepatoscopy are well known to historians of the ancient Mediterranean and often discussed as having an influence far beyond Mesopotamia, especially on Etruscan and Roman forms of divination. But as far as Mesopotamia is concerned, the practice of reading omens from the entrails and livers of sacrificial animals ought to be seen in the broader context of the mantic body. Extispicy and hepatoscopy were not isolated practices, but part of a broad range of anatomical-omens and forms of divination, and exegesis.

Livers and entrails of sacrificial animals were not the only source of body divination. In a similar way, fetuses and live births — animal as well as human — could be read as portents. Any unusual occurrence, such as multiple births or physical abnormalities were read as specific signs of some future event relevant to the country at large. These omens were recorded in a text known as *Šumma Izbu*, which means "If a malformed newborn creature."[21] All the omens begin with that protasis, then give specific deformities and their meanings.

Figure 3.2. Terra-cotta head of Humbaba, Sippar, 1800–1600 BC. British Museum, London. Photo Erich Lessing/Art Resource, New York.

Physiognomy

Divination based on body signs is known from a catalog of omens called *Alamdimmû*, meaning "omens of form or figure."[22] This reading of people's bodies for signs can be seen within the context of a broad range of physical omens, alongside numerous other forms of divination: interpretations of smoke, oil, and everyday terrestrial occurrences, augury, astronomy, oneiromancy, and necromancy. These were seen as scientific, not superstitious, processes. They were considered an integral part of nature. Likewise, the message in the body was naturally inscribed into it, not unlike the medical symptoms described in Babylonian medical texts.

In grammatical terms, the protasis always precedes the apodosis. For example, "If P symptom is observed: A disease; X prognosis will happen to the patient." The records adhered strictly to a system of two linked parts. The system works as a chiastic link. Each side leads back to the other in both directions. The disease emits the symptom, and the symptom points back to the disease. Medical symptoms are listed in texts in a perfect parallel to omens. Parts of the body are listed systematically from the head to the toes, giving possible conditions and their consequences:

> If he is stricken by pain at the right side of his head: hand of Šamaš; he will die.

> If he is stricken at his head and the veins of his forehead, hands, and feet rise all at once, and he is red and hot: he will get well.

> If he is stricken at his head and his face is alternately red and greenish, his mind becomes deranged, and he has convulsions: hand of the Lamashtu-demon his days may be long, but he will die from it.[23]

On the one hand, this symptomatology was described in terms of destiny as all omens, on the other hand, it was seen as a scientific

fact, since the condition must result in the effect. In the medical texts, the protasis was the physical symptom that led to the prognosis of illness. The healthy body's mantic signs were also seen as inscriptions into the organic body made by the gods. This means that the gods did not always communicate by word of mouth through an oracle (such as the Delphic oracle) but sometimes coded their messages graphically, wrote them into things, and represented them in pictograms, for example, in the image of a dream or on the body and other things in the world.

If the logic for this sort of thinking emerged in a culture where priests were literate, we might see that a script that was a polysemous system and required that meaning be deduced from context might have had some influence. The signs could be read as ideograms, phonetically, or according to similarities of homonyms, synonyms, or even metaphors. Parts of the body could thus be seen as divine pictograms, having a type of code that was similar to that of script. Clay was the original material of both bodies and tablets, and both could bear signs.

The physical appearance of bodies was always significant, but liminal moments were even more important, so the way a body or its parts looked at the moment of birth or dying could have far-reaching significance, affecting not only the destiny of a specific person or animal but also the world at large. It could be an oracle of universal value. This was especially true for humans whose physiognomy and conduct were significant, but it was also the case for animals and their behavior. The Mesopotamian belief in oneiromancy can also be understood in this context. It can be read simply as an extension into the unconscious realm of the very same system of divination through human bodies. Oneiric signs were not so different from other forms of bodily manticism. Within the broad field of oneiromancy are treatises that list and classify possibilities of dreams involving human and animal bod-

ies. These codes of decipherment follow the same forms as the medical text:

If a man dreams that he eats the meat of a dog: rebellion.

If a man dreams that he eats the meat of gazelle: skin rash.

If a man dreams that he eats the meat of a wild bull: his days will be long.

If a man dreams that he eats the meat of a dead man: someone will take away all that he owns.

The list goes on making predictions for the possibility of a man eating the flesh of his neighbor, his companion, and his own body, then different parts of his own body — hands, feet, penis — followed by all sorts of fruits and vegetables, organic and other materials from the environment, such as bricks, straw, and leather, and so forth:

If he eats his own flesh: he will walk with a disturbed mind.

If his friend eats his face: he will enjoy a large share.

If he eats the eye of his friend: his bad luck will be straightened out.

If he eats the flesh of his hand: his daughter will die.

If he eats the flesh of his foot: his eldest son will die.

If he eats his own penis: his son will die.

In addition, numerous dream omens relate to bodily functions, such as urination and sexual intercourse:

If in a dream his urine, directed by his penis, inundates a wall: he will have children.

If his urine inundates a wall and the adjacent street: he will have children.

If his urine inundates several streets: his belongings will be stolen.

After a large number of hypothetical situations involving urination, the tablet ends with the following:

If he lets his urine run when he is sitting: sorrow.

If he urinates upward: he will forget what he said.

If he drinks the urine of his wife: this man will live in great prosperity.[24]

In physiognomantics, the actual body — not in dreams but the living organic body — contained signs that could portend an individual's future or make reference to universally relevant future events:

If a man's face is flushed: he will become wealthy.

If his face is flushed and his right eye is flecked with spots: he will have success, (but) his father shall die.[25]

If a man's right eye is pinched together: he is a liar.

If his nose is like the crescent moon, he will die an evil death.[26]

That seems very direct and relatively simple, but sometimes the signs are absurdly specific. For example:

If a man has a flushed face and his right eye sticks out: he will be devoured by dogs far from his house. [27]

If the whorl on his head goes to the right: his days will be short.

If his lips are long: his eldest son will become rich.

If his face is long: his days will be long, but he will be poor. [28]

In one example of a tablet enumerating body omens images are included as a visual aid for the interpreter. At the top, the tablet lists a palm-tree shape and explains that its presence somewhere on one's person is a positive sign.

There are hundreds of these interpretive codes, and the lists certainly make an attempt to be encyclopedic. Every possibility, rational or irrational, is listed to the point of apparent absurdity. But taken seriously, these body omens can provide a wealth of information on conceptions of the body and its functions in Babylonian and Assyrian culture.

In all of these conceptions of body manticism what we encounter is clearly not unlike the notion of the symptom in medicine. In medical terms, a symptom is something provoked in the organism by a particular physical state or condition — the state of the disease — and then seen and identified by the physician. In physiognomy, the somatic sign is divined by the priest. In both cases, the sign is read to determine the prognosis.

Besides the reading of marks on the body, there are also behavioral omens involving both animals and people. In one method, pure spring water is poured onto the head of a recumbent ox and the ox's reaction is observed.[29] The diviner would look to see if the ox would get up, lift its tail, or neither. Before pouring the water, one would appeal to the gods of the night for the portent. There were also specific behavioral divination rites to observe the lamb's movement before its sacrifice. The omens in the behavior of the sacrificial animal would indicate whether the entrails would hold a positive or negative sign. [30] Thus these behavioral

omens were portents of portents, since they foretold what the entrails would predict. After the slaughter, the diviner observed the animal's corpse for any movement. An omen series called *The Behavior of the Sacrificial Animals* describes these portents, which were concerned with any flaws found during the inspection of the body before the slaughter. The diviner also observed such things as the animal's bleating or struggling before death. The omen lists also mention the corpse's behavior using protases such as "if a sheep shakes its tail," "if the sheep wiggles its ears," "if the corpse thrashes after its throat has been cut," "if the sheep's right eye is open and its left eye is closed,"and "if the sheep's left ear points toward the slaughterer."[31] At times, diviners seem to have listed all possible aspects and features and tallied them.[32] Remarkably, the omen lists include the behavior not only of the sacrificial animal that was observed. The slaughterer responsible for killing the animal was also observed. It is portentous if the diviner falls before or during the process, or if he tips over his beer, breaks a libation cup, or knocks over the altar table.[33]

The Portrait as Nonorganic Body

These omens were encoded in the aspects of organic bodies. But since sculpture was seen as indexical and linked to the essence of the thing or referent, such signs could also be encoded into the image (fig. 3.3). The word for image in Akkadian, *ṣalmu*, also means bodily substitute. It is not insignificant that the same word was used for the shape of the body in the physiognomic omens, since in the Mesopotamian tradition no similarity was ever simply a coincidence. Thus a portrait could signify more than a representation of the sitter, since body parts encoded in the image could have an effect on the destiny of the person represented. Portraits can therefore be described as both referential and performative, and these performative images worked through an encoding of the

96

Figure 3.3. Bronze head of an Akkadian ruler, possibly Naramsin, c. 2250 BC.
Iraq Museum, Baghdad. Photo: Scala/Art Resource, New York.

body. Since one could alter the original organic body by altering the indexical image-body, the deliberate destruction of an image could have a very harmful effect on the organic body. Likewise, accidental changes in the surface of a statue of a king, for example, could be read as negative portents for the king and country.

Irene J. Winter has argued convincingly that representations of rulers — such as Gudea and Naramsin — were encoded with signs of their rule. In her essay on Gudea as the able-bodied ruler, she points out that aspects of his physical representation in sculpture are paralleled by textual metaphorical descriptions of the ruler in the Sumerian language. She finds parallels between the emphatic representation of parts of the body, such as the musculature of the biceps, and the Sumerian expression of the strong arm of the ruler. In her discussion of the Victory Stele of Naramsin (see fig. 4.1), she notes that the image of the ruler Naramsin was an image of divine kingship, portrayed not simply by the iconographic device of the horned crown but also by a number of visual details of clothing and bodily ideals all of which can be read as the image of the King.[34]

In the discussion regarding the Victory Stele of Naramsin, the work of Louis Marin on images of King Louis XIV of France is at issue. Marin stresses the difference between the image of Louis as king and Louis as a person. Beyond the image of kingship, there is no king; there is only Louis the man. Kingship is therefore formulated in and through the image, but that dichotomy of sitter and representation is not similar to the Mesopotamian conception of representation, *ṣalmu*, nor is the inscription of the body a matter of the ideology of the monarch alone.

In Assyro-Babylonian thought, a physical body is inscribed as a text with signs from the gods. All bodies — not just the royal body — are therefore encoded by the gods. But the king's body bears the omens of kingship. The king's image could thus be encoded not just in a metaphoric or allegorical way, recalling literary

98

descriptions of the ideal ruler. Physical signs could be read as the divine destiny of kingship, literally written into the body-text. Destiny was inscribed into the world; this should be understood not in the figurative sense of inscription but as a literal translation of the Akkadian word *šaṭāru*, to inscribe, a verb used in describing all omens as they appear in the natural world, including those written into the body.

Body signs, physiognomy, and manticism belong to a history of the sign that is not limited to positivist surface readings but constitutes a complex, multilayered hermeneutics. The person or animal emits signs or messages, some of which can be read on the surface of the body, others of which are hidden under the skin and must be uncovered. This notion of the mantic body, or the body as a semiotic entity, should lead not only to a reassessment of the body as a referent of individual identity but also to a reconsideration of the boundaries between the organic body as referent and its representations in Antiquity. Since the body is referential in its very essence, boundaries are blurred, making artifice and reality, signifier and signified difficult categories to uphold in the context of ancient Mesopotamia.

Figure 4.1. Victory Stele of Naramsin, Susa, 2254–2218 BC. Musée du Louvre, Paris. Photo: Musée du Louvre. Reproduced by permission of Pierre and Maurice Chuvezille/Louvre.

CHAPTER FOUR

Death and the Ruler

If a King respects the law, that reign will be long.
He will proceed happily.

— From the omen series *Šumma Alu**

The state of exception is not a dictatorship
but a space devoid of law.

— Giorgio Agamben†

The Victory Stele of Naramsin (fig. 4.1) is a historical monument. It is a commemorative artifact that depicts an Akkadian victory in war over the people known as the Lullubi, who lived in the Zagros Mountains, northeast of Mesopotamia. The fragmentary inscription at the stele's upper left, below the starburst emblems, mentions this specific battle, names Naramsin as the mighty victor and the Lullubi ruler, Sidur, and the highlanders as the vanquished. The second inscription on the mountainside to the right was added as an act of disfigurement and appropriation during a war that took place more than a millennium later, but it confirms the identification of the stele as a dedication to Naramsin. The image carved on it is not a mythic or generic scene of victory and conquest but a depiction of an event, a moment that can be historically located. As a monument almost certainly associated with an historical battle, the Victory Stele of Naramsin is one of the first

* Freedman, *If a City*, p. 53 (translation emended).
† *State of Exception*, p. 50.

monuments in the history of art that can be identified as a war memorial. It stands at the beginning of a long tradition of public monuments of victory and memorials of war that continue into the present day.[1] But the Victory Stele of Naramsin is not just a scene of victory, whether accurately and truthfully recorded, imbued with ideology, or distorted by propaganda. It is an artifact of a particular historical juncture, in which kingship itself changed conceptually, metamorphosing into a new form that would come to influence the concept of kingship and principles of royal authority for centuries to come. Taking Alain Badiou's philosophical definition of an Event as an occurrence or moment that breaks with the known or normative situation, we might consider that the stele is perhaps also a monument of an Event, a moment that ruptures the passage of historical time. What is carved on it is indeed a representation of a historical battle against the Lullubi, but at the same time what we might see in this stele is also an artifact of the historical juncture in which kingship, a form of rule that had until then been conceived of in limited terms and within the local social structure of the city-state, came to be defined as *sovereign power*.[2] The Victory Stele (Akkadian *narû*) of Naramsin is not just the "Victory Stele"; it is also a monument of a new form of rule, one that has ceased to be a sociopolitical office and now presents itself specifically as a category of ontology. This sovereign power is effectively defined in the Victory Stele of Naramsin as a power over life and death.

A monument is an artifact of time as much as a political system or royal ideology. As such, rather than simply being a window into the past, the Victory Stele of Naramsin interacts with history. It actively formulates a new conception of kingship that breaks with the past and that is, at least to some extent, articulated through the monarch's virile, potent body.[3] Nevertheless, as will be shown below, this new conception of kingship was also

102

defined through the body of the other and, perhaps more significantly, delineated through the ruler's relationship to life and death, the span of life, and time itself. In the stele, it is this new conception of sovereign power expressed in Naramsin's historical position as the telos of historical time which sets his reign apart from all those before it. But the Dynasty of Akkad soon falls, and Mesopotamia was consumed by violent chaos without the rule of law. In Antiquity, the era of Akkad's hegemony over the other city-states was a theme of contemplation for later peoples, an instructive lesson of the outcome of hubris, but Akkad also "became the vehicle of textual mediations on history, kingship, and power."[4] Naramsin is the paradigmatic Akkadian ruler who figures prominently in *The Curse of Agade*, a literary composition that explains the destruction of Akkad by the barbarian foreigners as a result of the hubris and insolence of the Akkadian king.[5]

The wars of Naramsin and the expansion of Akkadian political hegemony over a great part of the Middle East are well known from numerous written accounts. Along with the great increase in cuneiform texts from this period which record dynastic rule, and the information that corroborates it from the archaeological record, the monuments of Akkad are important artifacts of the change in political power, the nature of kingship, and the idea of centralized rule as it was formulated for the first time as the Akkadian hegemony over Sumer and Akkad. The Akkadian sculpted monuments that survive are, for the most part, monuments of war. But this change is particularly clear in the Victory Stele of Naramsin, which formulates a new conception of kingship as not only a centralized authority entrenched in a single state but as an ontological category in the world order. All Akkadian monuments are to some extent agents of this political change, rather than simply reflections of it, but the Narmasin stele actively produces kingship and victory in terms of this new form of absolute power.

This new conception of kingship was formulated and under-
scored through the body of the king, although that in itself was
not entirely new, having been an aspect of images of local rulers
of the Sumerian city-states during the Early Dynastic period, in
the middle of the third millennium BC. Under the Akkadian dyn-
asty, the body of the ruler was presented as alluring, virile, and
potent, the male conqueror who imposes his will on the world
through geographic expansion and political control.[6] What is of
greater significance in both juridical and supernatural terms is
the ruler's relationship to death and the law that has now changed.[7]
Considered in all its radicality, the ontological shift is biopolitical,
insofar as it constitutes absolute power as the sovereign's ultimate
right to deal the blow of death. This ancient shift in the parame-
ters of power, which inscribed the absolute authority of the sover-
eign into the body of the other, demonstrates a point made by
Giorgio Agamben:

> It can even be said that the production of a biopolitical body is the
> original activity of sovereign power. In this sense, biopolitics is at
> least as old as the sovereign exception. Placing biological life at the
> center of its calculations, the modern state therefore does nothing
> other than bring to light the secret tie uniting power and bare life,
> thereby reaffirming the bond (derived from a tenacious correspon-
> dence between the modern and the archaic which one encounters in
> the most diverse spheres) between modern power and the most
> immemorial of the arcane imperii.[8]

In the second half of the third millennium BC, power came to be
centralized in the city of Akkad in Babylonia. This political cen-
tralization meant that while in the preceding (Early Dynastic)
period a number of cities in the southern part of Iraq were inde-
pendent and self-ruled as city-states, in the twenty-fourth cen-

tury BC, a single political structure with its center at Akkad arose, and with it came the imperial expansion through the surrounding Near East that created the Akkadian Empire. The Mesopotamian city-states, each of which had been governed by an independent ruler, were now unified for the first time. Sargon I of Akkad, Naramsin's grandfather, was the first king of this dynasty. From what can be understood from the historical record, Sargon I was a common man who rose to power in the city-state of Kish and gradually defeated the rulers of the surrounding city-states. In the later Sumerian king list, the kings of Akkad are described as a family of rulers, in the same way as earlier dynasties that had governed in the area before. The Sumerian rulers, such as Eannatum of Lagash, had also adopted titles that implied a dominion beyond their own city-states. The traditional title "King of Kish" was used, since according to legend, Kingship had descended to the world at Kish, a city just north of Babylon. However, despite the nomenclature of kingship and dynasties, the nature of the rule we call kingship changed significantly at the start of the Akkadian dynasty. In all respects, it differed considerably from what had existed previously.[9] The change meant that the ruler was no longer the king of a city-state but of a larger geographical region, encompassing numerous Sumerian city-states and, gradually, the surrounding area. For Mesopotamia, this was no less than the emergence of sovereign power.

The Stele as Artifact

Since the stele's discovery in 1898, scholars of Near Eastern Antiquity have looked at the Victory Stele of Naramsin and seen a historical record through visual illustration, and at the same time a propagandistic or ideological image of the king. Pierre Amiet, an authority on Akkadian art, puts it succinctly:

The original inscription, which is fragmentary, describes the campaign of the deified Naram-Sin against the Lullubi mountain people. The subject is illustrated on the bas-relief in a scene centered around the monumental figure of the king, who wears the horned helmet symbolizing divine power.[10]

The king's deification is the primary feature that stands out in the relief. The horned helmet he wears is a direct signal. The iconographic helmet corroborates the written accounts that describe his deification and strengthens his divine status by means of the image. The king's transfiguration into a god was also clearly indicated by the divine determinative placed before his name in all of his inscriptions. The image on the stele is a narrative; the historical moment is true, yet it is an ideological distortion at the same time. But let us return to the image and consider some other aspects that operate in the representation. The Victory Stele of Naramsin uses notions of time and narrative to depict a historical moment. How, then is time depicted in the monument? The ruler's body is emphasized, but does the narrative scene depict more than the fact that the king's body is ideal or even divine? What is the king actually doing in this visual narration of a battle in enemy terrain?

Let us begin by making some general observations. The monument was carved after the battle, so it has a temporal distance from that battle. It is not a direct observation of a war scene, nor does it aspire to represent a skirmish in progress. Therefore, it is not a record of a particular battle — but it is nevertheless a historical monument of war. Although the inscription records a military campaign against the Lullubi, the scene itself appears to be somewhat ceremonial. The king is the apex of the scene. The Akkadian troops, bearing military standards, appear below him in an orderly procession. The visual narrative deploys the magnificent body of the king, silhouetted against the sky, emerging at the moun-

taintop in his royal splendor. But beyond the encoding of the physical body and divine kingly attire of Naramsin, there is another sign. There is the central place of death in the image.

Let us consider that the Victory Stele of Naramsin is a monument of the king in victory; that it is a monument of the king in relation to war. In other words, the image is not just concerned with divine kingship or the declaration of the king as divine; it is about the king as one who defeats and subjugates others through war, violence, and physical aggression. What is the role of the king in war? How is masculinity as a mark of royal ideology displayed in the image in and through the notion of *kuzbu*, a term that denotes a charismatic sexual allure, here merged with violence? How is the king's body inserted into a narrative that involves time? How is it embedded into an image of history?

The stele is a large limestone slab, measuring about two meters tall in its present, fragmentary condition. The stele can be dated with some certainty to 2254–2218 BC on epigraphical grounds, as it bears the remains of the royal inscription of Naramsin, which had been partially erased in Antiquity. As noted above, it mentions a victory over the ruler Sidur and the highlanders of Lullubum. This is what remains of the inscription:

d[Nar]amsin, the mighty
Lacuna. Sidu[r] (and) the highlanders of Lullubum assembled together...
... bat[tle]. For/to
the high[landers...]
Lacuna
[...]ed up...
... and dedicated [this object] [to the god].
Lacuna.[11]

The original text uses a divine determinative as a prefix for the name of Naramsin and describes him as *dannum*, the mighty or powerful. A second text, from the twelfth century BC, was added onto the mountainside at the right by the Elamite king. As far as we know from its later history, when the Elamites removed the stele and took it as war booty to Iran, it first stood in Sippar, a Babylonian city sacred to Šamaš, the sun god and the god of justice and divination. The scene carved in relief depicts a rocky, mountainous terrain. Troops in several rows march upward, toward the highest peak, depicted on the right. A row of trees marks the landscape, and above, the remains of several starburst emblems or sun disks form the summit of the scene.

The king is unique; he stands alone. He is crowned with the horns of the gods. His written name takes on a divine determinative, just as his image takes the horned helmet as his sign. The king is divine. His body is magnificent and stands out in the pictorial space, appearing alone against the sky at the top of the mountain. But it is not simply the body that is unique. It is the attire. Naramsin wears a horned crown which is, in fact, a battle helmet, with bull horns attached to the sides. In the iconography of Mesopotamia, where the gods are anthropomorphic, it is the horned headdress that marks the wearer as a god. Naramsin is dressed in battle gear: a short tunic, tied at his waist, and sandals. In his left hand, he carries a bow; in his right, he holds a spear. A battle-ax rests in the crook of his left arm. These are the types of weapons that were used in war in the third millennium BC.[12] But they also represent two different types of weaponry: the piercing and the cutting weapon. The weapons represent kingship, in that the ruler controls both methods of combat, both technologies of violence.

The bodies of the soldiers below seem to echo the king's on a smaller scale. The soldiers differ from Naramsin in being more covered and in carrying the upright spears and standards that

form the vertical elements that pull the viewer's eye upward toward the king. The soldiers are repetitive, like the elements in the landscape, and can be read as a single group rather than as several individuals. As Henri Frankfort observed in his description of the relief, the repetition of the Akkadian soldiers' bodies is a visual device that impresses on the viewer the relentless march forward of the armies of Naramsin.[13]

The Lullubi are dead and dying. At the top, a Lullubi warrior pleads for mercy; below, another stands with his spear broken. The broken weapon is a metaphor known from textual sources meaning defeat and, more specifically, subjection. The hair of the Lullubi is long and worn in a thick braid. They wear animal skins, while the Akkadian soldiers wear the proper attire for battle, helmets and military tunics. The Akkadians' vertically raised standards bear emblems of war, and one of them appears to carry a small image of a deity at the top.

If the event on the stele is a historical battle depicted retrospectively, and the scene uses realistic details of landscape, it falls into the category of narrative art. But despite being a narrative, the monument presents events not linearly or sequentially but hierarchically. Naramsin, the mighty king of Akkad, is the telos of the temporal narrative. The king is therefore the culmination of the event. He arises from the narrative as the embodiment of authority and its end point. He even influences time, since the sequence of events is ordered not temporally but hierarchically. The narrative works through Naramsin's centrality as the apex of the relief and the events in the movement of historical time.

Sovereign Power, Life, and Death

One important aspect of the compositional use of violence in the Victory Stele of Naramsin has never been addressed directly. Violence is central, both literally and formally, to the composition of

the stele. It is what I would call the stele's cipher. At the center of
the composition, Naramsin stands, his left foot placed upon the
bodies of the enemy soldiers (fig. 4.2). Nudity is used as a narra-
tive device here. The enemy dead are naked, and one has fallen
over the edge of the mountainside. The enemy who is wounded by
a spear is in a state of collapse; he wears only a kilt as he attempts
to pull out the spear lodged in his neck. The enemy soldier at the
far right (perhaps the ruler of the Lullubi), pleading for mercy, is
still fully dressed.

The junction of Naramsin's foot and the bodies of the dead
forms a pinwheel. The horizontal bodies lie in different direc-
tions, their heads facing to the right and left. The wounded enemy's
foot meets their bodies at the edge of the mountain, at the point
where Naramsin's disproportionately large left foot presses down
on the corpses. The Egyptian Palette of Narmer has something
similar in it, but there the king of Upper Egypt deals a blow to the
defeated enemy ruler kneeling in front of him. In the Victory
Stele of Naramsin, power is not simply the might of a heroic war-
rior or king, but also fully expressed as power over the bodies of
others. Naramsin is powerful in his physical form. Sexual allure,
kuzbu, is a significant aspect of this. Size, shape, and virile beauty
mark his body as that of the ruler because this is also the mantic
body of the king, a body marked with the portents of kingship.

The starbursts at the top of the relief all look very much like
the standard emblematic sun disk of Šamaš. Scholars have gener-
ally interpreted them as emblems either of three major gods in
the pantheon or of Ishtar, the king's protector. Regardless of this
protection, the king is divine; the horned crown makes this clear.
In Louis Marin's analysis of the phenomenology of the monarch,
the king's body is only a representation. For Naramsin, this is not
the case. His kingship is not a representation of a god. It is visceral.
He is not a reflection of a god; he is a deity in his own right.[14]

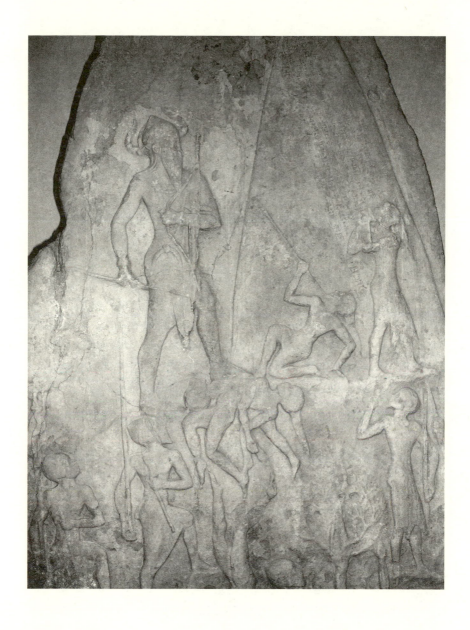

Figure 4.2. Victory Stele of Naramsin. Detail of fig. 4.1. Photo: Zainab Bahrani.

This definition of Naramsin works through a juxtaposition with the Lullubi warriors, who are his opposite. His power is expressed not only through his own body — virile, heroic, and larger than life — but also through the contrast with the other. The Lullubi are mountain people, so they can stand for all that is other or foreign to the Mesopotamians. Lullubum, a region in the Zagros Mountains, is depicted here in the landscape. Like a cuneiform sign of foreignness, their bodies are silhouetted against the mountainside. They are foreign and strange in attire and behavior. They wear animal skins, their hair is in long, loose braids down their backs, and they are beardless. Like everyone else, they are smaller than the king, and one of them pleads directly to him for mercy. The landscape sets the scene as a historical event, in a location that is recognizable as northeast of Mesopotamia. The trees may be identified as a local variety of oak, and the rocky terrain locates the scene in the mountains. The stele is, therefore, a statement about the conquest of place as well as people.

Violence is central to the theme of the stele, but to think of it merely in terms of violence is to miss the point. It is not just violence but also death, or, rather, life and death, that is the subject of this composition. People are depicted as dead or in different stages of dying. The dying process is central to the stele's iconography and is depicted through the narrative device of nudity and the exposure and display of the naked body. Nudity was used as a device in the narrative of death in an earlier stele, from Telloh, attributed to the reign of the Akkadian ruler Rimush (2278–2270 BC).[15] The stele depicts a battle scene in which the enemy about to be dispatched is naked. In the visual art of the Early Dynastic period, enemies are often shown naked, but they are usually prisoners, paraded after the battle. In the Victory Stele of Naramsin, the correspondence between the stages of undress and death is more clear. On the upper right, the Lullubi warrior pleading for mercy

before the victorious Naramsin is fully clothed. Before him, the Lullubi warrior who struggles for his life, having been impaled by a spear, is partially dressed. At the center of the stele, the dead beneath the king's feet are all naked. This last detail calls for closer consideration, as it is arguably the central subject of the monument.

In this stele, Naramsin's power is underscored centrally through his control over life and death and over the bodies of the other. This is what Michel Foucault in his treatise on power, *Discipline and Punish*, described as Sovereign Power in the clearest form.[16] The king's body is therefore virile and alluring, but it is essentially violent. It is important to see that this is not a generic depiction of masculinity as violence, a device that appears elsewhere in ancient art, including other periods in Mesopotamian history. This is violence taken to its limit as power over the body of the other. Naramsin's power is the nucleus of this new sovereign power. To paraphrase Agamben, by placing control over the body of the other and of life itself at the center of the image, the stele brings to light the secret tie uniting sovereign power and bare life.[17]

This power over life and death is at the center of the scene, manifest in the king's act of placing his foot on the bodies of the dead. He has the power not only to end life but also to prolong it. This ultimate control of the span of life is shown by means of the enemy's plea for mercy. Naramsin can decide if this man's life will end. Therefore, if the scene is historically set and identifiable as a particular battle, it is at the same time a depiction of sovereign power as power over bare life.

The absolute power over life and death is related to the function of war. As Foucault stressed, the right to punish is an aspect of the sovereign's right to make war on his enemies.[18] This extension was to become clear and fully formulated in the Neo-Assyrian reliefs of war. What we observe in the Victory Stele of Naramsin is an emphatic affirmation of the workings of sovereign power.

That power is not just the physical strength of the king's body but the right of the ruler over the lives of others.

The stele reproduces scenes from mythological combats among the gods. In these battles, the victorious gods hurl the vanquished ones into the depths of the mountain sides, an action that symbolizes casting them into the netherworld. The mythological and the historical are merged into one vision, but the victory is portrayed as a human achievement, unlike earlier monuments, such as the stele of Eannatum of Lagash, in which the god is represented as an active participant in the battle (see figs. 5.3 and 5.4).

Naramsin's act of trampling the bodies of the enemies would later be used as an image of sovereign power on, for example, the cylinder seals of the Old Babylonian period. It was also a visual formulation used for images of gods of war. But the Victory Stele of Naramsin provides the earliest preserved example of this motif.[19] Even from ancient Egypt, where the king is always absolute and divine, no such image exists from this time. The unique development of such a statement of power over the body and the life of the other is a remarkable formulation of sovereign power's structure as one that is fundamentally biopolitical and functions as the power over bare life.

Hammurabi, the King of Justice

There is another Mesopotamian monument in which one can contemplate the king's relationship to death. This monument is best known as the Codex Hammurabi, or the law stele of the Babylonian king Hammurabi (1792–1750 BC) (fig. 4.3). Like the Victory Stele of Naramsin, this monument was discovered in 1902 at the site of Susa, in Iran, to which it had been taken as war booty. According to its inscription, the monument stood in Babylon before it was removed in the twelfth century BC by the troops of the Elamite king Shutruk-Nahhunte.[20]

The Codex Hammurabi is a tall, monolithic pillar, two meters high, made of black diorite. The larger part of the pillar is covered with cuneiform script. Twenty-three columns of writing appear on the front, the last seven of which were erased by the Elamites in the twelfth century; twenty-eight columns of writing appear on the back. Five columns of text at the beginning and the end are written as the prologue and epilogue to the list of laws. Hammurabi first explains that he was chosen by the gods and then recites his military conquests in succession. The gods also chose him to govern and to regulate the law. Because the laws compiled in the inscription do not cover all areas of the law, and because what is there is limited to a few areas of life, the stele's identification as a law code is no longer accepted. The monument is now generally defined as one that represents Hammurabi as a king of justice, listing some legal decisions, without being a complete code of laws.[21]

At the top of the obverse side, a scene carved in relief appears above the text (fig. 4.4). Here, Hammurabi is shown in front of the god Šamaš. He enters his world. The spaces of the sacred and the profane are merged in ways that are perhaps more alarming than the Victory Stele of Naramsin or Naramsin's transfiguration of himself into a divinity. Hammurabi has come face-to-face with the god. He is smaller than the god Šamaš, yet very like him in many respects.

Šamaš is seated on the right. He wears a multi-horned crown, and rays of sunlight emerge from his shoulders. He wears a layered garment that bares his muscular right shoulder and arm. Šamaš is seated on a throne in the form of a temple structure, and beneath his feet is the scale pattern of the standard Mesopotamian iconographic motif, representing the mountains from which the sun emerges. With his right hand, he gives the emblems of rule to Hammurabi, who stands before him. Hammurabi holds his right hand up to his lips in a gesture of worship. He wears the attire and

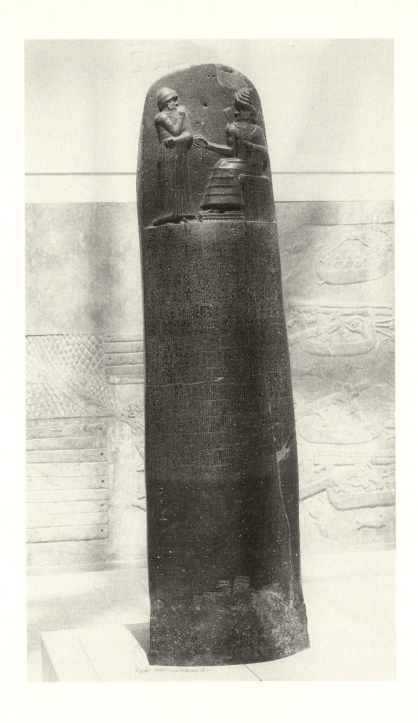

Figure 4.3. Codex Hammurabi, Susa, 1760 BC. Musée du Louvre, Paris.
Photo: Zainab Bahrani.

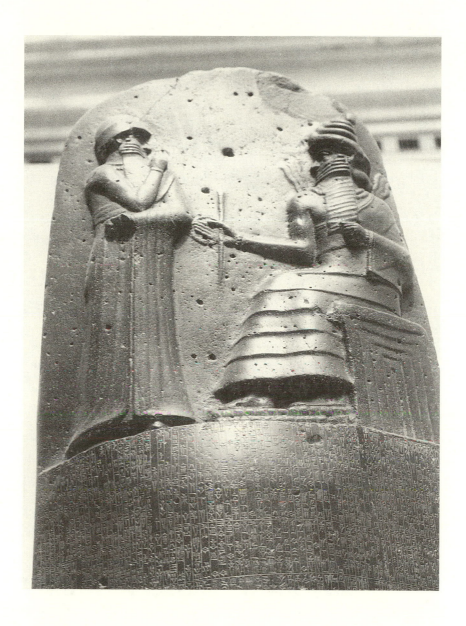

Figure 4.4. Codex Hammurabi. Detail of fig. 4.3.

headdress of a mortal king. There is nothing about him that would indicate a body that is more than human. Physically, Hammurabi is mere man — unlike the divine Naramsin. He holds none of the weapons of the warrior king, despite the lengthy prologue that describes his remarkable and extensive military conquests. In the Codex Hammurabi, the king is mortal, but he is nevertheless enclosed in the space of the god.[22]

We can say that the justice stele of Hammurabi is a monument that configures the place of the ruler in relation to the law. It is similar to the Victory Stele of Naramsin in that both are concerned with the expression of sovereign power. Like the Victory Stele of Naramsin, the Codex Hammurabi was a historical monument that stood in Babylon for centuries before it was taken as war booty by the Elamites in the twelfth century BC, and the power of the ruler is central to both monuments. Still, the Codex Hammurabi is very different from the Victory Stele of Naramsin, not only iconographically and stylistically (as art-historical and archaeological studies of the reliefs discuss). They differ in the configuration of sovereign power which is a subject of concern to both monuments, specifically in relation to punishment.

While the Victory Stele of Naramsin represents sovereign power in terms of violence and of the ruler's physical control over life and death, Hammurabi's power is more subtly expressed. It is the right to decide punishment that may include the ability to end the identity and the life of a citizen. Hammurabi points to the actions that fall outside the social pact that would disqualify the man as a normal citizen, and strip him of his identity. These are the actions that put him outside the accepted forms of social or civilized behavior.

The monument of Hammurabi therefore constitutes a horizon of juridical certainty, even if it is not a Codex of Law. The text reads, in a standard formulation of protasis and apodosis, "If such

then such."[23] It is a scientific (and arguably a metaphysical) formulation of justice. As a monument, it articulates and performs the force of law as transcendental, even beyond the actual cases mentioned in the over three hundred specific examples. Its subject is not each legal case but law itself as an abstract notion. The Codex Hammurabi, then, beautifully demonstrates Blaise Pascal's argument that "the law is based only in the act of its own enunciation."[24] The monument of Hammurabi can thus be read as an enunciation of the law. The monument of Hammurabi is not a law code but is nevertheless a codification of law. It is a monument to the abstract metaphysical notion of juridical power annexed by the sovereign, the force of the law, which certainly involves the lives of others. The laws it lists are specific instances of the wise decisions that Hammurabi has announced. They are decrees. In legal doctrine, the force of law technically refers not to the standard laws but to decrees that the executive can issue in exceptional situations.[25] This is more or less equivalent to an exceptional authority. As Giambattista Vico writes, "An esteemed jurist is, therefore, not someone who, with the help of a good memory, masters positive law, but rather someone who, with sharp judgment, knows how to look into cases and see the ultimate circumstances of facts that merit equitable consideration and exceptions from general rules."[26] The epilogue of the Codex Hammurabi states that Hammurabi set up these laws in Babylon, before his image as *šar mīšarim*, King of Justice, thus presenting himself as one who dispenses the law. He declares at the end, "May any wronged man who has a case come before my image as king of justice, and may he have my inscribed stele read aloud to him."[27] It is his image as king of justice, as the just king *par excellence*, that we see here.

There were other monuments of Hammurabi, known from fragmentary inscriptions, that presented him as a valorous warrior king, but in this particular monument he is presented, instead, as

the juridical king. His power is expressed through the force of the law rather than emphasized as military prowess. The Codex Hammurabi is therefore a monument that reconfigures the relationship of the sovereign to the law. Considered in this way, one can imagine the reasons that the Elamites took this monument and the Victory Stele of Naramsin. As centuries-old historical monuments of ancestral kings, they had a totemic power for the Babylonians. Furthermore, the Codex Hammurabi and the Victory Stele of Naramsin were monuments of the force of law, authority, and sovereign power as extending to life itself.

The King's Mantic Body

Anthony Van Dyck's painting of Charles I of England is suffused with a mantic feeling about the body of the king, who has just dismounted from his horse (fig. 4.5). The king turns to the viewer, hand on hip, holding a stick and the attributes of his rank. His beard, cocked hat, and jaunty pose are all signs of an elegance and rightful place. This is a cultivated, courtly body, which conveys a sense that this, too, is a mantic body of kingship, like that of the Mesopotamian king. Van Dyck's *Charles I* is a court portrait, made for a limited audience and specific context. It is not a public monument like the ancient stelae. The portrayal of the king's courtly body was for a particular, restricted audience that was able to read the visual signs of his rightful identity as king.

In Mesopotamian monuments, such as Naramsin's image on his Victory Stele, there was a more fundamental reason for the depiction of the king's body in a propitious way. The stele publicly represented the king. In looking at images of rulers we often take for granted that such royal portrayals are images of power, but we do not often stop to think of the intended audience. Yet, as in the case of the famously ideological image of the small, engraved agate *Gemma Augustaea* from the early days of the Roman Empire

Figure 4.5. Anthony van Dyck, *Charles I*, c. 1635. Musée du Louvre, Paris.
Photo: Scala/Art Resource, New York.

Figure 4.6. Gemma Augustea, Roman Empire, c. 10 AD. Kunsthistorisches Museum, Vienna. Photo: Erich Lessing/Art Resource, New York.

(fig. 4.6) — there is little reason to believe that masses of people saw these depictions. There is a function for nonpublic images of kingship; often they exist and function alongside public images. In Rome, this public face appeared in the triumphal arches and columns and in architectural and public sculptures. But the categorizations blur. It is difficult to say what is a political monument and what is to be designated a votive offering.

If Rome is the clearest, most familiar example of the formulation of absolute power in ancient arts and, according to art-historical tradition, the place where political monuments were invented, what does such a public monument do there? Was the triumphal arch or column emblematic of imperial power? The answer is certainly yes, but there was much more to these monuments than that level of coercive propaganda. Arches are passageways, transitional points for reentering the city, the urban center, after battle. The triumphal arch is emblematic of the religious post-battle ritual of the triumph. The arch is also commemorative of a historical event and dedicated to one person's honor, as decreed by the Senate. The arches entailed an entire complex ritual of religious and political aspects of Roman culture in which empire was only one among many facets.[28]

The Victory Stele of Naramsin in the History of Art

In "Art for Eternity," Ernst Gombrich wrote that the Victory Stele of Naramsin was fundamentally a monument for eternity. Because of a belief in the power of images, the event would be perpetuated for all time. The depiction of Naramsin standing over his enemies, in this case, would stand forever. While putting all Near Eastern art into one category, as Gombrich began to do, is somewhat restrictive, the idea of art for eternity ought to be seen as a specific development of that time.[29]

In his textbook on the history of Near Eastern art, still the

standard text used for Mesopotamia, Frankfort devoted only a few lines to the Victory Stele of Naramsin describing it as an unusual representation of the Mesopotamian king as a divinity, without discussing the issue further.[30] Henriette Groenewegen-Frankfort's discussion of this stele is far more insightful and detailed. She describes the significance of the focus on topography and the use of naturalism, pointing out that they make a clear break with the imagery on earlier stelae. The topography is formalized but has concrete details in a "subtle balance between the decorative and the dramatic."[31] The Naramsin monument was a freestanding stele (narû) located in a public context in Sippar. This form of stele, the public historical monument, is distinctively Mesopotamian. While the historical monument existed in other times and places, most notably in Rome as a form of public art, its use in Mesopotamia is fascinating because it has no precedent.[32]

The Victory Stele of Naramsin, as we have seen, is historical. But it is also allegorical and relies on metaphor to represent the victory. The broken weapon of defeat, the absolute power of the king who stands as a god on the corpses of the subjugated, the mountains that are also the land of the foreign, the act of hurling the dead down the side of the cliff that is also a hurling of corpses into the netherworld, the death of the enemy that is also Naramsin's power over death, and the plea for mercy that is Naramsin's power over the span of life are all such representations. It is a monument that depicts what Foucault describes as the semiotechnique of physical control. It is the power to punish, the power over life and death, not just victory but the regulation of the entire environment. The Victory Stele of Naramsin, the Codex Hammurabi, and other monuments from Mesopotamian Antiquity fit into a genre of art that is essentially and fundamentally historical, in ways that are unparalleled in other ancient art before the rise of the Roman empire two millennia later.

The Monument and Time

At some point, at least by the middle of the third millennium BC, a commemoration for eternity carved into stone was invented. The idea came about that an event that was confined in time, or temporally located, could be framed and kept and yet stretched out into the future. This did not just involve capturing a specific moment or event. The monumentalized event would also become, in some respect, a future conception of the past.

This thinking of the public monument in relation to a conception of a future time and the obviously related reflections on the past developed in Mesopotamia and, in a somewhat different manner, in Egypt. Both of these cultures are places where writing had already been invented, and where its uses were becoming more ubiquitous and extensive.

This commemorative object, with words and images carved in stone, was a means of making a specific event permanent and immortal. Its invention therefore demonstrates a consciousness, a conception of the notion of Event: an occasion that stands out from others as a rupture within space and time.[33] The event could be preserved somehow and restrained within sequential time, so that the past could remain in the present and continue into the future.

Writing was important to this development. Through the invention of script and its access, records came to be kept of various activities — economic, religious, and so on; it became clear that the record was removed from the action but could refer to it in the future. This historical consciousness of a future time and the possibilities of access to a historical past can be seen, for example, in the practice of inserting foundation deposits into public buildings. Inscriptions were used in foundation deposits starting in the third millennium BC. Such deposits are known from Lagash in the Early Dynastic period and, perhaps more famously, in the case of

the kings of the Third Dynasty of Ur (fig. 4.7).[34] Thus what we have is a development in the third millennium BC whereby writing is used both in foundation deposits and in the daily affairs of the social, religious, administrative, and economic spheres.

In the foundation deposits, votive inscriptions that were both religious and historical began to be made of more durable materials, in copper or in stone, instead of the clay that was normally utilized. This turn to durable materials was conceptually important in many ways and reveals something about a historical consciousness that has not been sufficiently addressed. The inscriptions were laid into the foundations of the temple with figurines. The early deposits were thus constituted of an inscribed tablet and figurines of anthropomorphic deities made in copper with peg-shaped endings. These are the divine guardians of the foundation, or the divine pegs of the foundation themselves. The deposits were placed together as a votive offering in the foundation for some future time, hopefully to remain for eternity. The entire temple was a votive offering to the god, yet somehow at the same time given by the god as an architectural plan. The inscriptions stated this link clearly. Perhaps the deposits also formed a chiastic link between the temple plan as god-given and a votive offering. But the main and clear point is that the deposit was created with the intention of being present for eternity. In subsequent centuries, the inscriptions dedicated by kings made this intention clear. They are also greatly concerned that "some future king," as they address him, would protect their foundations and inscriptions. Consider this excerpt from a typical Neo-Assyrian historical text, which was created in order to be buried as a foundation prism:

> A memorial inscribed with my name and the praise of my heroism
> ... I wrote and left for the days to come. Let a later king (let in later

Figure 4.7. Foundation Deposit of Urnammu, Nippur, c. 2112–2096 BC.
Photo: Courtesy of The Oriental Institute of the University of Chicago.

days, my sons, grandsons, and their sons), among my royal descendants... when that palace shall have grown old and dilapidated, restore its ruins. The memorial inscribed with my name, let him behold, anoint it with oil, offer sacrifice; with the memorial inscribed with his name and the name of Sennacherib, my grandfather, let him return it to its place and set it up.... Who so destroys this memorial inscribed with my name or through some deceitful machinations permits it to become lost... may the great gods of heaven and earth curse him in wrath, destroy his kingship, eradicate his name and his seed.[35]

The interred historical prism is a memorial for the future. This much is clear from the practices of placing a foundation inscription in a palace or temple and from the warnings written on it. But what of the uninterred, freestanding monument?

Around the same time temple architecture and foundation deposits were invented, people began to carve roughly hewn flat slabs of stone with narrative representations. These are the earliest forms of historical monuments known. Historical and public monuments, therefore, developed alongside written foundation deposits. They are thus two aspects of the same concern with time and memory.

The foundation deposit is the opposite of public art. It was made specifically to be interred, not for immediate human audiences. While the notion of public art is more familiar now, especially if it is political, it is possible that in Antiquity the order was reversed. The public monument may have been a sort of foundation deposit in the public sphere inspired by the foundation deposit. At least one can see the monument as a public parallel to the foundation deposit.

The public stele, from the very beginning, contained images and texts. It does not seem that the monument in Mesopotamia

was invented as a carved stone object to which text was later added. During the looting of archaeological sites of southern Iraq in 2003, a new object came to light that, fortunately, was stopped en route out of the country and sent to the Iraq Museum. This was an as-yet-unpublished boulder-shaped monument of a type generally called Kudurru by Near Eastern archaeologists. It can be dated to the late Uruk-Jamdat Nasr period in archaeological terms (c. 3000 BC) and bears traces of writing as well as figural scenes. Like the Uruk Vase, the new discovery indicates that the combination of written signs and images was not an afterthought or secondary development in the conception of a monument. This integration of writing into the monument is generally regarded as problematic, because one expects low levels of literacy in any place in Antiquity, especially when writing was a newly invented technology. Why, then, was writing integrated into the earliest concept of a monument in Mesopotamia?

The monument was meant to stand forever — and to be seen within the context of a specific terrain, like the foundation deposit. The deposit was interred in a clearly defined and fixed place, the sacred earth of the sanctuary whereas the terrain of the public stele was an open surface. The stele was an external message to the future. In a way, one may consider the terrain itself as a context directly linked to the object's efficacy. In other words, context is not just the temple precinct or city square, but outside and inside the earth. The interior and exterior terrain are contexts at the most fundamental level, so to say that the terrain is a context is not to make a statement regarding the archaeological context of excavation methods but to think more deeply about ancient views of relationships between artifacts and place.

Let us consider that the public monument may be a parallel of the foundation deposit in an exteriorized form, but because of its differing function-external, its audience included contemporary

people as well as future viewers and the gods. This would take a shift, a total reversal, in the way that we have thought about public and private or the function of writing in relation to reading. If the public monument is an externalized version of a votive or foundation deposit, then the originary use of writing on monuments was not concerned with a living audience.

The use of wall plaques, carved in relief and with a central perforation for attachment is well documented for the Early Dynastic period.[36] These plaques were votive offerings meant for an internal wall within a temple. For example, the plaque of Urnanshe (c. 2600 BC), from Telloh, commemorates the building of a temple, and the names of Urnanshe and his family members are written directly on each of their images. Taken as a genre, the Early Dynastic votive plaques are similar in material and intent to monuments, yet they are small-scale votive offerings. This discussion should lead to a new way of thinking about the meaning of genres, because the Mesopotamian record problematizes the standard categorizations. Since the Mesopotamian material was made at the very beginning of the use of writing and images in relation to political and religious ideologies, it should be assumed that genres were invented for a purpose. We should not apply categories from the later art historical tradition that we take as universal. In Mesopotamia during this period, the public monument emerged out of these local developments, inventions, and genres.[37] The remarkable inventiveness of the monument is clear. Something happened in the third millennium BC that was, or became, distinctive to Mesopotamian culture: the connection between monument and memory and between commemoration and concepts of time that were clearly articulated when the historical monument was invented.

CHAPTER FIVE

Image of My Valor

War itself requires no special motivational basis but
appears to be engrafted on to human nature; it may
pass even for something noble, to which vainglorious
love drives men, quite apart from any selfish urges.
Thus among the American savages, just as much as
among those of Europe during the age of chivalry,
military valor is highly prized, not only during war
(which is natural) but in order that there should be
war. Often war is waged only in order to show valor;
thus an inner dignity is ascribed to war itself, and even
some philosophers have praised it as an ennoblement
of humanity, forgetting the pronouncement of the
Greek who said, "War is an evil inasmuch as it pro-
duces more wicked men than it takes away." So much
for the measures nature takes to lead the human race,
considered as a class of animals, to her own end.

— Immanuel Kant*

In a number of Mesopotamian monuments, a specific historical
battle or war is referenced and described in a narrative account
that is both visual and textual. These monuments are described as
victory stelae in modern scholarship and *narû* in Akkadian. They
are usually large, free-standing, roughly hewn slabs of materials

Zum ewigen Frieden. I am grateful to Scott Horton for bringing this passage to
my attention and providing this translation.

such as limestone, basalt, and diorite. They are carved in relief
with scenes, often on all sides, and inscribed in cuneiform script.
The names of the rulers involved in the battles appear on the
monuments, unless the inscription has been damaged or broken.
Some inscriptions, such as the ones on the Victory Stele of Naram-
sin, name the defeated as well as the victorious. The information
in the texts is useful for the reconstruction of histories of politics
and warfare; however, a stele's text, together with its iconography
and composition can also be analyzed as a means of understanding
both the function and the historical and local concept of *narû* or
monument. From the inscriptions on the stelae, a great deal about
the significance of war monuments in the ancient Mesopotamian
world is revealed. The texts show that such stelae were displayed
visibly, either in a temple courtyard or in an even more public
place, such as an open field or a city square. In addition, we also
learn from the inscriptions that such monuments were looted
during battles, and taken to enemy lands where they might be
recut and rededicated as war trophies.

I would like to consider how these stelae functioned as monu-
ments of victory and how military campaigns and the subjugation
of enemies are commemorated through the *narû*, which as we
have seen in the previous chapter, is essentially a monument
meant to stand for all time. Acts of violence, movements of
troops and battle weaponry are common themes in all the images
of war, whether on stelae or in other visual-arts genres. Yet al-
ready in the third millennium BC, battles are organized as narra-
tive events with a clear and triumphant message shown through
the conquest of enemies, the display of bound prisoners of war,
and the corpses of defeated soldiers on war stelae. Victory is thus
declared in the *narû*, and the sign of victory is the body of the
vanquished.

The Stele of Dadusha

The stele of Dadusha (1790–1780 BC), who was king of Eshnunna in the early eighteenth century BC, is an excellent and well-preserved example of a commemorative monument (fig. 5.1). It provides a lengthy, detailed account of battle and visually represents Dadusha as heroic and victorious. Across four registers of relief we are shown this victory. We may read it as a victory primarily through the enemy's bodies which appear in various states of subjugation and defeat. The central focus of each of the upper three registers is the subjugated bodies of the enemy, collapsing as a result of the prowess of the heroic Dadusha. A lower register bears two rows of severed heads in profile, neatly organized into rows of five (fig. 5.2). Here in the stele of Dadusha, heroism and victory are both depicted as a power over the body of the other. This power is expressed in the written text and through the visual narrative, not only through the collapsing enemies below Dadusha, but also through the severed heads forming the ground-line at the lower part of the monument. The remaining three nonsculpted sides of the stele bear 221 lines composed into neat rows of seventeen columns of text. This long and remarkable inscription describes the battle and the victorious and defeated cities and their rulers are identified by name.

The stele was discovered accidentally in the Diyala region of Iraq in autumn 1983. It is a large gray stone monolith of an irregular oblong shape, with a tapered base and a rounded top. It is 180 centimeters tall, 37 centimeters wide, and 18.5 centimeters deep. The stele was found by workers in an agricultural development project in the area near Tell Asmar, ancient Eshnunna.[1] Therefore, while the area of Eshnunna is known as the ancient location of the monument, little can be said about its original context beyond what can be gleaned from the inscription on the monument itself, which has recently been translated.[2]

Figure 5.1. Stele of Dadusha, Eshnunna, 1790–1780 BC.
Iraq Museum, Baghdad. Photo: Zainab Bahrani.

Figure 5.2. Stele of Dadusha. Detail of fig. 5.1.

The sculpted side of the stele is subdivided into four figural registers and one register that appears to have been left uncarved. Although the center of the stele is broken by a vertical groove running down the length of the sculpted side, and some parts of it have been restored, the stele is fairly well preserved. In the upper register stand two figures. The one on the left is mid-stride, his left leg forward and his right arm raised to deal a blow. His head and part of his arm and body are damaged, making it impossible to identify him as a god or king by means of the iconography of the headdress. He wears a long, fringed tunic that exposes his muscular left leg. With his left foot, he is stepping on the chest of a fallen enemy.

In front of this pair, an upright male figure stands in profile, with his right leg forward. He wears a knee-length tasseled tunic wrapped around his body and has short, thick hair depicted in rows of beaded curls. A necklace with a large central medallion hangs at his neck. His left arm is raised at shoulder level, and his right arm crossed over the waist. He holds his thumb and index finger together, in an attitude of reverence or prayer. Above, a sun-disk of Šamaš is encircled from beneath by the crescent moon of Sin. Below, warrior figures stand on a band that forms the ground-line depicted as the buttressed walls of a citadel. But rather than being depicted according to the same perspectival point of view as the warrior figure and worshipper, the citadel is seen from above, in a bird's-eye view. It is depicted as if it were a ground plan or a blueprint.

Bahija Khalil Ismail, who was the first to read the inscription and compare it to the iconography of the carving, suggests that the incomplete smiting figure on the upper left may be a representation of the god Adad and the figure on the right may be an image of Dadusha. Khalil Ismail points out that the identification of the figure on the left as Adad is possible, although the head was

entirely lost in the damage the monument suffered, because the inscription thanks Adad for his assistance with the defeat of the enemy. The adorant figure on the right would then be an image of the king, Dadusha, in a state of worshipping Adad. According to the inscription, the celestial emblems of Sin and Šamaš, the deities of the moon and the sun, rise over the scene, cosmically assisting in the victory. The combined sun and crescent moon emblem does appear above the scene. But the meaning of the iconography in the upper register is far from obvious. The scene depicted here is one that in the history of art and studies of iconography and iconology in the ancient Near East would be immediately categorized as a standard image, but is this type of iconographic classification so clear? And how does this stele function as a monument of war?

The smiting warrior god and adorant figure make up a type of scene known from cylinder seal carvings of the early second millennium BC. We have an unexpected large-scale parallel of a glyptic motif that usually depicts Nergal, the god of war, trampling on the body of the dead. In the Victory Stele of Naramsin and a few examples of later glyptic art we see the king in this position.[3] If the god and the king appear together in this kind of scene, it has a similar effect to the stele of Hammurabi, discussed in the previous chapter. It brings the king and the deity into the same physical space. In the Dadusha stele, the image identified as a god and the adorant king are almost equal in size and resemble one another physically. Nevertheless, the inscription is fairly clear about who deals the blow that destroys the enemy king and tramples him. It is Dadusha.

The city on whose buttressed walls the smiting and adoration scene on the uppermost register takes place can be identified from the inscription. It is the northern city of Qabara, in the vicinity of Arbil. The inscription further names the defeated warrior as the enemy ruler, Bunu-Ishtar, the king of Arbil. In the register below

this scene, two figures stand on a ground-line formed of two rows of a scaled mountain pattern. The mountain motif creates the border between this and the register below it. The smiting warriors here have short hair and wear the same wrapped fringed tunics as Dadusha. Each figure holds an ax in one hand and either spears or ropes in the other.

The figures in the middle register appear to be striking a captured enemy in the center of the relief. The central area is damaged, but enough remains to show outstretched helpless arms at a lower level than the victorious warriors, indicating that the captured enemy was depicted as either kneeling or in a state of collapse. The man on the right uses his right hand to grasp the enemy's hair. In his left hand, he wields an ax. The man on the left appears (more or less) to mirror the actions of the warrior on the right, but he holds a weapon close to his own chest. Are these two images of the same person? Are two enemies or a variety of enemy soldiers depicted?

The next register down appears to be almost a mirroring of the one above it (see fig. 5.2). It bears two warrior figures, each of which grasps a man kneeling before him. The captured man on the right clearly has his arms bound behind his back. Although the center of the monument is damaged here as well, the scene is easily reconstructed. The enemy warriors crouch; they do not kneel. Each victorious warrior holds, but does not wield, a weapon. The warriors have the same thick, cropped hair and wear the same fringed tunics as the warriors in the register above. They are in battle dress. The warriors also wear similar anklets and necklaces. The men stand on a double-layered ground-line that divides the register from the one below. As above, the border is composed of a scaled mountain pattern.

The lowest register is unusual (see fig. 5.2). It is not a narrative setting or an action scene. It simply bears two rows of sev-

ered heads in profile, facing left. A vulture pecks the mouth of the head on the upper left, and another pecks at the nose of the head on the upper right. All the severed heads have short, thick hair, shown as horizontal lines or striations radiating from the top into a blunt, caplike shape, and all can be identified as the heads of men by their beards, incised into a grid pattern.

The exact identification of most figures on the monument is uncertain. Both the text and the image describe a specific event, a military victory by Dadusha of Eshnunna over Bunu-Ishtar of Arbil at the battle of Qabara. Each mode of representation, text and image, relates that event in different, if similar, terms, fitting into a word-image dialectic that, as I have argued elsewhere, was standard in Mesopotamian art.[4] Yet what is remarkable about this monument is that it inserts alongside the written narrative of battle, an identification of the most important actors in the visual narrative and a commentary on the monument as a work of art.

Given that the monument is sculpted on all sides, is it fair to assume that it was publicly displayed and visible from all sides to the ordinary viewer? The inscription states that the monument was placed in the E.TEMEN.UR.SAG, the temple of the god Adad in Eshnunna. Temple precincts included open spaces, courts in which standing monuments could be placed and viewed by the citizen. The inscription is written in a typical Old Babylonian monumental script, which might be described as an epigraphy of display. Are these details enough to prove that the narû was publicly displayed? The idea of the public monument as an ancient Near Eastern genre is not fully accepted by the discipline of art history. But, again, the inscription provides ample evidence to support the notion that the monument was displayed publicly.

The text carefully describes a series of events in the war between Dadusha and Bunu-Ishtar. First, the cities of Tutarra, Halkum, Hurara, and Kirhum were defeated and plundered and

the statues of their gods taken to Eshnunna. After overcoming the cities and surrounding areas, Dadusha attacked Qabara. He vanquished Bunu-Ishtar and had him decapitated, then had the head carried to Eshnunna in all haste. Dadusha took the treasures of the wealthy city of Qabara for Eshnunna, but he gave the city itself to Šamši-Adad of Ekallatum. The following is a partial translation:

(viii 1–14) After I laid waste to his territories, his entire land I subjugated, I went to Qabara, his capital city, with full force.

I closed it off with a siege wall. I put earth ramps up to it. I put siege tunnels there. I used my entire force against it and captured the city within ten days.

Its king, Bunu-Ishtar, I took with a strong weapon and overpowered on the spot. Indeed, I had his head sent speedily to Eshnunna.

(ix 1–13) The morale of his fellow combatant-kings and his supporting troops, I overthrew simultaneously, and I brought silence upon them.

Immense booty, the richness of the city, gold, silver, precious stones, luxury furniture and whatever else that land possessed, proudly I brought it to my royal city, Eshnunna.

(x 1–11) I presented it for display, before the people of the upper and lower lands, great and small.

What remained in this land, the city itself, the wide countryside and the swarming people within it, I gave as a gift to Šamši-Adad, the King of Ekallatum.

(x 12–xi 8) Above, in the land of Subartu, I defeated the territory between the lands of Burunda and Eluhtum and the lands/moun-

tains of Diluba and Lullum with my mighty weapon. So that the kings in all the land and forever will sing my praises, I did this.

(ix 9–14) In the middle of that year, on the shores of the Tigris, I built Dur-Dadusha, my frontier city, and in that way I gained for myself a glorious name forever.

This inscription is important for historical reasons. It provides evidence to link Dadusha and Šamši-Adad as contemporaries and allies. It also refers to Šamši-Adad with the royal title, King of Ekallatum, a title that had hitherto been known only from Šamši-Adad's own inscriptions. The historical campaign described in the Dadusha stele is also known from the Mari letters, and the defeat of Qabara is the subject of a fragmentary basalt relief (said to be from Mardin), now in the Musée du Louvre, that also depicts a smiting warrior with a defeated man at his feet. Beyond the historical importance of the text is its relevance for the significance and function of the monument itself. In terms of the iconography, we learn that Dadusha himself "steps upon Bunu-Ishtar, in the position of a victor." This suggests that it is Dadusha, not Adad, who is depicted in the uppermost register, in the smiting warrior position. In addition, the monument is referred to as *ṣalam qarrādūtiya*, which translates as "image of my valor [or heroism]." The scene in the uppermost register can therefore be read as an image of heroism and victory.

The victory is signaled through the heroic act of Dadusha, who pinions and immobilizes the body of the King of Arbil, who lies struggling yet powerless beneath Dadusha's foot. This is the moment of subjugation; it is not after the battle, since Bunu-Ishtar, we are told, would be beheaded later. According to the text, Dadusha stands on the King of Arbil as a hero and victor, which is an act to be celebrated; at the same time, his munificence

to the King of Ekallatum is also important. It is this double act, the two-edged sword of munificence and violence, that formulates power over the life of the other.

Near the end of the inscription, a passage that can be described, with some certainty, as *ekphrasis*, a description and commentary on a work of visual art. The passage is perhaps the earliest example of such a text in the history of art:

> (xii 1–xiv 3) In order to [...] an enduring name [...]..., I had an image of my heroism erected for all time in the center, in E.TEMEN.UR.SAG, the house of Adad, the god who raised me. I am as a warrior, in greatness, ready to flatten the enemy land with the aura of the shining light of battle.

> (xii 7) Above, Sin and Šamaš, who strengthen my weapons, in order to lengthen the years of my reign, they are clearly shining.

> Above the wall of Dur-Qabara is Bunu-Ishtar, the King of the land of Arbil. I bound him in my power. (I) stand upon him. He whom I furiously defeat with my powerful weapon, I am standing on top of him. I am standing like a young hero. Below, ferocious heroes hold enemies carefully with a rope.

This description may indicate that such written accounts of images existed on other monuments, now lost. In the Old Babylonian period, copies were made of texts on Akkadian monuments, many of which are no longer extant and are known only through these copies.[5] The Old Babylonian scribes sometimes included descriptions of the images on the monuments or sculptures in the round, which suggests that this kind of descriptive addition was already in use in the Akkadian period. Alternatively, the Old Babylonian scribal practice of copying the text may have

been the moment at which scribes decided to describe the monument on which the inscription appears. In other words, *ekphrasis* may have been a development of the Old Babylonian scholars who were interested in preserving a record and cataloguing ancient monuments. The scribe of the Dadusha stele, in that case, would have incorporated into the monument an additional commentary, similar to scribal commentary but now transformed into an integral part of the monument.

This passage of *ekphrasis* continues with a clear commentary on the aesthetic qualities of the technique and visual attributes of the monument. This commentary reveals that excellence of the carving and the originality of the work were both aesthetic aspects that were a matter of concern and pride to the patron Dadusha:

> (xiii 7) Its carving has no equal. In the craftsmanship of its carvers it is superior. It is worthy of praise, and it will be praised in the future.

> Daily before Adad, the lord who created me, it will perform good things for me and it will renew the destiny of my rule. In E.TEMEN. UR.SAG, the house of Adad, the god who raised me, I did set it up indeed forever.

> (xiv 4–10) Adad, give as a gift to Dadusha, the prince who loves you, sovereignty, a powerful weapon that destroys his enemies, a long lasting life, years of abundance and prosperity.

> (xiv 11–xv 4) So that my praises would be sung forever, from generation to generation, from old men to young children, and the tale of my valor (heroism), in order for it to be repeated, [...] I had my enduring name inscribed on a [...] *narû*.

The commentary on the aesthetic aspects of the work immediately flows into a description of the installation and function of the *narû*: it is to be put in the sacred precinct of Adad, where it will act on behalf of Dadusha, performing beneficial acts to strengthen and renew his rule. This section of the text is important because in it we are told that the monument is effective and has agency. It revitalizes his authority and ensures that in future generations, both old and young will remember his valor.

The last part of the inscription deals with the installation, location, and treatment of the monument, and it bears a curse:

(xv 5–14) Whoever, with evil intent, commissions that my magnificent work be effaced, removes it from its place, puts it where no eye can see it, throws it in water, buries it in earth, or destroys it in fire.

(xvi 1–7) If someone orders that the signs with which my name is inscribed be scratched out and his name inscribed there, or someone, due to fear, because of this curse, has a third person do the deed, scrapes off the signs with which his name is written and writes my name instead (that is, as the one to be cursed).

(xvi 8–13) Such a king, may An, Enlil, Sin and Šamaš, Inanna, Adad, my lord, and the great gods in true intention damn him without pity.

(xvi 14–15) The enunciation (memory) of his name will not be uttered in the land.

(xvii 1–10) The Anunnaki, the gods of heaven and earth, may give him all the severest treatment, that he and his offspring and his entire kin be annihilated. May Ninurta, the guardian of Ekur, deny him any heirs who carry his name, and may his beloved be scattered by the wind.

The curse further explains the *narû*'s power and agency which was made clear in the statement before the curse: "In E.TEMEN. UR.SAG, the house of Adad, daily before Adad, the god who created me, it will perform good things for me and make solid the destiny of my rule."

As a historical text, the monument of Dadusha is important because it allows a reconstruction of a chronological relationship between several kings from the early second millennium BC, and provides further evidence for a military campaign also documented elsewhere in royal correspondence. Nevertheless, considered in its own right, this monument explains a great deal more through its image and its text. A close reading of the monument as an artifact in which image and text are both integral to the logic of the artifact reveals the following: the identification of this victory stele as a commemorative and perpetual "image of my valor" (*salam qarrādūtiya*), analogous to the image genre known from examples such as the "king of justice" (*šar mīšarim*), discussed in the previous chapter in relation to the Hammurabi stele, and the "image of my kingship" (*salam šarrūtiya*), known from other monuments and their inscriptions.[6] Second, the stele's agency as a performer of beneficial deeds for Dadusha is clear. Its possible treatment by his foes reveals the anxiety involved in the belief that if the monument can be beneficial for the patron, it can also be a vehicle of power over its prototype or the patron of the artifact, as, for example, in volt sorcery. The curse's specific warning to anyone who "removes it from its place [or] puts it where no eye can see it" further reveals something about the stele's potential access and audience. The *narû* was clearly meant to be available for people to view in an open space. Finally, the description of the image can be seen as a remarkable early example of *ekphrasis*, a mode of writing about art generally regarded as an aesthetic genre having developed in Greek in the Hellenistic period. Through

all of these aspects of the stele of Dadusha, we can begin to come to an understanding of the notion of the victory stele as a commemorative monument of war. In its formulations of victory as heroism and masculine power, the depiction of violence over the body, the life, of the other is the central motif. It is that image which signals the triumph.

This image of heroic power is not unchanging. In earlier and later Mesopotamian monuments of war, formulations of power and depictions of the ruler's participation in violence vary enormously. One aspect of the stele I have not mentioned is the identification of all the warriors on the multiregister relief. The men depicted may be Dadusha's troops; the inscription states, however, that it is Dadusha and not another person or god who stands on Bunu-Ishtar in the upper register: "I am standing on top of him. I am standing like a young hero." Who, then, is the adoring warrior before the scene? Is it Šamši-Adad? Is it one of Dadusha's troops? I propose that it is Dadusha himself, shown twice in the same register.

In the two lower registers, two warriors hold enemies by ropes. These warriors are almost mirror images of each other. In fact, all the warrior images may be those of mirrored heroes, repeated on the multiregister monument in the acts of their "ferocious heroism." While such a repetition of one actor whose image is repeated in close proximity does not fit into what we might commonly expect of a visual narrative, it is not as peculiar in the ancient Mesopotamian context where repetition was a more accepted aesthetic device.

The stele of Dadusha, a commemorative war monument described as "ṣalam qarrādūtiya," the "image of my valor," depicts Dadusha in militaristic acts of heroism, expressed as Dadusha's physical power over the body of the enemy. Significantly, images of the king's direct action, the depiction of power as his virility

and masculinity and his body as that of a young, ferocious hero, and his personal participation in the acts of violence through which sovereign power was expressed — that is, standing on the enemy and dealing the final blow — were used neither before the Akkadian period, in Early Dynastic art, nor in the arts that were produced at the height of the reigns of the most powerful and tyrannical Assyrian kings. As we have seen, the Victory Stele of Naramsin was the first to depict the king standing on the bodies of the dead, even before images of gods took on this role in the miniature art of cylinder-seal carving. Naramsin was the original source of this iconography, not the war gods Adad and Nergal. While some Akkadian cylinder seals depicting battles between gods show one god lifting a foot and placing it on another god in the midst of battle, as if to brace himself against the enemy, the actual stative act of placing a foot on a corpse, of standing in triumph on the dead and wounded bodies of the enemy, first appears in the Victory Stele of Naramsin. To stand on the bodies of the dead was a remarkable new formulation of sovereign power.

Just War

The Stele of Eannatum of Lagash (often referred to as the Stele of the Vultures) was another public monument (figs. 5.3 and 5.4). It was carved and erected after the settlement of a border dispute around 2460 BC, over the ownership of the Gu'edenna, a fertile tract of land between Lagash and the neighboring city-state of Umma.[7] It is to date the earliest known public war monument in history. It represents the vanquished as corpses piled high in mounds or trapped in a net by the god. In it, Eannatum is a warrior, in battle, but he is not pictured dealing the blow of death.

The stele is in extremely poor condition: seven fragments remain of the original limestone slab with a semicircular top. The pieces were excavated in the 1880s at Telloh, ancient Girsu, in

147

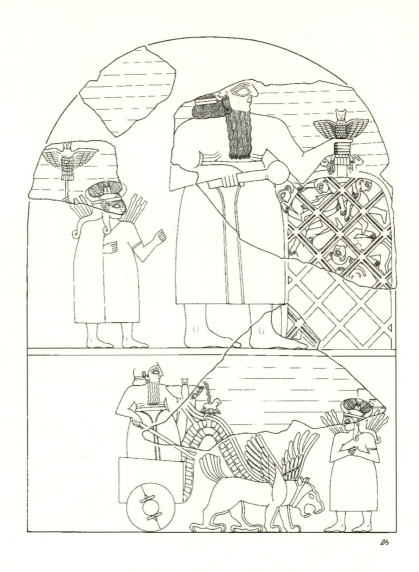

Figure 5.3. Stele of Eannatum of Lagash (Stele of the Vultures), Girsu, 2460 BC. Musée du Louvre, Paris. Drawing: Elizabeth Simpson.

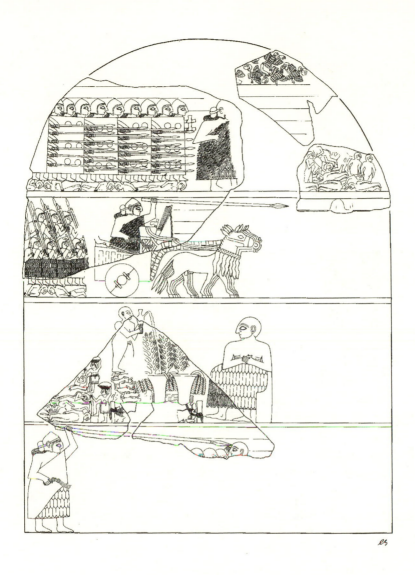

Figure 5.4. Stele of Eannatum of Lagash (Stele of the Vultures). Reverse of fig. 5.3.

southern Iraq. The pieces were found scattered throughout the site, not in their original, third-millennium-BC context. They had already been relocated and reexhibited in Antiquity, yet remained in the city of Girsu. The fragments, with the addition of another fragment that appeared on the antiquities market in 1900, were reconstructed into the stele now displayed at the Musée du Louvre in Paris.[8] As reconstructed, the stele is a large, free-standing object, 1.8 meters high and 1.3 meters wide, completely covered with images and text. Script appears on each fragment, allowing for the correct positioning of the broken pieces in relation to one another. Enough remains of the stele to permit an assessment of its text and iconography.

Eannatum appears several times on the reverse of the stele, in series of events depicted on multiple registers. At the top, Eannatum leads his troops, marching in a military formation (see fig. 5.4). Before him, a fragment shows naked prisoners and corpses. Above, a group of vultures hovers in midair, waiting to devour the dead. In the next register, Eannatum leads his troops in a war chariot, wielding a spear. Advancing in an orderly manner behind him, his troops march over the bodies of their dead enemies. At a lower level in the stele, a fragment shows a libation scene, perhaps a postbattle celebration or a prebattle entreaty to the gods. To the left of this scene is a pile of naked corpses, recalling literary passages that describe creating tells out of enemy corpses. Several men bearing baskets of earth on their heads climb the side of the mound of corpses, to cover the heap with earth and turn it into a tell.

A large, bearded male figure dominates most of the obverse side of the stele (see fig. 5.3). The bearded man is not labeled with a name, but it is clear that he is an image of Ningirsu, the patron god of Eannatum and city god of Lagash. Unlike Eannatum who is clean-shaven, the god is bearded. He grasps what appears

to be a small eagle, with a broken head, in his left hand. The eagle originally had a lion's head and can be identified iconographically as the Imdugud bird, Ningirsu's emblematic mythical animal. This bird forms the upper part of the shushgal net of the Sumerian gods, a large battle net, which is depicted here swarming with the naked bodies of the war dead.

We can identify the larger figure on the obverse of the stele as the city god, Ningirsu, not only because he holds the Imdugud bird, but also, as Winter has pointed out, because of his relationship to the female horned figure on the fragment right behind him and because of his long beard and his size relative to the net full of corpses that he holds.[9] It is not Eannatum who holds the bodies of the dead, it is his god, Ningirsu. The act of controlling death is thereby attributed to the god, not the ruler. While the soldiers here and elsewhere in Early Dynastic arts trample their enemies, in a battle narrative, these works do not use the iconic image of the king standing upon the dead as a sign of victory and heroism that appears in the Victory Stele of Naramsin and later royal imagery of the second millennium BC.

How does the stele of Eannatum function as a monument? It is a monument of war, yet rather than simply commemorate a victory, it is also a contractual agreement to terminate a state of war. It declares the end of battle and proclaims geographical boundaries. A large part of the inscription bears oaths repeatedly sworn by the ruler of Umma on the battle nets of the gods that he will not transgress the boundary. Before the battle, Eannatum went to a dream oracle. The dream omen that was given told him that "the sun-god will shine at your right," Lagash would defeat Umma, and "myriad corpses will reach the base of heaven."[10] Lagash's victory in this conflict is presented as divine destiny. The battle is sanctioned by the gods, and Lagash's claim on the land is justified in the monument.

151

The justification of the battle in extant Sumerian texts about the Lagash-Umma border conflict indicates that the act of war against another city-state was not acceptable unless it was defensive. Thus Eannatum often insisted that his wars were all fought within his own territory, the terrain of Lagash, from which he drove the enemies back to their own lands.[11] The gods fix the boundaries of the land. Any repulsion of invasion or aggression into the area of a city-state was divinely sanctioned as a just cause to battle, a *jus ad bellum*. It is interesting also that in the textual accounts of Eannatum and the later Lagashite ruler, Enmetena, there is an emphasis on the measuring of borders:

> Enlil, king of all the lands, father of all the gods, by his authoritative command demarcated the border between (the territories of) Ningirsu and Shara. Mesalim, King of Kish, at the command of Ishtaran, measured it off and erected a monument there. Ush, ruler of Umma, acted arrogantly: he smashed the monument and marched on the plain of Lagash.[12]

This text makes the case that the trespasser was Ush of Umma and that the war that ensued was a defensive war. It indicates that making the case for just war was an important enough obligation before the gods and before history, to be written upon a foundation deposit, an inscribed cone. The text also speaks of erecting a monument at the location, and the subsequent smashing of the monument as an act of war.

Elsewhere in the Lagash texts we read that envoys were dispatched to find diplomatic solutions to border conflicts and when these failed, declarations of war were sent before an attack. From Lagash we have the earliest example of a declaration of war sent in advance to the enemy.[13] It is interesting that so many of the Early Dynastic records of battle indicate that the cause for war

had to be justified as defensive, as the protection of home territory against an outside aggressor. This concern with justification implies that taking the lives of others, even for the king and his military, was a source of anxiety, and required justification and sanction from the gods. In the Eannatum stele, the text recounts that Eannatum sought the council of a dream oracle in order to ascertain the sanction of the gods in the matter, and the ruler of Umma is given the blame of first aggression.

The stele of Eannatum was erected outside. Even if the fragments were not discovered in their original location, a number of texts make clear that this and other monuments were set up outside, at the boundary. We can say then that it is a commemorative monument of war but it is also a legal treaty bound to a borderland. Its erection and connection to the terrain were essential to its function: they tied the monument to the land, just as a foundation deposit interred in a specific location was fixed to that terrain and had to remain unmoved. A curse added to the end of the stele of Eannatum suggests that moving or tampering with the monument would mean breaking a legal treaty and oath. Such curses also appear on other Lagashite texts that deal with borders, boundaries, and wars that were perceived or presented as acts of aggression. The stele is a social and legal contract, and at the same time a monument of *just war*.

The battle is governed by the laws of war. The stele of Eannatum is concerned with the event's judicial and divine correctness. It is not an exception to normative human behavior as in the power of the king over the lives of others so visible in the Victory Stele of Naramsin. It is a stele that asserts a just war. The stele's name, according to the ending of the inscription, is "Ningirsu Lord, Crown of Lumma, is the life of the Pirig-eden Canal. The stele of the Gu'eden, beloved field of Ningirsu which Eannatum, for Ningirsu returned to his hand. He (Eannatum) erected it."[14]

What does this emphasis on the divine and the just in the first commemorative monument of war mean? In the stele of Eannatum we see a bundle of dead and dying men in a net, defeated by Eannatum and his troops in battle but held by the god Ningirsu. It is a sign of the gods' power and control. It is not Eannatum that controls the bodies of his enemies, the imprisoned and the dead, but Ningirsu. By the time of the Akkadian ruler Naramsin we have the king, larger than life and heroic, standing above the bodies of the dead, and the enemy Lullubi pleading to the king. Naramsin had a power over life and death, a power not held by the earlier Eannatum, despite the latter's hyperbolic statements of justice and divinely sanctioned victory. Naramsin's sovereignty entailed the emphatic power to deal the blow, to trample the body of the enemy. The same power is not held by Eannatum. Instead it is literally held by the god, and it is the god who must sanction and decree by dream oracle the Lagashite victory. The god grasps the bodies of the dead, and controls the life span of the enemy. The authority over the body and life of the other in the Victory Stele of Naramsin can also be found, almost five centuries later, in Dadusha's monumental self-presentation. Dadusha steps on the king of Arbil, and he gives his munificence to the king of Ekallatum. Both acts are emphasized in the Dadusha text as emblematic of the sovereign power of Dadusha of Eshnunna.

Empire and the Display of Torture

It is remarkable that even if sovereign power both in the Akkadian period and in the early second millennium is depicted as the power and the right to kill, we are not shown any scenes of explicit torture. Bound and dead prisoners are known from the very earliest images of battle in late Uruk cylinder-seal carving, but the depiction of the act of torture is unknown for most of Mesopotamian history. Nevertheless, in the Neo-Assyrian reliefs that

lined the palace walls from the ninth to the seventh century BC we are shown explicit torture: the extremes of physical violence that bring the captive near to death and are really a slow form of death. We are spared no gruesome detail of the breaking and tearing of bodies, of impaling and flaying the outstretched bodies of living prisoners who are brought to the edge of death. We are also shown the dead who have been decapitated or impaled. This torture is not the blow dealt by the earlier kings, it is the physical torture that Foucault describes as "the art of maintaining life in death."[15] Significantly, in the Neo-Assyrian palace reliefs, torture is at no time carried out by the hand of the Assyrian king. It is not Ashurbanipal or Sennacherib who takes part in the flaying, the impaling and the tearing apart of limbs. It is the Assyrian soldier on the field of battle who is responsible for these acts of horrendous violence (figs. 5.5 and 5.6). Yet the scenes of bodily torture depicted on the palace walls must have been sanctioned, if not chosen, by the king.

An important contradiction of the Neo-Assyrian period is that in the written accounts of war the king did indeed claim to take part in this violence. The standard statement repeated in various studies of Assyrian war reliefs, that the image and texts bear the same message, must be reconsidered. The written accounts are narrated in the first person, in the king's voice. In numerous passages, the Assyrian king claims to have performed the act of torture himself. For instance, Sargon II of Assyria said, "That the Mannean land might be avenged and that it might be restored to Assyria, I flayed Bag-duttu and showed him to the Manneans."[16] Ashurnasirpal II also stated that he had executed a man and placed his skin on public display.[17]

The palace walls were not always carved with images of battle. They also depicted the king and his courtiers accompanied by supernatural beings or elaborate hunting scenes. The depicted

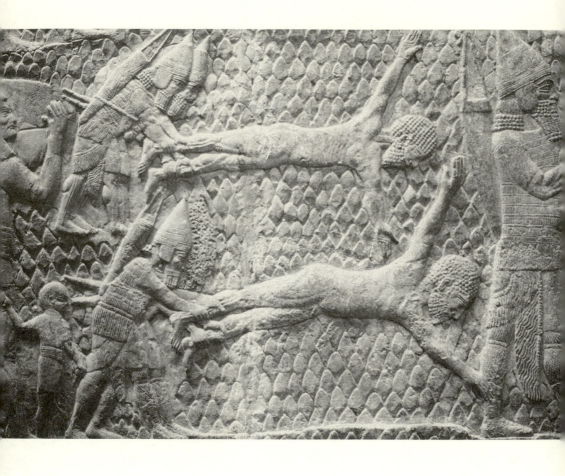

Figure 5.5. Assyrian soldiers flaying men of Lachish, Nineveh, c. 700 BC.
British Museum, London. Photo: Zainab Bahrani.

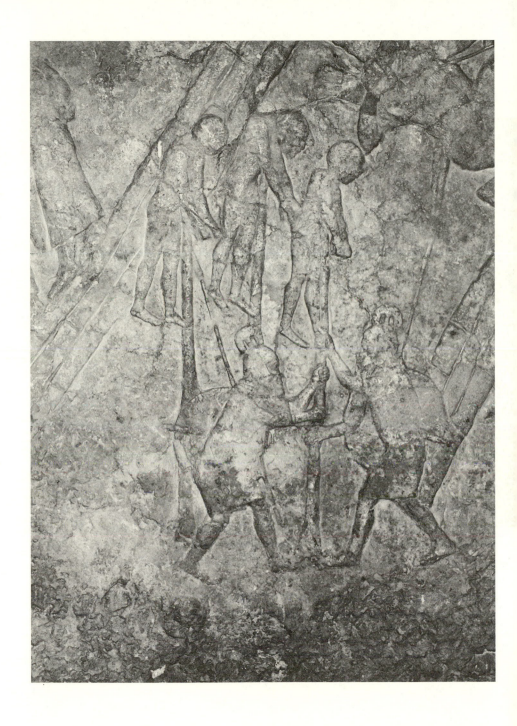

Figure 5.6. Assyrian soldiers impaling captured men, Nineveh, c. 700 BC.
British Museum, London. Photo: Zainab Bahrani.

wars are identifiable as historical events, rather than generic war scenes. The details of terrain and enemy costumes are given careful attention. The weapons and machinery of war are shown, and the acts of torture are shown in detail. One relief depicts a row of impaled, naked bodies in front of a besieged citadel in Anatolia, a display that was surely meant to terrorize the inhabitants of the city into capitulation. Scenes of Sennacherib's battle of Lachish portray men lying on the ground, their hands and feet tied to pegs, their naked bodies ready to be flayed by the Assyrian soldiers, who hover above (see fig. 5.5). In the representation of Ashurbanipal's Elamite campaigns, men being flayed and torn limb from limb are depicted in a register above rows of conquered Elamites paying homage to a new puppet king installed by the Assyrians. An Assyrian officer leads the new king toward the genuflecting crowd of Elamites.

While the Mesopotamian king had at no time been as powerful as the Assyrian monarch, the sovereign's absolute power was also no longer portrayed visually in the same direct terms. Torture is not so much depicted as a sovereign right, as a natural and legitimate part of the broader aspects of war, and the act of war also takes on this role. It becomes an extension of the sovereign right over the lives of others so that the war machine becomes the instrument of the sovereign's power over life and death. War is just and good, because it is in the order of divine plans, decreed and justified through omens from the gods.

Chapter Six

The Art of War

If the image of the king of the country in question,
the image of his father, or the image of his grandfather
falls over and breaks, or if its shape warps, this means
that the days of the king of that country will be few in
number.*

If a man moves or damages a sanctuary, the anger of
that man's god will not be released from him.

If a man repairs a figure of Gilgamesh, the anger of the
god will be released.†

A distinctive military tactic in Near Eastern Antiquity was the
assault and abduction of monuments in war. To the extent that
war aims for the annihilation or defeat of the enemy and the con-
trol of land, military acts that rely upon the efficacy of public
monuments, buildings, and other works of art, were — and remain
in contemporary warfare — an integral aspect of military strategy.
Such strategy is akin to the reconfiguration of space by territorial
and architectural destruction and by means of the mass deporta-
tion and relocation of civilian populations.

We are accustomed to thinking about the history of war and

*Babylonian omen text, after Pritchard, *Ancient Near Eastern Texts*, p. 340.
†Excerpted from the omen series *šumma ālu*, after Freedman, *If a City is Set*, p.
161.

even of its mythic dimensions, but we do not often think of the space of war with the same degree of attention. In his many discussions of war, Paul Virilio makes the point that politics is first and foremost the *polis*, the urbanist and the politician are, etymologically speaking, the same, so that war, like politics, is inextricably linked to the city.[1] Such collapsing of boundaries is instrumental to Virilio's thought. He argues that the *polis*, the centralized urban space, emerges from war. It is a by-product of the war machine. Virilio *thinks* with war. He takes pure war as a framework within which culture and social structure, the economy and technology, are the various lines of the greater logistics of the war machine. Territorial space is drawn into the service of the war machine and reconfigured for and by sovereign power.

The relationship between urban space, architecture and aesthetics, and the militaristic may seem tenuous, but it is not. The destruction of monuments and images redefines the forms of the state or the city as urban phenomena, even in our own time. The identities of the ancient city-states were continually constructed and marked through monuments, images, public rituals, and architectural structures. War was fought at the level of monuments as much as land and natural and economic resources. War was a means of unsettling and reordering space, monuments, and populations and reconfiguring them into new formations.

The movement of images during battles was an elaborate and complex practice in the ancient Near East, which is recorded in historical annals and a number of other ancient texts known from numerous cases throughout Near Eastern Antiquity, as well as in the classical world. At times, wars were fought specifically for images, to acquire royal monuments and the cult statue of a god, or to recover a divine statue that had been carried off by an enemy in an earlier battle (figs. 6.1 and 6.2). This removal of the image, especially when it involved the cult image of a deity, was a form of

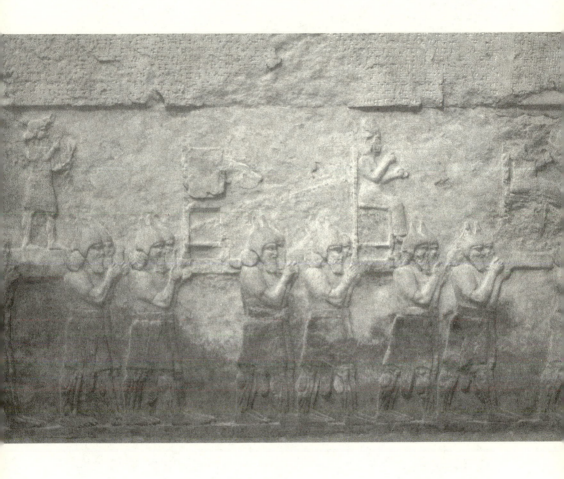

Figure 6.1. Removal of statues of gods, Nimrud, reign of Tiglath-Pileser III, c. 730 BC.
British Museum, London. Photo: Zainab Bahrani.

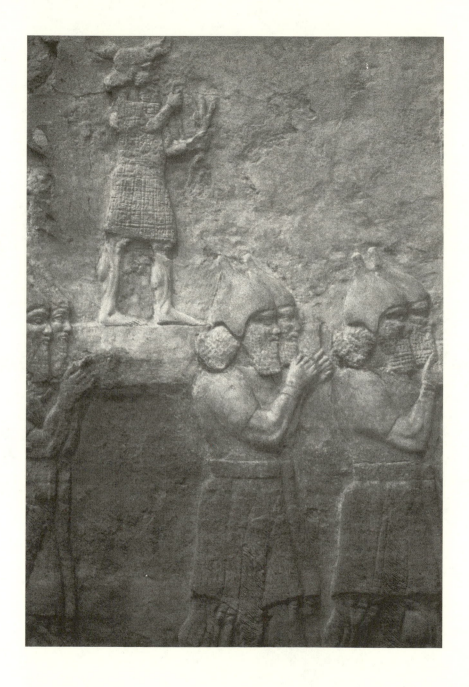

Figure 6.2. Removal of statues of gods, Nimrud, reign of Tiglath-Pileser III, c. 730 BC.
British Museum, London. Photo: Zainab Bahrani.

banishment and exile that had profound repercussions for the entire land.

Images and monuments were taken, like booty, but the aim in obtaining sculpture and monuments was not the acquisition of material wealth. This abduction and transfer of images to another land is more similar to the well-known late Assyro-Babylonian practice of deportation: the exile and relocation of human beings. The taking of statues was therefore not an impulsive act during a raid on an enemy city or land. It was a productive operation of war, like what are known in today's military terminology as "psyops." The deportation, relocation, and torture of human beings are extreme instances of this type of strategy. The destruction and abduction of monuments and cult statues functioned along similar lines as mass human deportation, in that both reconfigured space. Especially in the Neo-Assyrian period, both practices, although not new, grew more frequent and involved more people and monuments. These practices developed into major strategies of dislocation that allowed a reordering of space in the vision of the imperial center.

The power of cult images of the god and depictions of the king on statues, stelae and ancient public monuments was such that the removal of any of these was believed to have serious consequences for the state. Each of these works of art was linked to the land in its own way: the god was connected to the city, the king to the land and, in time, the empire, the standing monument to the inherited historical, ancestral space of time and memory.

The importance of images in war and their movement or mutilation also reveals something about the representation of war itself, as an image. Consider the form of battle. It is already a narrative the moment it takes place. Ostentatious display in combat was an integral part of the reasoned organization of war, the aims of which were the increase of political and economic power and, by the Neo-Assyrian period, the vast territorial expansion of empire.

If the aesthetic presentation of troop formations and legions is an aspect of the strategy of war and the establishment of absolute or sovereign power worked into the actual battle as well as in its images, the relationship between war, sovereign power, and aesthetics becomes more clear. This line of reasoning leads in several directions, which I address in this chapter.[2]

Art in War

In the middle of the first millennium BC, Ashurbanipal, the king of Assyria (668–627 BC), exhibited statues of Elamite kings at the Southwest Palace of Nineveh. The statues had been taken as war booty from Susa, the Elamite capital. After being transferred to Nineveh, they were deliberately mutilated and then displayed in damaged condition in the Assyrian palace. The inscription makes clear that the defacement was an act of punishment analogous to the mutilation of humans:

> The statue of Hallusu, King of Elam, the one who plotted evil against Assyria and engaged in hostilities against Sennacherib, King of Assyria, my grandfather, his tongue, which had been slandering, I cut off, his lips, which had spoken insolence, I pierced, his hands, which had grasped the bow against Assyria, I chopped off.[3]

The detailed battle inscription on the Dadusha stele discussed in the previous chapter states that the victorious king took the statues of the gods of Qabara and brought them back to his capital, Eshnunna. The removal of cult statues in battle was a common strategy by the early second millennium BC, when the Dadusha monument was made. As the ancient texts make clear, this strategy is one of deportation and even banishment.[4] The domination of cities and the rise of empires resulted in the appearance of major city and national gods.

Relationships of deities to the world existed in terms of astral bodies, the earth, trees, rivers and seas, minerals, all manner of plants and animals, and so on. These relationships were studied and expounded as logical correspondences by Babylonian and Assyrian scholars. In this context, deities were associated with particular cities as patron gods, and each city was the place in which that deity's house, his or her main temple, was located and where the cult statue lived. Representations of each deity existed in various forms and media, but the cult statue was more than an image. It was the manifestation of the god in the realm of human beings. The cult statue was made according to specific elaborate ceremonies, using particular materials that were treated by priests. The statue was then put through a mouth-opening ceremony, in which the image was brought to life. After that, the statue was no longer an image; it was the phenomenon of the deity proper on earth. The texts no longer use the word *ṣalmu* (image) to refer to the sculpture after the mouth-opening ceremony: it is referred to simply and directly as the god, by his or her specific name.

The removal of the god from the city had disastrous consequences. The god was exiled. He (or she) went into a form of occultation wherein divine power and protection were removed from the city. The literary form of the lament, known from a number of examples of the late third and early second millennia BC, provides an early record of this belief. These laments were performed publicly, recited accompanied by harp, tambourine, and kettle-drum music. The long composition known as *The Lament for Ur* recounts the desolation wrought by war and invading armies at the end of the third dynasty of Ur, in 2004 BC. The lament begins by describing the destruction as the consequence of the gods' departure from their cities. The gods' absence and the cities' ruin caused the loss of all bearing for the inhabitants.[5]

165

The Lament over the Destruction of Sumer and Ur of c. 2000 BC
contains a poignant passage describing the destruction of a temple:

> The great door ornament of the temple was felled; its parapet was
> destroyed; the wild animals that were intertwined on its left and
> right lay before it like heroes smitten by heroes; its open-mouthed
> dragon and its awe-inspiring lions were pulled down with ropes like
> captured wild bulls and carried off to enemy territory.[6]

The ancient poet illuminates the people's sorrow in facing this
destruction of architecture and sculpture. This lament does not
appear to note just that this was the house of the city god, the seat
of divine power; it is also a lament over the destruction of the
architectural sculpture, the magnificent creatures torn from the
lintel and captured like wild animals. Later, the poet laments the
destruction of the architrave, made of "gold, silver, and lapis
lazuli, and the great bronze pins of the door." The poet grieves for
the ornament of the architectural sculpture, its beautiful crafts-
manship and wondrous materials. When the gods left their cities,
they abandoned them to the desolation and ravages of war. The
desolation is described vividly in terms of the bodies of dead that
littered the streets, and the remaining suffering people. But the
destruction of monuments and architecture was a dominant nar-
rative theme in the war laments.

The Cult Image of Marduk, God of Babylon

Moving cult statues as a strategy of war is known most famously
from the case of the cult statue of Marduk, the patron god of the
city of Babylon. Not only was the statue stolen a number of times
over the centuries, but later battles were also instigated and
fought specifically for its return.

It is clear from a large number of ancient texts that the move-

ment of the gods' statues was taken seriously and not simply performed for the manipulation of public opinion. According to the private archival record of Neo-Assyrian kings' queries to the sun god Šamaš (see Chapter Seven), the king and his priests performed private rituals of reading the omens from the entrails of sacrificial animals. In a number of these recorded omens, the king requested oracles from Šamaš in order to decide how to deal with the cult statue of Marduk, which had been taken to Assyria in a recent campaign against Babylon:

> [Šamaš, great lord, give m]e a firm [positive answ]er [to what I am asking you].
>
> [Should Šamaš-šum-ukin, son of Esarhad]don, king of [Assyria, within this year], seize the [han]d of the great lord Marduk in the Inner City, and should he lead [Bel] to Babylon? Is it pleasing to your [great] divinity and to the great lord Marduk?
>
> Is it acceptable to your great divinity and to the great lord Marduk?
>
> Does your great divinity know it? [Is it decreed] and confirmed [in] a favorable case, by the command of your great divinity, Šamaš, great lord? Will he who can see see it? Will he who can hear hear it?
>
> I ask you, Šamaš, great lord, whether Šamaš-šum-ukin, son of Esarhaddon, king of Assyria, should within this year seize the hand of the great lord, [Marduk, i]n the Inner City, and lead Bel to Babylon, whether it is pleasing to the great lord, Marduk, whether it is acceptable to the great lord Marduk. Be present in this ram, place in it a firm positive answer, favorable designs, favorable propitious omens by the oracular command of your great divinity, and may I see them. May this query go to your great divinity, O Šamaš, great lord, and [may an oracle be given as an answer]. [Month] Nisan (I), twenty-third day. Eponym year of Mari-larim (668 BC). In the Succession Palace.[7]

The question of the god's desire to move and how that desire could be learned from the omens is followed by more specific considerations of the method of travel. In this context, one omen-query asks whether the statue of Marduk ought to be loaded onto a boat:

[Šamaš, great Lord, giv]e [me a] firm [positive answer to what I am asking you]!

[In the month Iyyar (II) of the coming year], [should they load the statue of the great lord Marduk] on the boat [in the Inner Ci]ty, and should he g[o to B]abylon?

Is it pleasing [to your great divinity and to the great lord] Marduk? [Is it acceptable to your great divinity and to the great lord M]arduk? [Does the great divinity know] it? [Is the going of the statue of the great Lord Marduk] to Babylon [decreed and confirm]ed [in a favorable case, by the command] of your great divinity, [Šamaš, great lord]? Will he who can see see it? Will he who can hear hear it?

I ask you, Šamaš, great lord, whether, on the xth day of Iyyar of the coming year, the statue of the great lord Marduk should be loaded on a boat in the Inner City and go to Babylon? [Whether it is acceptable to the great lord Marduk]; whether it is pleasing to the great lord Marduk? [Be present in this ram, place] in it a firm positive answer, favorable designs, favorable propitious omens by the oracular command of your great divinity, [and may I see them]. [May this query go to your great divinity, O Šamaš, great lord, and] may [an orac]le [be given as an answer].[8]

It is important to note that these queries were not for public consumption. They were the king of Assyria's private devotional practices, meant to ensure that the gods were satisfied with the

king and that he did not offend them by making the wrong decision, especially in war.

The cult statue of Marduk is first mentioned in the Old Babylonian period. By 1594 BC, Marduk and his consort, Sarpanitum, were taken out of Babylon to Anatolia after the attack on Babylonia by the Hittites that ended the Old Babylonian dynasty. The same gods were rescued by Agum-Kakrime, a Kassite king of Babylon, who declared that it was his responsibility to bring these gods, living in exile in a foreign land, back to E-sagila, Marduk's main temple, in his home city of Babylon. Marduk himself gave the order to the king to return the cult statues, because it was Marduk who had decided that the time had come for his return home. The king received the command through an oracle delivered through a consultation with the sun god, Šamaš. In addition to making the arrangements for the journey, there was also the question of how the gods were to be treated and cared for while their temple was being prepared for their return. The gods rested on cedar thrones, and specialist craftsmen came to see to their restoration. Their clothing and jewelry were renewed, and their sanctuary was purified by the priests.

In 1225, Marduk was captured again, this time by the Assyrian king Tukulti-Ninurta I (1243–1207 BC). He remained in Assyria until the mid-twelfth century, when he returned to Babylon. He was not long in his home city however. An Elamite attack soon carried him off to Elam, along with Nabu, the god of wisdom and writing, whose home city is Borsippa. According to the ancient texts, when the gods were taken, all sacred rites stopped and the sanctuaries were deathly still.

Nebuchadnezzar I (1125–1104 BC) claimed that he had mustered his troops and marched against Elam specifically to bring Marduk back to Babylon. When Nebuchadnezzar finally returned the cult image to E-sagila, his home in Babylon, there were great

festivities. Nebuchadnezzar initiated a period of great literary and artistic production to celebrate the event of the return. A number of hymns and poems written at the time describe both the exile in Elam and the return to Babylon as the god's own decisions.[9] The cult statue-god was responsible for the departure that allowed or permitted the war and the plundering of the city. Even according to Nabonidus, the king of Babylon, Sennacherib's destruction of Babylon was at the command of Marduk, after a voluntary absence by the god. The annals say that Marduk became angry with his city and decreed its continued destruction for seventy years.[10]

A palace relief from Nimrud dating from the reign of Tiglath-Pileser III shows the Assyrian troops during an incursion into Babylon removing the architectural sculpture and the cult image of Marduk. A fallen palm tree of the southern land of Babylonia, and a group of civilian women and children about to be deported, are nearby. Four soldiers lift the image of Marduk (identifiable by his spade scepter) onto a platform that they carry at shoulder level. There is no indication that the image was treated as an inanimate object of purely material value.[11] It is clear from both images and texts that these deities were carefully carried back to Assyria, again indicating, as in the texts, that the Assyrians believed in these cult statues' efficacy.

The ritual known as "The Marduk Ordeal," recorded in texts from the first millennium BC, describes the Babylonian supreme deity Marduk as a prisoner in exile who is then released. The text has to do with the destruction of Babylon by Sennacherib in 689 BC and the deportation of the cult statue of Marduk to Assyria.[12] Texts found in Nineveh and Aššur comment on specific rituals in which Marduk is seized and imprisoned. The texts also say that the creation epic is to be recited before Marduk in the month of Nisan. The meaning of these rituals remains somewhat enigmatic, but they were certainly related to the practices of image abduc-

tion in war and clearly draw a parallel between the taking of pris-
oners-of-war from the ruling elite of the defeated city and the
abduction of the city's deity.

The campaign for the return of the image, conversely, was a
pious act of just war or, on occasion, a diplomatic act between
states. The Babylonian Chronicles and the chronicles of Esarhad-
don of Assyria say that in the month Addaru of 674 BC, there was
a thaw in the relations between Assyria and Elam when Elam
returned Ishtar and other gods of Akkad to Babylonia.[13] Esarhad-
don also records that he returned gods taken from Elam back to
their land. The image of Ishtar of Akkad, Babylonia's most impor-
tant goddess, appears to have been taken the previous year.[14] A
letter written by a man called Mar-Issar, a representative of the
Assyrian court in Babylon, speaks of "the lady of Akkad's depar-
ture for Elam," adhering to the age-old tradition in which the
removal of the gods of a city was described as being a result either
of their own free will or of anger with their own city.[15] Somehow
this idea of the gods' free will coexisted with the descriptions of
forced deity abduction in battle and gods taken as prisoner of war.
Whatever the reason for the god's removal from his city it was
that action — his abandonment of the city — which made possible
the devastation of war. The way in which war takes over the city is
most eloquently described in an epic poem of the eighth century
BC, *The Erra Epic*, a work in which we encounter a profound con-
templation of the relentless violence and horror unleashed by war.

The Erra Epic is part of an ekphrasistic tradition in Mesopo-
tamia that is concerned with cities and fits into the broader liter-
ature of laments, first recorded in the third millennium BC. It is a
long Akkadian narrative-poem, composed by the scribe Kabti-
ilani-Marduk, that uses mythical allegory as a vehicle for an
astute and perceptive description of the destruction wrought by
war. One passage tells of the destruction of Babylon and the god

Marduk's lament for his city. While Marduk's cult image was being repaired, Erra, the warrior god, the personification of the force of war, was enthroned in his place, thus bringing about a reign of violence. Earlier in the poem, Marduk speaks about the materials needed to refurbish his cult statue, which had fallen into disrepair, a condition that was ultimately responsible for the ravages of war:

> Where is the wood, flesh of the gods,
> Suitable for the lord of the universe,
> The sacred tree, splendid stripling, perfect for lordship,
> Whose roots thrust down a hundred leagues,
> Through the waters of the vast ocean to the depths of hell,
> Whose crown brushed Anu on high?
> Where is the clear gemstone that I reserved?
> Where is Ninildum, great carpenter of my supreme divinity,
> Wielder of the glittering hatchet who knows that tool,
> Who makes it shine like the day,
> And puts it in subjection at my feet?
> Where is Kusigbanda, fashioner of god and man,
> Whose hands are consecrated?
> Where is Ninagal, wielder of the perfect tool,
> Who grinds up hard copper as if it were hide
> And who forges tools?
> Where are the choice stones, created by the vast sea
> To ornament my diadem?[16]

The cult image of Marduk plays a major role in the poem. The war (as an anthropomorphized abstraction) is explained as a result of Marduk's temporary absence from his throne. The takeover by Erra, the warrior god and the force of war, occurs because Marduk's cult image is damaged and in need of renovation. The

removal of the cult statue for repair leaves an empty throne that is then occupied by war and desolation.

The Removal of Monuments and Royal Images

The removal or relocation of cult images was an organized and clear strategy of war. But statues of gods were not the only targets of this kind of image movement. The assault and abduction of statues of kings and of public monuments is best known from the case of the Mesopotamian monuments uncovered in the Elamite city of Susa, in Iran. That occasion involved the careful and calculated abduction of royal monuments and statues of kings by Elamite raiders in Babylonia in 1155 BC. The Elamites took the monuments and, in many cases, mutilated them, cutting away their Akkadian inscriptions and adding Elamite dedications to the local god, Inshushinak.[17] This extensive collection of booty includes some of the most famous works of Near Eastern Antiquity: the Codex Hammurabi (see fig. 4.3), the Victory Stele of Naram-sin (see fig. 4.1), the portrait statue of the Akkadian king Manishtushu, and numerous monuments carved in relief and inscribed with the names and images of ancestral kings. These monuments had been publicly displayed in the cities of southern Mesopotamia for a thousand years before being carried off to Elam in the twelfth century BC. Far from being the targets of random looting, the monuments appear to have been chosen specifically because of their historical and local significance. Images of more recent kings were treated as substitutes for the enemy king, their captivity reenacting his, as exemplified in the passage from the Assyrian annals quoted earlier in this chapter.

In Nineveh, statues of Taharqa, the Kushite ruler of Egypt, were excavated in the entrance area of the military arsenal. These statues may have been part of the spoils the Assyrian king Esarhaddon took when he plundered Egypt.[18] The royal inscriptions describe

the booty taken at the defeat of Taharqa in Memphis. Among a large assortment of artifacts, precious objects, and monuments, the Assyrian king also counted as booty Taharqa's queen, sons and daughters, physicians, and priests.[19] Three statues of Taharqa have been excavated at the Assyrian capital of Nineveh, and his scarab was found in the nearby city of Nimrud. The statues were displayed at the entrance of Esarhaddon's arsenal on Tell Nebi Yunis, just as the bodies, body parts, and severed heads of defeated royal enemies were exhibited at the city gates. The statues were identified by inscriptions on their bases. Ashurbanipal's records say that two obelisks were also taken from an Egyptian temple and brought back to Assyria, but these have never been recovered. The annals further state that the defeated Egyptians were later forced to send, among other tributes, fifty-five royal statues.[20]

The parallels between organic bodies, the corpses of defeated enemies, and their portrait-statues were used as a terror tactic and a form of magical violence that relied upon the blurring of boundaries between the body and the *salmu*.[21] The Assyrian annals describe several instances where the king displayed the heads or bodies of high-ranking, mostly royal, defeated enemies at the city gates. Ashurnasirpal II recorded a case where a flayed enemy's skin, rather than his severed head, was publicly displayed. Ashurdan II said, "I flayed the king of Katmuhi and draped his skin over the walls of Arbil."[22] In other cases, the statues of enemy kings and princes were exhibited in the same way, presumably as substitutes. These displays of high-ranking enemies' bodies and body parts at the city gates had the effect of instilling pure terror. The annals make numerous references to piles of severed heads, to impaled bodies, and to flayed skin spread on the walls of the city (see figs. 5.5 and 5.6).[23] Pieces of the corpse, especially the severed head, constituted proof of death, the annals state in several cases. Ashurbanipal received the corpse of Nabu-bel-shumate, preserved

in salt for the journey from Elam, along with the head of the man who killed him.[24] But these body parts also carried a threatening message to enemies and traitors about what their fate would be if they were to oppose Assyrian rule, just as Teumman's head was paraded around "to announce the good news."[25]

Human Booty and Biopolitics

The Assyrian accounts and inventories of booty register inanimate objects of material wealth, treasures made of precious stones and exotic woods, objects of the best craftsmanship, and the most valuable materials, but also cult statues of the gods, public monuments, and human beings. All these objects were counted on the same list of booty to be reviewed by the king.

In the image of Sennacherib reviewing the booty from Lachish (fig. 6.3), the king, holding a bow and a set of arrows, is seated on his exquisite ivory throne, his feet resting on an elaborately carved footstool. Below the seat, three carved rows of winged caryatids carry the throne. Behind him, servants whisk away flies and cool the back of his neck. The scene is set in rocky terrain, marked by the grape vines and olive groves of the eastern Mediterranean. The king watches the booty being brought to him: his troops carry forward objects made of exotic precious materials with excellent craftsmanship, but these are at the farther end of the procession. Directly before the king are his heir, the prince, and his valorous military officers, followed by groveling human beings, no doubt the local Judaean rulers who have capitulated to the might of the Assyrian king. The epigraph near the king's head describes the scene as the booty of Lachish passing before Sennacherib, so there is little reason to doubt that the people are included with the inanimate objects in the list. On the next relief panel from the same room (fig. 6.4), the scene continues: and we are shown civilians, women, children and men traveling by cart

175

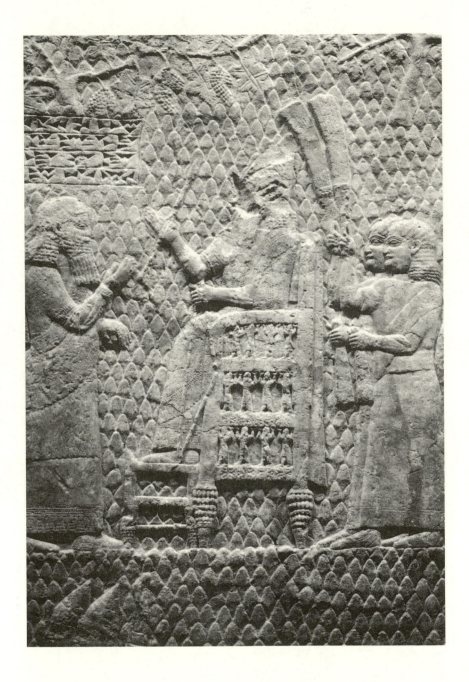

Figure 6.3. Sennacherib receiving the booty of Lachish, c. 700 BC. British Museum, London. Photo: Zainab Bahrani.

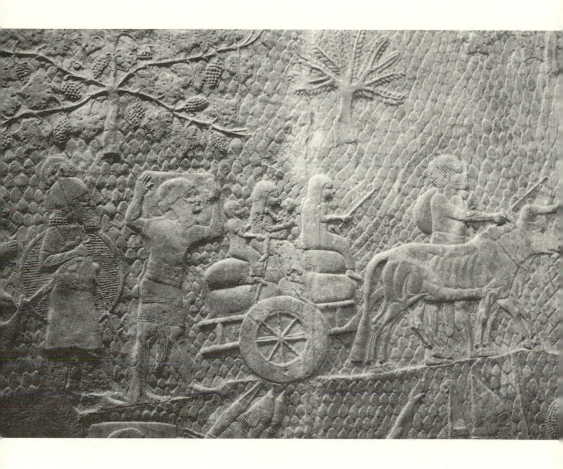

Figure 6.4. The people of Lachish deported, Nineveh, c. 700 BC. British Museum, London. Photo: Zainab Bahrani.

and on donkey-back at the start of their journey into exile. It is at the farther side of this procession of human beings that we see the soldiers carrying plundered objects.

The Lachish panels represent one of the better-known cases of mass deportation: the movement of a conquered Israelite population from Judaea to Mesopotamia. But mass deportation was a standard feature of war, not limited to any one population or region. Civilians were shuffled into Mesopotamia; the Babylonians were likewise dispersed into exile to various countries, in this case by Sennacherib. People, like objects and animals, were counted as loot, as property of the king. But human deportation was, at least in part, the uprooting of civilians as a form of punishment. That this form of punishment was considered a terrible hardship is clear from the textual record. The treaty between Aššur-nirari V and Mati'ilu of Bit-Agusi warns: "If Mati'ilu sins against this treaty, Mati'ilu, together with his sons, daughters, officials, and the people of his land, will be expelled from the country, will not return to his country, and will not behold his country again."[26] Curses calling for the exile and deportation of populations were invoked when treaties or oaths of state were broken. In addition, a number of terrible omens record the possibility of captivity or deportation.[27]

In Sennacherib's campaign against Hezekiah, the campaign record states that the army took more than 200,150 people, including men, women and children as well as mules, asses, camels, and sheep, all of which were counted under the category of spoils of war. Mass deportation was a standard feature of Assyrian imperial policy in the early first millennium BC, but it was not new. The large-scale deportation of civilians occurred in earlier periods in Egypt, the Hittite kingdom, and Mesopotamia itself.[28] In the Neo-Assyrian period, exile and deportation became a standard strategy of imperial expansion, domination of people, and

demographic control. But deporting civilians was, as it is today, also a means of geographic control, a reconfiguration of space in the vision of and for the aim of political power. While one cannot, strictly speaking, talk about ethnic cleansing in Antiquity, ethnicity being an unknown category to the Mesopotamians, the practice of moving civilians certainly was a deliberate and reasoned act of control. The deportees' bodies were not simply counted as fundamental units of work, although they were certainly tallied as commodities in the lists of war booty. The primary aim of deportation was not, it seems, to acquire bodies for slave labor, or to parade them as prisoners of war for their symbolic value (a form of triumphal display commonly used for the captured enemy elite). This uprooting was, in some respects, analogous to the destruction of orchards but belonged to a larger vision of territorial change. In some cases, the record states, the deported people were not taken to Assyria but reshuffled into the empire elsewhere, in the Levant or even Egypt. Sargon II stated that he had taken tribes of Tamud, Marsimanu, and Haiapa — "distant Arabs who inhabit the desert" — and settled them in Samaria.[29] Ashurbanipal recounted that on his fourth campaign he defeated Kirbit, in Harehasta. He took Tanda, the governor of Kirbit, into captivity in Assyria, but he deported the people of the city and resettled them in Egypt.[30]

People were taken with their possessions, dependents, and animals. They were not usually marched in shackles as prisoners or slaves, unless they were people of rank.[31] A number of letters written by military commanders in charge of deportees indicate that they were to be kept healthy and well fed. The ill were counted separately from the healthy, and reports on those who fell ill along the way were submitted to the Assyrian king. An inventory of war captives was sent to the king when the prisoners were first taken; in addition, army officers had to submit regular reports on

the captives' condition until they reached their destination.[32] After they arrived in Assyria, they were treated in the same way as the local population and were subject to the same taxes, since everyone belonged to the same populace under the king. The captives were considered the property of the Assyrian king and counted as booty. This is why, in the scene of the booty passing before the enthroned Sennacherib at Lachish, the local people grovel before him while the material objects are brought forward: these people, too, are counted as the booty of war.

Deportees were conscripted as a means of increasing the army's numbers; they were also used as laborers, for example, in building construction, and as craftsmen. There was no limit to what the deportees could be expected or required to do. In the army, they served as charioteers and horsemen, and were posted in logistical service units in camps and fortresses throughout the empire. They were even employed as the king's personal bodyguards.[33] The aim of the deportation, it seems, was not so much the acquisition of slave labor as the forced uprooting, deliberate dispersal, and at times even nomadization of settled communities. Since the city was the primary locus of identity and allegiance, exile was a harsh penalty for revolt. The urban and the civilized were more clearly synonymous for the peoples of the ancient Near East than they are in the West today. Deportation was a two-way street. Deportees from a conquered city were settled in a distant land, and their own city, ruined by war and mostly abandoned due to the forced exile, was repopulated by yet another dislocated population forced into exile by the Assyrians. Such a policy ensured that there was little opposition to Assyrian imperial territorial expansion, since the idea of a local population was systematically eradicated, not through mass killing of the civilian population, but through these reorganizations of land and populace.

One of the functions of war is the reconfiguration of space.

The reordering of space is not something that only occurs as territorial expansion, armies or colonizers taking land and occupying it. Space can be reorganized by moving things and people. Mass deportation reconfigures space, as does the destruction of orchards, buildings and cities.

The reordering of space (or, perhaps, space and time, if historical monuments are involved) is not only the seizure of land and the resulting imperial territorial expansion, or even the suppression and destruction of monuments. It is a production. It is a constitutive act. It creates a new space and a new world order that allows new social contracts and state formations. But the Assyrian empire may not have used these strategies of dislocation and delocalization as a means to an end, namely, a new geographical formation. It may have aimed toward dislocation as a permanent structure, using destabilization as a form of political organization similar to the current policies of global war.

The queries are systematic and thorough in listing the possible procedures and outcomes in the omens regarding war written in the body of the sacrificial animal. The question is put twice, once at the beginning of the tablet and a second time, repeated in the same words, at the end. These queries suggest that the god was asked about numerous possible strategies, and the god would respond. Sometimes these questions were extremely specific. Perhaps this is why modern Assyrian scholarship has often described these queries as tedious and repetitive. The ancient Assyrian haruspex covered all manner of potential procedures and outcomes. But this relentless repetition was never meaningless. Instead, it reveals a profound anxiety about coming events, an anxiety that lay beneath the external display of power and propaganda of an invincible Assyrian might.

"Will the troops escape from the enemy? Will the Assyrian army return alive? Will the king survive?" And after the conquest, within Assyria itself, "Will there be a rebellion and an insurgency? Will the cargo of the ship be plundered if it takes this course?" And then, "Should the king appoint so-and-so as an official? Should he admit so-and-so into his entourage? Should he give his daughter in marriage?" Finally — a number of queries ask — "Should the king take this medication?" These are the types of anxious questions put before the oracle of the sun god on behalf of the mighty Assyrian king.

The method of reading the exta is recorded in texts from much earlier times. The Old Babylonian instructions cover readings for the king and the army, as well as those for normal citizens. The instructions describe the markings or peculiarities of the exta in the protases, and the apodoses give the resulting meaning. For example, the vertical groove on the left lobe of the liver and the surrounding area are called "the view" or "the presence"; a number of readings are listed for the condition of the

that a clean or unclean person has touched the sacrificial sheep. Disregard that the ram offered to your great divinity for the performance of the extispicy is deficient or faulty, or that he who touches the forehead of the sheep is dressed in his ordinary, soiled garments. Disregard that I, the haruspex, your servant, am dressed in my ordinary garments, have eaten, drunk, or touched anything unclean, or changed or altered the proceedings, or that the oracle query has become jumbled and faulty in my mouth.[2]

The above query is not unusual, in that the diviner asks detailed questions about the activities of other rulers and armies. More often, however, questions are asked about ways for the Assyrian army to proceed, listing exhaustive possibilities for battle plans and strategies:

> Should Esarhaddon, King of Assyria, send Ša-Nabu-šu, chief eunuch, and the army at his disposal to take the road and go to capture the city of Amul? If they go and set up camp before the city Amul, will they, be it by means of war, or by force, or through tunnels and breaches, or by means of ramps, or by means of battering rams, or through friendliness or peaceful negotiations, or through insurrection and rebellion, or through any other ruse of capturing a city, capture the city, Amul? Conquer that city. Will it be delivered to them?[3]

> Šamaš, great lord, give me a firm positive answer to what I am asking you. Should Esarhaddon, King of Assyria, strive and plan? Should he take the road with his army and camp and go to the district of Egypt, as he wishes? Should he wage war against Taharqa, King of Kush, and troops which he has? If he goes, will he engage in battle with Taharqa, King of Kush, and his army? In waging this war, will the weapons of Esarhaddon, King of Assyria, and his army prevail over the weapons of Taharqa and his troops?[4]

Dynastic stele of Eannatum, the battle begins after Eannatum of
Lagash receives a dream omen from the patron god of his city-
state, Ningirsu. This dream message serves to justify the battle as
a defensible, just war and by means of the oracle the victory is
foretold as decreed by the gods. Two thousand years later, the
Neo-Assyrian queries were placed before the sun god, Šamaš,
usually along with another clay or papyrus document. The name
of the person, the name of the city or fortress about which the
query was made, or various details relating to the exact question
the haruspex-priest would ask on behalf of the king were all writ-
ten on this accompanying document. The document stipulated a
specific term for the efficacy of the request or the validity of the
answer to the question set forth. Would the result occur within
twenty, thirty, or ninety days, for example, or would it occur in
the more distant future? The documents also include a formula in
which the god is asked to disregard any possible mistakes or lapses
in the ritual procedure or in the formulation of the question that
could affect the answer to the query:

> Šamaš, Great lord, give me a firm positive answer to what I am ask-
> ing you. From this day, the 11th day Ayyar (II) of this year, to the 10th
> day of the month of Sivan (III) of this year, for thirty days and nights,
> my stipulated term — within this stipulated term, will Mugallu the
> Medean strive and plan? Will he mobilize a large and powerful army
> and mount an attack against Mannuki and the magnates and army of
> Assyria, who have gone to the city Ba[...], a fortress that Mugallu
> abandoned? Or will they ambush them or attack, kill, and plunder
> them? Will Esarhaddon, King of Assyria, become gloomy and wor-
> ried? Will he who can see see it? Will he who can hear hear it? Dis-
> regard what happens after my stipulated term. Disregard what they
> may speak with their mouths or what they think. Disregard the for-
> mulation of the prayer for today's case, be it good, be it faulty, and

Omens of Terror

I captured Susa, the great metropolis, the abode of
their gods, the place of their oracle revelation.

— Ashurbanipal*

The course of battle was determined by the gods. The Assyrian
faith or belief in destiny did not only consider the outcome or the
future a result of divine will. In fact, specific military decisions and
strategies were thought to have been handed down as oracles from
heaven. In a series of queries to the sun god, Šamaš, the Assyrian
king and his advisers determined the course to be taken in the bat-
tle. The most extensive records of such queries to the gods are
found in a series of texts that form part of a scholarly palace archive
from the first half of the first millennium BC. The queries are best
known from a group of texts from the reigns of the Neo-Assyrian
kings Esarhaddon and Ashurbanipal; however, inquiries to various
gods are also attested as early as a millennium before, in the Kassite
period (c. 1475–1155 BC) and in the Old Babylonian period (c.
1900–1595 BC). The earlier queries, known as *tāmītu* texts, have a
similar grammatical or semantic formulary to the Neo-Assyrian
omens. This similarity indicates that the Neo-Assyrian queries
were based on a long tradition of oracular military strategies, going
back to the beginning of the second millennium BC.[1]

In Chapter Five, we saw that in the earliest sculpture that can
be identified with certainty as a monument of war, the Early

* Royal annals of Ashurbanipal, Luckenbill, *Ancient Records*, p. 309.

presence when it relates to the army. The following instructions for reading the liver date to the reign of Samsuiluna of Babylon but they could have been referenced at any period, making the historical omens that describe the fate of the Akkad dynasty or Sargon I (2334–2279 BC) timeless messages:

> If the presence is seized tightly by red filaments, the fall of my principal diviner in battle.
>
> If the presence is seized tightly by black filaments, the fall of the population of the reed hut (southern Sumer).
>
> If the presence is seized tightly by white filaments, the army will return empty-handed.
>
> If the view is like the sign, HALLA: the end of the ruling dynasty.
>
> If the divination is performed for the armed forces: the fall of the army.
>
> If the view is like the ANA sign: the dynasty of Akkad is terminated.
>
> If the view is like a scepter: the weapon of Sargon. (victory).[5]

Other battle omens, called *têrtum*, could be read not through the sacrificial animal but by means of *egirrû*, random portents understood through chance occurrences or terrestrial omens. For example:

> If numerous eagles are repeatedly flying in front of an army on campaign, the downfall of the army will occur.
>
> If the army goes on campaign and a crow is repeatedly calling in front of the army, that army that went on campaign will not return.
>
> If a severed head laughs, conquest of the army.[6]

187

At times in the Neo-Assyrian queries to Šamaš, an entire compli-
cated battle strategy was drawn out on a papyrus and placed
before the god (in front of his cult statue in the temple). The
questioner then asked "Should this particular strategy, on this
document, be followed?" The strategy was not written out in
detail, like the other queries, but put before the god in the form
of a drawing or diagram. The god, in the guise of his cult statue,
observed the document and gave his response (whether positive
or negative) through the entrails of the sacrificial animal, which
was offered at the same time as the submission of the document
for divine consent. The oracle was described as having been writ-
ten (*šaṭāru*) into the body of the animal, just as other omens were
written into the sky or the city and could be read by the expert
seers, the *barû* priests. These diviners lived at court, but they
were also taken into battle. As early as the Old Babylonian period,
a diviner accompanied the king into battle: "The diviner Ilšu-
nasir, servant of my lord, will lead the troops of my lord, and a
Babylonian diviner will go with the Babylonian troops."[7]

The presence of the *barû* priest in military campaigns, repre-
sented by the image of a priest reading the omens, appears in bat-
tle reliefs beginning with the earliest versions of Neo-Assyrian
royal art at Ashurnasirpal II's palace in Nimrud (883–859 BC) (fig.
7.1). In a relief depicting war scenes from this king's campaigns, a
priest in a military camp is shown leaning over an altar, in the
process of examining the entrails of a sacrificial animal (fig. 7.2).
In a detail within Sennacherib's relief series of the battle of
Lachish, priests before an altar also appear within the military
camp. Similar scenes of priests at camp appear in battle reliefs
from the reign of Sargon II.[8] In most of these scenes, priests stand
in front of an altar, a high, table-like object with animal legs carved
as its support. The priests wear tall headgear. A rounded *dinos*-like
vessel is in some cases set in front of them on a stand. These orac-

ular consultations and requests for signs of sanction from the gods
at the moment of battle were a necessary step in justifying war and
ensuring victory through the approval of the war by the divine.
But the inexhaustible listing of omens and queries regarding war
in every arena, terrestrial and celestial, chance events, and spec-
ified queries were not just a means of recruiting divine favor for
the Assyrians. These catalogued battle omens and strategic queries
reveal an intense anxiety and unease about deciding the tactics
and strategies of war.

The Destiny of Weapons

War was launched by the king, but it was also the will of the gods.
It was an ordeal by battle in which the gods' verdicts emerged as
the triumph of the victorious. On some level, even weapons were
seen as the instruments of divine purpose. Bows, maces, and
blades were sometimes deified and named. This practice was
recorded as early as the third millennium BC, when weapons were
given names and made divine through ritual incantations. Weap-
ons were also given to the gods as votive offerings as early as the
third millennium as numerous votive inscriptions and objects
found in sanctuaries indicate. For example, Gudea dedicated a
"mace, lion-headed weapon studded with hulalu stones," to the
Eninnu sanctuary.[9] A Babylonian scholarly work called *The Weapon
Name Exposition* reveals a good scholarly knowledge of the older
Sumerian tradition of the signifying power inherent in the weapon
names.[10] This work connects Sumerian phrases with weapons by
means of a philological reading that manipulates Sumerian and
Akkadian lexical equations and homophones in order to demon-
strate the relevance of each name to its weapon.[11] The text begins
with the names of the constellation Libra and the planets Saturn
and Mercury. These are followed by the names of divine weapons
in Sumerian. The names of the Sumerian gods or weapons are

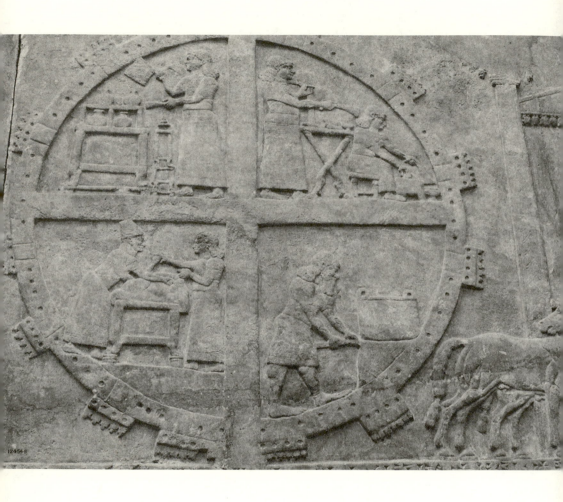

Figure 7.1. Priest performing extispicy in a military camp, Nimrud, ninth century BC. British Museum, London. Photo: Zainab Bahrani.

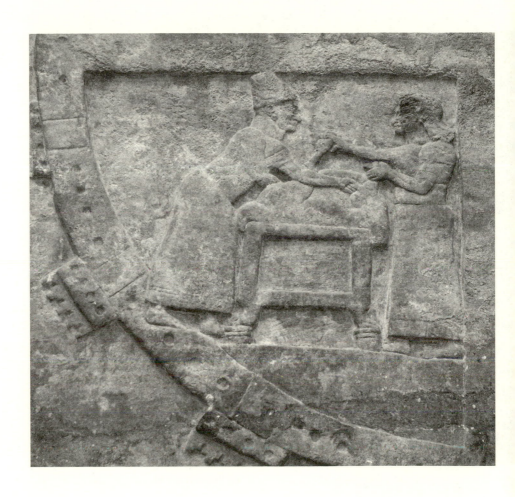

Figure 7.2. Detail of fig. 7.1.

paired with Akkadian interpretations or translations that work through semantic and hermeneutical readings. The weapon names listed include the following:

That which Throws Down a Multitude
That which Slays a Multitude
Fifty-headed Weapon
Fifty-headed ME (archetypal) Weapon
Lion-headed Weapon
Relentless Storm
Enemies Lack Its Strength[12]

In this list, a divine weapon's signifying power is carried in the polyvalence of its name. Thus "Lion-headed Weapon" is also "Radiant Weapon" because of a play on the similarity between *nimru* (small lion, leopard, or cheetah) and *namru* (radiant).[13] Divine weapons are mentioned in myths and religious narratives; named weapons are known from as early as the third millennium BC. They carry a power that is both associated with a particular god of the pantheon and is divine in its own right, as a separate entity. The ritual naming of the weapon was no doubt an effective act. As a result, the weapon's name carried potential strengths and capabilities that were then considered inherent in the weapon itself. This kind of belief in the power of named weapons is not unlike the well-known medieval Islamic and Christian examples of named and inscribed swords or blades.

When weaponry is depicted as an attribute of a king or hero, there is more than likely a reference to a particularly powerful weapon. In the Victory Stele of Naramsin, the divine king holds the combined power of the bow and blade — the piercing weapon and the cutting weapon — controlling the technologies of warfare, the types of weapons in use at the time. Neo-Assyrian depictions

of the king with his personal dagger inserted neatly inside his elaborate and jeweled belt are also significant. This dagger is never a simple blade: we can see the animal head protomes on the hilt; the decorated sheath; and the handle encrusted with gemstones. All these details were more than decorative. They were key in the manufacture of royal weapons and were laden with significance in their material, method of manufacture, and figurative iconography.

Similar values seem to have been ascribed to military equipment, such as chariots and battle standards. Such standards often appear in the sculpted Neo-Assyrian battle reliefs (fig. 7.3), as well as in much earlier images of battle. The Victory Stele of Naramsin shows Akkadian troops carrying tall standards with heraldic and divine emblems (see fig. 4.1), and similar standards appear in reliefs from the third dynasty of Ur. In the first millennium BC, different divisions of Assyrian troops, each with its own patron deity and designated standard marched into battle. For example, a text mentions Nergal/Erra on the right and Adad on the left, and the chariots of Nergal and Adad.[14] Texts describe the gods' chariots as accompanying the king into battle and images of deity emblems are represented in the Neo-Assyrian reliefs of war hovering over the chariot of the king as warrior (see figs. 7.3, 7.4, 7.5).

The chariots themselves had attached deity-emblem protomes, which were at once heraldic and apotropaic. The lion protomes of Nergal, the bull-headed attachments of Adad, the emblem of the archer god Ninurta, a winged disk bearing the god Aššur, and Ishtar in a medallion in the form of a star-nimbus all appear on Assyrian war equipment (see figs. 7.4 and 7.5). The yoke poles of the chariots to which the harnesses were attached are depicted with the rosette and star-nimbus of Ishtar, the crescent moon of the moon god, Sin, and the Sebitti, the seven warriors, as well as

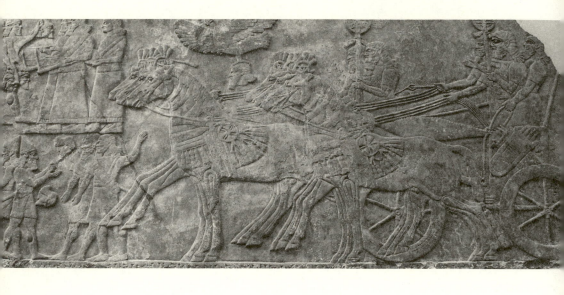

Figure 7.3. Ashurnasirpal II war relief, Nimrud, 883–859 BC. British Museum, London. Photo: Zainab Bahrani.

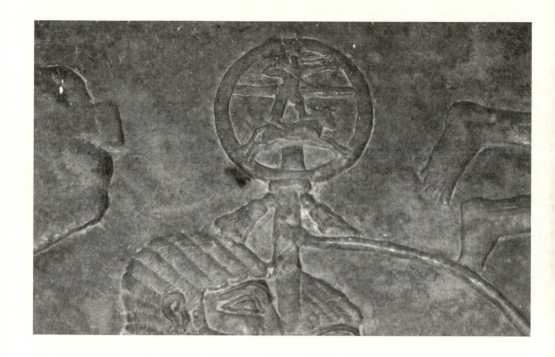

Figure 7.4. Ashurnasirpal II war relief, Nimrud, 883–859 BC. British Museum, London. Photo: Zainab Bahrani.

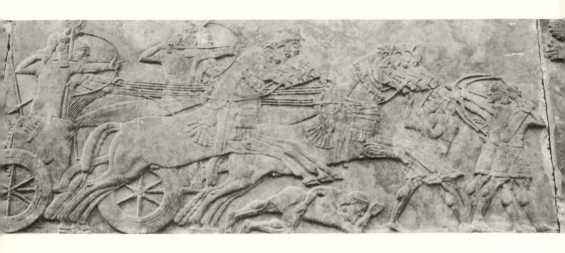

Figure 7.5. Ashurnasirpal II war relief, Nimrud, 883–859 BC. British Museum, London. Photo: Zainab Bahrani.

dragon-headed and bird-headed protomes. These types of emblems appear not only on chariots but also on the standards that are represented in battle reliefs.[15] The gods traveled in chariots. When the cult statues were transported by land, it was in special vehicles, and some references to the gods' accompanying the troops at war may mean that the cult statue was taken into the battle.[16] The chariots of the gods were part of a military display that made a spectacle of power, which was integral to the tactics of war. The gods mediated the decisions of war by means of the omens, and they provided the vehicles and the weapons, which had to be purified (*elēlu*) before and after battle.[17] As in the Roman postbattle rituals, the expiation of the blood of battle was a concern, just as the defensibility of the campaign as a just war was of the greatest importance to the king and court. When battles were lost, troops killed, or home cities destroyed, these disasters only occurred because the gods had decreed them as just decisions.

Scapegoats and Substitute Kings

The king was the commander in chief, the leader of the army, but he followed the decrees of the gods, whose will was made known through omens and oracles. At least one *barû*-priest marched in the vanguard with the troops, and every military plan was checked against the omens before being put into effect. The omens were taken and corroborated by means of other omens in a series of observations and repetitive queries. The corroborating omens were taken from other forms of portents — from Astronomical observations, from dream interpretation, chance portents, and so on.

It is clear that the omens were taken seriously; they were not propagandistic acts for repression or coercion of the people but part of a religious ideology to which the king himself submitted. The same system of belief resulted in the ritual of the substitute

king, in which violence and evil were localized into the body of the substitute as scapegoat. In this distinctively Mesopotamian ritual, the king was provided with a substitute (*šar-pūḫi*) when astronomical omens spoke of an evil fate for the king that would affect the entire kingdom.

The substitute king was a citizen carefully chosen for this role by the priests. He was never a prisoner or a slave. He was dressed in the king's regalia and made to submit to a series of ritual incantations naming him as the king in an incantational utterance, and also by means of inscribing the name of the king onto his person. The name was either written onto something that was attached to his garment, or alternatively, the name was written onto something that could be ingested by the substitute. In either case, in order to be incorporated, it appears to have been important that the name was both uttered and written into the body of the substitute king. When the imminent evil finally came, it was expected to leave the previous-real king unharmed, the substitute king having become the decoy that would absorb the evil fate in his place. In some cases, it appears that the substitute was in fact killed as the final part of this ritual, but the texts are unclear on the matter, and the question of sacrificial death remains open. In one instance, which occurred in the nineteenth century BC, the (first) king, Erra-imitti (1868–1861 BC), seems to have died while the substitute, Enlil-bani (1860–1837 BC), was still functioning in his place as the virtual monarch, so that the substitute continued as king, taking the place of the deceased original.[18]

Whether the substitute king was — occasionally or usually — ritually killed or not, there was certainly a human sacrifice here, even if it need not have resulted in death in every case. The sacrifice of the substitute, who is also referred to as the body-double (*ṣalmu*) in the ancient texts, is clear because it was nevertheless the sacrifice of a life, a submission of a life before destiny and the

gods that entailed the possibility of death. Whatever the total process may have been, this was not a rite to which the Mesopotamians often turned. It had no regular or repeated place in the Babylonian or Assyrian ritual calendar of feast days, nor was it a standard feature of war ritual, like the queries to the sun god. It seems to have been a last resort in the attempt to avoid the portentous terror read primarily in the astronomical omens. While the violence was to some extent predicted for the king himself and his reign, it also concerned the entire land. As we have seen in our discussion of the seventh Elamite campaign in Chapter One, Teumman's reign ended after a lunar eclipse, but the eclipse specified the defeat of the land of Elam, not only the death of the king.

This conception of the king's possible demise, as predicted in omens, recalls the logic of the sacrifice of scapegoats as described in anthropological theories of sacrifice. In this logic, guilt is projected onto and localized in the scapegoat, whose sacrifice then allows the reestablishment of social order. According to this explanation of sacrifice, the victim is never killed as something horrible. Rather, he gains some aura of sanctity. The victim, therefore, has to be acceptable to the gods.[19] In the Mesopotamian ritual, it was especially important that the substitute king be suitable for this critical replacement since the process could have great consequences for the land.

When the Assyrian letters mention this substitution ritual, there seems to be some anxiety about the correct procedure for enthroning the substitute and the exact reading of the omens that called for the substitution in the first place. In one case, the scribe Balasî writes to the king Ashurbanipal regarding the difficulties of interpretation. In another case, the court exorcist asks for additional scholars, philologists who were expert in the Sumerian language in order to read and interpret the omens as accurately as possible. The question arises whether the substitute should be

enthroned or not. And when the decision is taken, there is still a procedure to follow:

> Concerning the substitute king of Akkad, the order should be given to enthrone him. Concerning the clothes of the king, my lord, and the garments for the image of the substitute king, concerning the necklace of gold, the scepter and the throne.[20]

The court maintained scribes and scholars, diviners, and exorcists whose names and activities we know rather well for the Assyrian period. These experts were employed for the preservation of historical knowledge and for the development of scientific inquiry. Neo-Assyrian sources record that court scholars were involved in activities that were both religious and political. During the height of the empire, these scholars were responsible for celestial observation and research. They had to know what to watch for and when, as well as how to find the corresponding prognostication in the scholarly texts. Then they had to decide which would be the best course of action to follow in terms of ritual and magical procedures. Another group of scholar-priests was in charge of sacrifices and extispicy on behalf of the king. But the expert scholars were not just responsible for astronomical and divinatory omens. They were scholars who were broadly trained in the sciences and the scribal arts. In addition, they held important advisory positions to the king.[21] These activities appear to have been more distinctive at the height of the Neo-Assyrian empire than any other period in Mesopotamian history. In the later Babylonian period, for example, the center of astronomical scholarship moved away from the palace to the temple, in separate academies called *bīt mummu*. It seems still to have been based close to the temple during the Achaemenid period, although the records from this era are few, but the temple reemerged as the scholarly center in post-

Achaemenid Babylonia. This change of scribal workplace from palace to temple did not end the rituals of political divination, even if it did allow scholarship to develop in other directions at the same time.[22]

The Image of War, Severed Heads, and Sacrifice

The practices of omen reading, ritual substitution of organic body or image, the theft and mutilation of images and ancient monuments, and, consequently, the reliance on curse formulas as a deterrent all carry a sense of profound anxiety. In observing the composition and pictorial imagery of the Til-Tuba battle relief as a work of art (see Chapter One), we can see a similar sense of anxiety like that which can be observed in a reading of the queries to the sun god. The repetition of elements within the composition, the interweaving of the head within the scenes of battle in the midst of the narrative, and the constant reemergence of the decapitated head seem almost compulsive. The relief depicts the historical Battle of Til-Tuba, but the primary subject of the composition is no less the king's severed head than the battle. Or perhaps it is better to say that the battle, as a narrative, was about the king's head; the king's head was its target, and the battle can be described as a head-hunt.[23] The parallel with the animal sacrifice is drawn in Ashurbanipal's remark likening the head to an offering before the city and in the libation to be poured over the head, the severing of which Ashurbanipal claims to have been decreed in a historical omen:

> I, Ashurbanipal, King of Assyria, presented the head of Teumman, King of Elam, as an offering in front of the gate inside the city. As it has been said of old by the oracle, "You will cut off the heads of your enemies; you will pour wine over them."[24]

The presentation of Teumman's head described here — its submission as an offering — parallels the treatment of animals captured in the royal hunt. Hunting panels with scenes of libations poured by the king over the killed animal were also depicted on the palace walls of the Assyrian kings. Written accounts described similar events. A poorly preserved scene from Nineveh that has been identified as taking place outside the temple of Ishtar in Arbil may be an image of a libation ritual in which Ashurbanipal pours wine over the head of Teumman, just as libation offerings were poured on dead lions.[25]

The narrative theme of the head-hunt and the sacrifice of Teumman of Elam is interesting. This cannot have been the standard practice for prisoners of war or even the normal treatment for enemy kings, despite Ashurbanipal's remarks regarding the oracle that predicted, "You will cut off their heads; you will pour wine over them." Defeated enemies were pitilessly relocated, tortured in heinous acts of revenge, and violently killed; their bodies were desecrated and denied proper funeral rites; but sacrifice is different. Sacrifice has an overtly religious character.

A text of Aššur-nirari V of Assyria (754–745 BC) concerning a treaty with a Syro-Hittite ruler contains evidence of a remarkable ritual that enacts the threat of a curse that will operate if the oath and treaty are broken. The ritual, which is in some sense one of substitution, seems to have been carried out during an animal sacrifice. It has the performative quality of an incantational utterance: "This head is not the severed head of a ram but the head of Mati'ilu ... should Mati'ilu break these agreements, his head should be cut off, just as this head of the ram has been cut off."[26] The sovereign's right to manage and direct violence and his power over the lives of others are god-given. Mystical and military effectiveness are linked. Teumman's head may have been treated like a sacrifice, offered to the gods and dowsed with liba-

tions, but this was no favored victim given the honors of a proper animal offering or even a substitute king. This is not a typical sacrifice in which, to render the victim sacred, "it is necessary to separate it from the realm of the living; it is necessary that it cross a threshold that separates the two universes."[27] That definition applies to the substitute king but does not seem to apply to the severed heads and other body parts of the defeated enemies that were displayed on city walls and gates. Was Teumman's head presented to the gods differently from those of other victims of war?

Beyond the narrative of the historical event of the defeat of Teumman, the head and its repetition in the Nineveh panels become signifiers in the economy of sovereign power and bare life. In Giorgio Agamben's philosophical analysis of power *Homo Sacer*, sovereign power founds itself on bare life; "sovereign violence is in truth founded not on a pact but on the exclusive inclusion of bare life in the state."[28] It is the dimension of absolute violence over bare life that is the immediate referent of sovereign power. The ability to control the means of violence over bare life outside the juridical boundaries that apply to common man constitutes sovereign power as exceptional (see Chapter Four). The head's reemergence across the relief becomes such an image-sign, a referent for sovereign violence by means of the dimension of bare life.

The relief's account of the Battle of Til-Tuba is unusual in that both the written narrative and the pictorial image focus on Teumman's head. Such close parallels are not generally found in Neo-Assyrian sculpture. In the Assyrian war reliefs carved on the palace walls, the king does not dominate the battle scenes by his size, action, gesture, or position within the narrative.[29] Ashurnasirpal II says that his conquests are his *šīmtu*, the destiny allotted to him at birth. When a city was devastated by war, that too was explained as the result of a divine decree, even if that city was

Mesopotamian, and the divine decree was acknowledged in a lament sung after its destruction (see Chapter Six). While the Assyrian historical texts and palace reliefs do not depict a defeated Assyria, it is not the case (as one often reads) that the Mesopotamians never acknowledged defeat in war. Some of the most moving literary texts that survive from Antiquity address the aftermath of a defeat in war, the chaos that ensues when a government has fallen and the land remains lawless. The Assyrian palace reliefs that depict wars do not glorify the king as an individual in any obvious way. It is the Assyrian army that is victorious and heroic. The Assyrian king is not singled out as Naramsin was distinguished in his victory stele as the divine warrior king, or as Hammurabi was singled out as the one who controlled and directed the law on behalf of the gods. Without some proficiency in the iconography of Neo-Assyrian art, it is difficult to locate the king in narrative scenes of battle. Pictorial images of Assyrian wars thus differ from the written accounts, in which the king, in a first-person narrative, takes credit for the main events of each campaign. What explains this divergence? The function of each, the text and the palace relief, was different. The written accounts of the campaign are known primarily from inscriptions on clay documents known as historical prisms. These texts were written and buried as foundation deposits for posterity. The palace reliefs were visible to the members of the Assyrian court and to visiting foreign dignitaries. The reliefs also bore inscriptions, but these were not copies of the buried historical prisms made public and visible.

The reliefs are architectural sculpture. They are part of the fabric of the elaborate construction of the palaces, a process that included consultations with exorcists and diviners as well as architects and engineers (see Chapter One). Architectural rituals for palace construction required the use of bitumen at thresholds,

the burial of magical figurines, and the incorporation of protective demons into the structure. Clay figurines, sometimes inscribed, were buried in corners and protective beings were carved onto walls.[30] In the first Assyrian royal buildings bearing sculpted reliefs — the Northwest Palace of Ashurnasirpal II and the temple of Ninurta at Nimrud — protective images appear: anthropomorphic figures in fish clothes, human- and eagle-headed figures, and multiwinged anthropomorphic figures. The placement of these figures on the walls was more than decorative. In Sennacherib's palace, they were also placed on the doorjambs. These images of supernatural protective creatures are the same type of apotropaic image as the foundation figurines. Their positioning in passageways seems to have been as important as it was in threshold areas. Fish- and eagle-headed *apkallu* appeared across walls, as well as in foundations. *Lahmu* and *ugallu* figures appeared on doorjambs, and the seven *Sebitti* identified with fate and the Pleiades stood in an entrance from Court O to Room I in at the North Palace of Ashurbanipal at Nineveh. None of these was simply decorative or narrative in function. All the figures were carefully placed in specific positions in relation to the architecture and the image of the king. They had magical and apotropaic functions beyond the narrative.[31] At the same time, as Mehmet-Ali Ataç rightly points out, their appearance on the palace walls was also a way for the elite to surround itself with the otherworldly.[32]

In Ashurnasirpal II's first palace at Nimrud, his standard inscription was repeated on every slab and in several rooms. Some slabs even have inscriptions on their backs. The inscriptions condensed the accounts of his conquests, prowess, and lineage into a repetitive formulation. This kind of repetition has generally been dismissed as public aggrandizement of the king, but this interpretation disregards both the reliefs' pictorial methods and their function, which worked with the architectural fabric in ways that

made the building a palace not just in external appearance, as a symbol of power, but technologically, for the internal performative logic of the building. The historical accounts of the campaigns of war inscribed onto prism texts that were created in order to be interred as foundation deposits are also often described by modern scholarship as being primarily propagandistic in function.[33] This limited, restrictive interpretation is inadequate. It does not consider the nature of the historical source material. It does not take into consideration the text as an artifact, its archaeological context, or its ancient function and use. As a result, the relationship of ritual and politics in Mesopotamian Antiquity has been understood as an interaction between two completely and logically unrelated areas of social behavior.[34]

The magic of the state, especially during the Neo-Assyrian Empire, was a significant dimension of the functions of political power and military practices. It allowed for the authority of the king as sovereign, with a liminal character beyond the common man, sanctioned by the divine, and sometimes even a king who was himself divine in nature. It allowed the king as a biopolitical category marked by somatic signs. It also permitted the *casus belli* and validated the war as defensible and just in every case, a *bellum justum* for the sake of civilized order and peace. But these notions of sovereignty and *bellum justum* are not expressed in the text solely or primarily for coercive propaganda, nor did these ideas rest on the religious alone. They depended on a combined juridico-political and biopolitical structure of power. The records of war and its rituals are not documentary historical accounts, if by that we mean truthful, objective descriptions of an event. Yet they are documentary in that they are primary sources for the processes of power in Antiquity and for the way in which state violence, the biological, the law, omens, and the divine come together in the service of the war machine.[35]

CHAPTER EIGHT

The Essence of War

> You (have become) master of all the earth, lord in the
> land,
> You convulse the sea, (you) obliterate mountains,
> You rule over humans and herd beasts.
> The primeval sanctuaries are now in your hands.
> You (have taken) control of Babylon and command
> (its most sacred precinct) E-sagila.
> You have gathered to yourself all authority.
> — Kabti-ilani-Marduk*

> In every respect the war machine is of another
> species, another nature, another origin, than the
> state apparatus.
> — Deleuze and Guattari†

One of the epic texts of Mesopotamian literature is the Erra and
Ishum epic, a narrative poetic portrayal of violence written in the
Akkadian language. This epic, like the tradition of the city lament,
is an early philosophical contemplation of the nature of violence
and the force of war. The author, who signs his work with his
name Kabti-ilani-Marduk of the family of Dabibi, lived in the
eighth century BC and wrote about the horrors and violence of war
that he must have seen and experienced and which he portrayed

* Foster, *Before the Muses*, p. 900 (translation emended).
† *A Thousand Plateaus*, p. 352.

not as a contemporary account of Assyrian warfare but by means of allegories and the mythological tradition.[1] He attempts to come to terms with and to explain the force of violence and the desolation wrought by war. In this way, the epic explains war as a force more powerful than any other, a mechanism which is a brute compulsive drive that destroys everything in its wake; showing that all creation — the world, every human or divine thing, the organic and inorganic — falls victim to its destructive power. Erra, the war god, takes over the land and wreaks senseless havoc, sparing nothing and no one from his violence and desolation. The technological force of violence in war is described as belonging to the realm of seven powers, "The Seven," mythical creatures created by Anu, the sky god, and the earth. Anu calls the Seven before him to ordain their destinies:

> He summoned the first to give him instructions:
> "Wherever you go and spread terror, have no equal."
> He said to the second, "Burn like fire, scorch like flame."
> He commanded the third, "Look like a lion,
> let him who sees you be paralyzed with fear."
> He said to the fourth, "Let a mountain collapse when you present
> your fierce arms."
> To the fifth, he said, "Blast like the wind,
> scan the circumference of the earth."
> To the sixth, he said "Go out everywhere like a deluge and spare no
> one."
> The seventh he charged with viperous venom, saying,
> "Slay whatever lives."[2]

After Anu (the sky god and a prime mover in the creation) had ordained the destiny of the Seven, he gave them to Erra, warrior of the gods, saying, "Let them go beside you. When the clamor of

human habitation becomes noisome to you and you resolve to wreak destruction, to massacre the black-headed people (the Mesopotamians) and fell the livestock, let these be your fierce weaponry, let them go beside you."

The Seven are weapons, but they are not simply blades or bows. They are the technologies of war through which the war machine becomes materialized; they are thus fundamental to Erra, who clearly embodies the abstract force of war and violence.

Perhaps the passage that most effectively portrays the mythic dimension of war is the first-person self-praise of the war god:

> I obliterate the land and reckon it for ruins,
> I lay waste to cities and turn them into open spaces,
> I wreck the mountains and fell their wildlife,
> I convulse the sea
> And destroy its increase.
> I bring the stillness of death upon swamp and thicket,
> Burning like fire.
> I fell humankind, I leave no living creatures. . . .
>
> I make omens unfavorable,
> I turn holy places into foraging grounds,
> I let the demon "upholder of evil" into the dwelling place of the
> gods,
> Where no evil should go,
> I devastate the king's palace and turn it into a ruin.[3]

Ishum, an adviser, tries to reason with the war god by pointing out his terrible acts:

> They have torched the sanctuaries of Babylon
> Like marauders of the land,

209

You (Erra), the vanguard, took their lead.
You aimed your shaft at the innermost wall.
Woe, my heart, it exclaims.
You flung the seat of Muhra, its gatekeeper,
Into the blood of young men and girls. [4]

War, the main subject of the narrative, is depicted as a force that can destroy civilizations and even the universal order decreed by the gods. But war takes over order, stealing in through the legal system of rule.

The epic relates how the war god takes the supreme throne as substitute ruler when the mighty Marduk, patron god of Babylon, must leave it temporarily. But this was Erra's plan. He finds a way to make Marduk leave his dwelling place in Babylon, an act that will inevitably bring about desolation for his people. This usurpation of the throne works according to the formal procedure of ceremonial royal substitution, a well-known ancient Mesopotamian rite. As shown in the previous chapter, in times of crisis, the king relinquished the throne and a substitute king, chosen from among the people, was crowned in his place, so that the king would not be harmed by the evil portents predicted by the omens. The substitute became a decoy into which the evil omens would manifest. This event was always a state of exception.

Erra "remorselessly plotted evil, to lay waste to the lands and decimate the people" for the sake of violence itself. War, then, is its own end, not a means to anything else. It is portrayed as a self-perpetuating machine that is in some sense in opposition to the urban state and civilized life yet comes to be annexed into state violence nevertheless.

Early in the epic, Marduk's cult statue is damaged and must be repaired. During that time, the vacuum in rule is filled by the war god. In this section, the poet beautifully describes the exceptional

situation that leads to war. In the Erra epic, it seems clear that it is
a state of exception that permits war to take over the city and the
land. War, then, is described as outside the normal situation of
civil order. It is a phenomenon in itself, like the war machine.

Marduk knows that the war god is going to wreak havoc and
desolation, and Marduk remains a deity, albeit in occultation and
out of commission for a time, but somehow the power of war is
able to threaten even the realm of the gods. War is abstracted and
personified as a god who is supremely powerful, even beyond the
pantheon of the gods. When Marduk sees what war has done to
his land, he weeps:

> Alas for Babylon,
> Whose crown I fashioned, luxuriant as a palm's,
> But which the wind has scorched.
> Alas for Babylon,
> That I had laden with seed, like an evergreen,
> But of whose delights
> I could not have what I hoped for.
> Alas for Babylon,
> That I tended like a thriving orchard,
> But whose fruit I could not taste.
> Alas for Babylon,
> That I suspended like a gemstone seal
> On the neck of the sky.[5]

The cult statue of Marduk figures quite prominently in the narra-
tive. It is directly due to its removal and damaged condition that
war is able to take over the land of the civilized — the cities and
urban centers. This poem is usually described as a hymn to the
war god or an epic about the dichotomy of chaos and civilization,
the destruction of urban life by the uncivilized. However, it is

fundamentally about the force of war. It is not a glorification of war but an expression of a fear of war, and a lamentation over its terrible and relentless force which spares nothing and no one in its path. It is in the tradition of the ancient Sumerian lamentations for cities, but it is even more worldly than those, because of the force of its descriptions of how the havoc of war destroys everything in its wake, how even the gods fall before the relentless march of the war machine.[6]

The Paradox of the War Machine

The war machine — to borrow a term from Gilles Deleuze and Félix Guattari, in order to elucidate the abstraction of the essential force of war as it was understood in Mesopotamian Antiquity — is directly linked to all the political institutions, cultural beliefs, and ritual practices discussed so far. These practices and rituals of war and violence are the ontotheological domain of war. In Deleuze and Guattari's terms, this machine is nomadic, in that it is outside the state order. The state sometimes appropriates or annexes it into the state's violence or into Repressive State Apparatuses.[7] The war machine and its rituals remain in a separate space and time. That is, war is outside daily life; it belongs to a time like that of ritual and festival.[8] But even if the war machine is a "pure form of exteriority" and must not be confused with the repressive violence of the state, it is nevertheless an exteriority or transgression that supplements the violence of the state. This relationship of exteriority is difficult to conceptualize. It has the same paradoxical formulation as that of sovereign power, in that it is both inside and beyond the law. War is appropriated as a Repressive State Apparatus but remains outside state power proper and outside the law. To kill in war is appropriate and sanctioned. It is not a punishable act. It is a transgression that forms an exception to the normal order of things and to the law. The war machine

falls between the juridical and the theological; it intersects with and connects them. But it exists only in its own metamorphoses, in industrial and technological inventions, in religious and militaristic rituals.[9] It exists in its own strategies and logistical needs.

The Assyrian kings of the early first millennium BC not only annexed the war machine into the Repressive State Apparatus, but also appropriated it into the state in ways that were extensive. The war machine of the Assyrian empire became the armature of absolute sovereign power. Visual images of violence, rather than expressing this power as the sovereign's ability to deal the death blow, that is, his right to determine the life or death of the other, showed the king as no longer performing such acts. This is a subtle but significant change from the images of earlier times, such as the Victory Stele of Naramsin. At first, it may seem to be a less powerful message for the Assyrian king not to be depicted as personally defeating his enemy or trampling the bodies of the dead. The king was depicted as expressing his prowess and virility by hunting lions or wild horses, not by torturing or executing prisoners of war. He was not shown standing on the corpses of his enemies like Naramsin. In the most egregious images of violence and torture, of tearing apart limbs and impaling and flaying the bodies of defeated, the Assyrian king relied on the military to torture, to deal the blows, to move populations, to destroy or relocate monuments, and to reconfigure space. It was through his military corps that he wielded the weapon and dealt the blow: the military had become a weapon in the hand of the king. Yet the weapons of the war machine are both destructive and productive. They destroy, obviously, but they also produce victory and absolute power.

The Body and Power

In the first volume of *The History of Sexuality*, Michel Foucault formulates a theory of biopolitics as the very essence of the form

that state power takes in the modern era. Organic life is annexed into the machinery of power; life itself becomes amalgamated into the repressive and ideological apparatuses of the state. Foucault presented a case for distinguishing sovereign power based on juridical models and repressive state apparatuses from biopolitics, as a calculated control of organic life within the processes of power. In the Foucauldian analysis of biopolitics as the modern form of power, the docile body and technologies of self-discipline are forms of voluntary servitude that are separable from the model of sovereign power as embodied in the king.

Giorgio Agamben reconceptualizes Foucault's division of sovereign power and biopower (or "anatomopolitics") into one realm, arguing that the juridico-institutional and the biopolitical cannot be separated. Agamben looks at the point of intersection of the two to investigate the workings of power. For Foucault, these divisions can be charted in time. They become markers of the premodern and modern workings of state power. Agamben states that the line of thinking that leads to the intersection of the two is logically implicit in Foucault's work; in his own treatise on power, he argues that the two analyses cannot be separated and that "the inclusion of bare life into the political realm constitutes the original — if concealed — nucleus of sovereign power. *It can even be said that the production of a biopolitical body is the original activity of sovereign power.* In this sense, biopolitics is at least as old as the sovereign exception."[10]

The magician-king and the jurist-king are the two ancient and mythical poles of political sovereignty defined by Georges Dumézil.[11] In Mesopotamian Antiquity, sovereign power is formulated and expressed in a number of monuments that move back and forth between these two formulations of kingship, taking up one strand or another of the hybrid substance of sovereignty. The development of the public monument in Mesopotamia

in the third millennium BC coincides with these formulations of sovereign power and its dependence on the juridical, the biopolitical, and the performative magic of ritual. Life, the body, and violence sanctioned by the letter of the law intersect most obviously in two of the best-known monuments of ancient Mesopotamia: the Codex Hammurabi and the Victory Stele of Naramsin. Monuments such as these outline the relationships between the law and the body and between the king and power — relationships defined by means of the lives of others. Just as the tortured body somehow produces the text of the law or its capabilities as an assertion of rule, the king's head in the Battle of Til-Tuba relief produces the text of Assyrian imperial power. As in the images of torture, there is a transformation of the body into the sign of the potentialities of power.

Just War and Monuments

The right to punish in torture and execution is an extension of the sovereign's right to wage war.[12] War is portrayed as an exceptional, if necessary, activity. In Antiquity, even when the war machine was annexed as a juridical instrument in the service of sovereign power, it always had to be carefully considered and justified. No hard-and-fast rules permitted war in Mesopotamian Antiquity. Each case was reasoned as a just war for moral and ethical reasons. That is why the gods were consulted to justify wars and plan strategies. Omen reading was calculated as part of the logistics of war. Priests were taken into battle, animals were sacrificed, and their entrails were read. These rituals were meant to magically ensure victory and protect and strengthen the king's šīmtu, his destiny. But the rituals were also the basic mechanisms of the war machine and state violence. Sovereign power and the power of the state were not just formulated in the realm of what we might consider the rational. Archaeological theories have

emphasized bureaucratic rationality as what defines the formation of the state, but state and sovereign power also base themselves in their own supernatural rituals.

The quintessence of sovereign power was captured magically in the public monument. That is why wars were waged over those monuments. The capture or destruction of monuments was strategic to warfare. These psychological operations rested on the magical or supernatural. The semiotics of war and power are fundamental to the war machine. The monuments are invested with political power — but that is not all. They have to be seen in time, as marking the space-time of the Mesopotamian world. They mark the passage of time. Standing public monuments, as well as the interred foundation inscriptions, the cylindrical texts on which the Assyrian kings at the height of the empire wrote their histories, are essentially historical artifacts.

Public monuments and foundation inscriptions are artifacts of time. In Antiquity, there was a real, visceral fear of the reconfiguration of history or destruction of historical time through the destruction of the monument and the text. That is why the ancients wrote curses and pleas that the future king maintain the foundation deposits and respect the sacrosanct nature of the historical artifact and its relationship to the land by not moving a monument from its place. That is why temple renovations and the restoration of sculptures and monuments were seen as pious acts that could bring about a propitious destiny, while the reverse was applicable to the deliberate destruction and obliteration of earlier works. The series *Šumma ālu* contains a set of omens concerned with temples, monuments, and sculpture restoration:

> If a man repairs a sanctuary: he will have luck.
> If a man tears down a sanctuary: the river will swallow him.
> If someone relocates a chapel: that man will go to ruin.

If a man repairs something old: the man's god will come to him.

If a man repairs a figure of Gilgamesh: the anger of the gods will be released.

If a man repairs a new-moon emblem: his god will shepherd him aright.

If a man repairs a sun-disk emblem: his god will shepherd him aright.

If he repairs a divine standard: he will (successfully) confront his adversary.

If he repairs a divine weapon: his days will be long (and) his misdeeds will be absolved.

If he repairs a statue: his adversary will kneel before him.[13]

The text is long and lists a series of objects from the image of the god or goddess to architectural repairs and the repairs of private votive statues or other objects. It lists the outcomes for if the conservator is a private person or if the patron of the conservation is the king. A list covers the possibility of various instances in which "a king is repairing (a place) and discovers (something)." The many things one might encounter in the course of making architectural repairs are listed in a series, and these things are to be preserved. There is always a concern for the relationship between the interred artifact and its ancient place.

The deportation of populations and the theft of monuments were part of the reconfiguration of space in territorial expansion. If territory or space is marked by people and monuments, that space is reconfigured when these are moved, shifted, destroyed, or relocated. That this process is turned into a ritual or a performative magical act is not surprising. During his campaign into southern Mesopotamia, Sennacherib conquered Babylon and not satisfied with conquest and destruction or the removal of booty and people from the city, he also took a handful of earth and hurled it into the Euphrates, in an act of magical destruction that, via

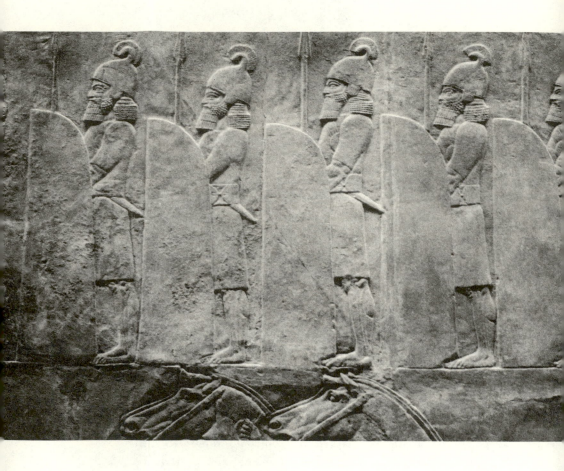

Figure 8.1. Assyrian troops on parade, Nineveh, seventh century BC. British Museum, London. Photo: Zainab Bahrani.

synecdoche, meant that the whole city would be swallowed by the river.[14]

The opposite of these destructive practices was the sacrosanct act of monument preservation, in which the state embedded itself into a mythical and ancient past. The records of numerous building rituals, and the very distinctive Mesopotamian image of the king as builder and conservationist of ancient edifices, affirm this connection with history.

Torture, Execution, and War in Art

Execution and torture belong to the rituals of war that affirm and restore power. The Mesopotamian images that represent such violence, such as Naramsin standing on the enemy dead or the Til-Tuba relief's focus on the severed head of Teumman, do not simply record the violence of war. They also delineate the power to punish. In the Assyrian reliefs, war and violence are staged as an aesthetic spectacle that relies on an image of violence that does not simply terrify but fascinates and entices the viewer. The reliefs' rhythmic repetition of chariots, soldiers, and dead and tortured bodies produce an aesthetic that relies on formal compositional elements (figs. 8.1, 8.2, and 8.3). This is an aesthetic of an interested engagement with the dramatic violence of war, not unlike that of contemporary representations of war in films that at once celebrate valor through violence and justify war by representing it as a contest of good against evil. Images of war and violence are a means of glorifying war and victory and exulting in that *gloria belli*. The Assyrian king and his court revelled in their victories by means of these aestheticized images of violence.[15] The relief sculptures brought the drama of war, heroism, and victory into the palace and provided an intense aesthetic experience for the audience.

The Assyrian images of war were designed for an audience

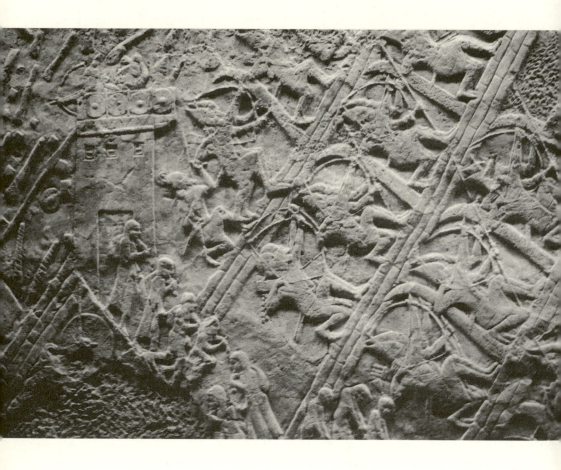

Figure 8.2. Assyrian archers in the Battle of Lachish, Nineveh, c. 700 BC. British
Museum, London. Photo: Zainab Bahrani.

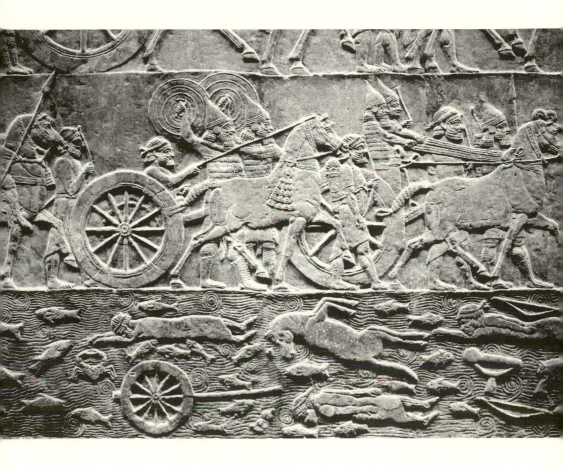

Figure 8.3. Victory over the Elamites, Nineveh, seventh century BC. British Museum, London. Photo: Zainab Bahrani.

that would willingly participate in the glorification of Assyrian power, and they were sculpted with the aim of providing visual pleasure. The reliefs were carved with a sharp focus on details and a complexity of linear rhythmic patterns that interacted with the smooth and polished surfaces of the stone (fig. 8.3). The king and court viewed the sculptures for their formal beauty.[16] But some of the pleasure in viewing these works of art derived from a voyeuristic thrill, an enjoyment in viewing the violence for the sake of the spectacle itself.[17] The ghastly, violent ancient Roman games of the arena clearly depended on such voyeurism. The fatal games and charades of the Romans included death by mythology. Pasiphae was raped by a bull and Ixion was killed on a wheel in *tableaux vivants* reenacting the myths. This was execution as theater. These mythical games of torture may also have inspired a taste for works of art meant not for public exhibit and coercion of the masses but for private voyeuristic consumption.[18]

The Assyrian reliefs combined tension and fear with the voyeuristic thrill of the bloody spectacle.[19] But voyeuristic participation in the kill is nevertheless ideological, not to be separated from the willing cooperation that is the fundamental basis of all ideological conviction and rituals of state power.

War in Assyria involved many aspects that we would today put in the realm of the supernatural, such as the queries to the sun god about what strategy to use or how to win a siege.[20] The lists of ways to win a siege, for example, are similar to other omen texts in that they present possible scenarios that seem somewhat unlikely. War, it seems, could be fought partly along supernatural lines, so the removal of statues of gods, the destruction of images of kings, and the removal of earth from a city were all ways to defeat the enemies of Assyria. They were somewhat analogous to divination and substitution rituals. The Assyrians saw them as real methods of warfare, not mere superstition. This was not just a

theater of state power. Especially during the era of Assyrian imperial expansion, war involved a political magic that depended on the deployment, manipulation, theft, and obliteration of images and monuments. The destruction of monuments that took place in Mesopotamia can be seen as a supernatural act, the annihilation of a record, which was a terrible fate in a society whose principal ideology was that immortality is achieved through history, monuments, and memory.

Notes

Introduction

1. Clausewitz, *On War*, p. 101.

2. For the text edition, see Farber Flügge, *Der Mythos Inanna und Enki*.

3. This view of war as an aspect of the city, of urban society, distinctive of the ancient Sumerian view may seem to differ from the proposition of the war machine that Gilles Deleuze and Félix Guattari describe, in their treatise *A Thousand Plateaus*, as a nomadic formation that is by definition external to the state (pp. 351–423). But the war machine is appropriated by the state despite its exteriority and is not to be confused with the magic violence of the state (*ibid.*, pp. 354–55) or the violence of Repressive State Apparatuses to use the terminology of Louis Althusser in "Ideology and Ideological State Apparatuses."

4. Bataille, *Erotism*, p. 64.

5. Ibn Khaldun, *Muqqadimah*, pp. 233–34; Walzer, *Just and Unjust Wars*.

6. See Freedman, *War*, and Walzer, *Just and Unjust Wars*, for the study of war within political science and war studies. For sociological and anthropological discussions, see Giddens, "Nation-State and Violence," and Bond and Roy, *War and Society*. For contemporary philosophical theories of violence and state power see Agamben, *Homo Sacer*, *Remnants of Auschwitz*, and *State of Exception*; Badiou, *Ethics*; and Žižek, *Welcome to the Desert of the Real!* and *Iraq*. For an anthropological study of violence and the state, see Feldman, *Formations of Violence* and "Memory Theaters."

225

7. Notable exceptions are Mirzoeff, *Watching the War in Babylon* and *What Do Pictures Want?*, which cover the images of violence and war in the contemporary Western media from the point of view of art history and visual cultural studies. For ancient Mesopotamia, Bersani and Dutoit, *Forms of Violence*, studies the depiction of violence in the reliefs of Ashurbanipal's lion hunts from a psychoanalytic perspective. The field of Mesopotamian art history has generally addressed images of war within the context of broader studies of Mesopotamian and, especially, Assyrian art. Julian E. Reade's series of long articles (most recently "Religious Ritual") is the most relevant to the present discussion. In other areas of art history, the literature on images of violence is extensive. See Elkins, *Pictures of the Body*, Groebner, *Defaced*, and Spivey, *Enduring Creation*.

8. An all-encompassing history or archaeology of violence, images of war, and their relationship to power is, of course, beyond the scope of this book. What I aim to provide here is a discussion toward an archaeology of violence, in the Foucauldian sense of archaeology. The study does not aim to be exhaustive, even for Mesopotamia.

9. The war machine is theorized in Deleuze and Guattari, *A Thousand Plateaus*, the second volume of their magnum opus, *Capitalism and Schizophrenia*. The first French edition of *A Thousand Plateaus* appeared in 1980; the English translation was published in 1987.

10. Deleuze and Guattari, *Thousand Plateaus*, pp. 351–56; Caillois, *Man and the Sacred*.

11. Caillois, *Man and the Sacred*, pp. 163–80.

12. Bataille, *Erotism*, p. 81.

13. Useful studies of war in Mesopotamia can be found in Dalley, "Ancient Mesopotamian Military Organization"; Fales, "Preparing for War"; Grayson, "Assyrian Warfare"; Littauer and Crouwel, *Wheeled Vehicles*; Mayer, *Politik*; Oded, *War, Peace, and Empire*; Pongratz-Leisten, Deller, and Bleibtreu (eds.), "Götterstreitwagen"; and Salonen, *Die Waffen*. Mayer's and Oded's are the most comprehensive studies of Assyrian warfare to date. A recent collection of essays on war in Antiquity is Meissner, Schmitt, and Sommer (eds.), *Krieg*.

14. Foucault, *Discipline and Punish*, p. 104.

15. Ginzburg, "Morelli, Freud, and Sherlock Holmes."

16. Todorov, *Theories*, p. 223.

CHAPTER ONE: THE KING'S HEAD

1. For the most recent discussion of this relief, see Bahrani, "King's Head"; Bonatz, "Ashurbanipal's Headhunt"; Dolce, "'Head of Enemy'"; Reade, "Religious Ritual"; Uehlinger, "Clio"; and Watanabe, "'Continuous Style.'" For comparison to Egyptian war reliefs, see Kaelin, "Ein assyrisches Bildexperiment," and Feldman, "Nineveh to Thebes."

2. Barnett, Bleibtreu, and Turner, *Sculptures*; Curtis and Reade, *Art and Empire*; Layard, *A Second Series of the Monuments of Nineveh*; and Reade, "Narrative Composition in Assyrian Sculpture."

3. Cf. Watanabe, "'Continuous Style,'" discussing the repetition of the head as a tool of the continuous style in the narrative used to indicate movement in time and space.

4. It is interesting to note that the images of the soldiers dealing the blow were attacked later. Both soldiers in the detail have had their faces hacked away. The other figures in the scene were left undamaged.

5. Agamben, *Homo Sacer*, p. 103.

6. After Luckenbill, *Ancient Records*, pp. 392–94 (translation emended). Cf. Weidner, "Assyrische Beschreibungen," and Barnett, Bleibtreu, and Turner, *Sculptures*, p. 95.

7. Luckenbill, *Ancient Records*, pp. 330–37; Piepkorn, *Historical Prism Inscriptions*, pp. 63–81; Borger, *Beiträge*, pp. 224–26.

8. Luckenbill, *Ancient Records*, pp. 299–330.

9. Piepkorn, *Historical Prism Inscriptions*, pp. 61–81; Borger, *Beiträge*, pp. 224–43.

10. Luckenbill, *Ancient Records*, p. 395.

11. *Ibid.*, *Ancient Records*, p. 396.

12. After Piepkorn, *Historical Prism Inscriptions*, p. 28, and Borger, *Beiträge*, pp. 92 and 205.

13. After Piepkorn, *Historical Prism Inscriptions*, pp. 60–65, and Borger, *Beiträge*, pp. 97 and 224.

14. After Piepkorn, *Historical Prism Inscriptions*, pp. 64–65, and Borger, *Beiträge*, pp. 99 and 224.

15. After Piepkorn, *Historical Prism Inscriptions*, pp. 67–69, and Borger, *Beiträge*, pp. 100 and 225.

16. Rochberg, *Heavenly Writing*, pp. 68–69. This book is an excellent study of astronomy and divination in Mesopotamia.

17. After *ibid.*, p. 109.

18. This matter is discussed in some detail in *ibid.* It is interesting that geographical regions are also associated with zodiac signs in the Islamic tradition of the region. See Ibn al-Faqīh al-Hamadhānī, *Kitāb al-Buldān* (c. 940 AD).

19. After Piepkorn, *Historical Prism Inscriptions*, pp. 72–75, and Borger, *Beiträge*, pp. 106–107 and 227; cf. Luckenbill, *Ancient Records*, pp. 323–40. Images of the Elamites carrying severed heads around their necks appear on the Nineveh palace reliefs.

20. Plutarch, *Crassus* 33.

21. Barthes, *Image, Music, Text*, p. 87.

22. Weissert, "Royal Hunt," makes the case for reading the Assyrian lion hunts as part of an entire ritual of triumph that draws a parallel between the battle and the hunt. Bonatz, "Ashurbanipal's Headhunt," further emphasizes headhunting as a form of battle. I remain unconvinced, however, by the argument made by Reade, "Religious Ritual," and Weissert, "Royal Hunt," that the lion hunt was a public spectacle similar to the Roman games involving gladiators and wild animals in fights to the death in the arena. There is no convincing evidence from Assyria that such hunts were open to the public.

23. Bahrani, *Women of Babylon*, pp. 134–40.

24. For the discussion of curse formulas and the power of images, see Bahrani, "Assault and Abduction" and *Graven Image*.

25. Luckenbill, *Ancient Records*, p. 178.

26. Bahrani, "Assault and Abduction," pp. 372–75.

CHAPTER TWO: BABYLONIAN SEMIOTICS

1. Benjamin, "Mimetic Faculty."

2. Vanstiphout, "The nth Degree of Writing at Nineveh," pp. 53–45. See also Joan Goodnick Westenholz, "Thoughts on Esoteric Knowledge and Secret Lore," in Proseck'y (ed.), *Intellectual Life,* pp. 451–62. For the relationship that ties together the concepts of representation, semiotics, and hermeneutics in Mesopotamian arts, see Bahrani, *Graven Image.*

3. Ginzburg, "Morelli," p. 89.

4. Sigmund Freud, quoted in *ibid.*, p. 86.

5. The importance of the divine realm, the supernatural, and the mythological in Assyrian palace art has been pointed out by Ornan, "Expelling Demons" and *Triumph*, and Ataç, "'Underworld Vision.'" These scholars rightly draw attention to a dimension that has usually been neglected in favor of a reductive view of Assyrian art as simple propaganda.

6. Benjamin, "Mimetic Faculty," p. 334.

7. Bottéro, "Symptômes" and *Mesopotamia.*

8. Falkenstein and von Soden, *Hymnen*, pp. 247–48.

9. Derrida, *Of Grammatology*, p. 3.

10. Bahrani, *Graven Image*, pp. 96–120.

11. Frazer, *The Golden Bough.*

12. Goody, *Power*, pp. 86–108.

13. *Ibid.*, pp. 132–52.

14. *Ibid.*

15. Liverani, *Uruk.*

16. *Ibid.*; Glassner, "Use of Knowledge" and *Invention of Cuneiform*; Bottéro, *Mesopotamia* and "Symptômes." For the economic impetus and uses of writing, see Nissen, Damerow, and Englund, *Archaic Bookkeeping.*

17. Baines, "Literacy."

18. Reiner, *Astral Magic*, p. 66.

19. Bahrani, *Graven Image*, p. 110 (my translation).

20. Althusser, "Ideology."

21. Žižek, *Mapping Ideology*, pp. 1–33; *Sublime Object*; and *Ticklish Subject.*

22. Adorno, "Beitrage zur Ideologienlehre"; Žižek, *Mapping Ideology*, p. 13.

23. Barthes, *Mythologies*.

24. Marin, *Portrait of the King*.

25. Porter, *Ritual and Politics*, p. 3.

26. The iconography of official rites and ceremonies as examples of scenes of ritual in Mesopotamia are recorded and studied in Reade, "Religious Rituals," and Collon, "Depictions." Instead, I have in mind here ritualistic acts that were not overtly acknowledged as being so.

27. Bahrani, *Graven Image* and *Women of Babylon*. For the discussion of the relationship between ritual and ideology in Marxist thought, see Žižek, *Mapping Ideology* and *Sublime Object*.

28. Pascal, *Pensées*, p. 46. Althusser invokes Pascal's statement regarding ritual. It is fundamentally performative. One believes because one kneels. The very act of kneeling effects belief. "Ideology," pp. 168–74. The importance of Pascal's writings in the understanding of the mystical basis of ideology are further emphasized in Žižek, *Plague*.

29. Benhabib, "Critique."

30. Bloch, *Political Language*.

31. A point formulated and stressed by Žižek, *Mapping Ideology*.

32. *Ibid.*, Žižek, *Plague* and *Sublime Object*.

CHAPTER THREE: THE MANTIC BODY

1. Gadd, *Ideas*, p. 8.

2. Starr, *Queries*, p. xix.

3. Bahrani, "Assault" and *Graven Image*, pp. 121–48.

4. Gell, *Art*, pp. 14–19.

5. Freud, *Uncanny*.

6. Mayer, *Untersuchungen zur Formensprache*, pp. 423 and 411.

7. *Chicago Assyrian Dictionary*, vol. B, p. 124. This is made clear in the omen compendia (see Jeyes, *Old Babylonian Extispicy*), as well as in numerous images (see fig. 7.1) and historical annals.

8. Reiner, *Astral Magic*, pp. 62–63.

9. *Ibid.*, p. 74.

10. Durand, *Mari*, pp. 3–80.

11. Ginzburg, "Morelli," p. 89.

12. Reiner, *Astral Magic*, p. 65.

13. Barthes, "Semiology and Medicine," p. 205.

14. Excerpted from Jeyes, *Old Babylonian Extispicy*, pp. 151–52.

15. For this biological research, I am grateful to my student at Columbia University, Christopher Burdette who consulted Larry Engelking, veterinary toxicologist and A. Kumar, veterinary physiologist, both at Tufts University in 2005.

16. Jeyes, *Old Babylonian Extispicy*, p. 145.

17. Bottéro, *Mesopotamia*, p. 130ff.

18. Jeyes, *Old Babylonian Extispicy*, no.2, and Guianan, "Divination," p. 423.

19. These examples are given in Bottéro, *Mesopotamia*, p. 133.

20. *Ibid.*, p. 131.

21. See Leichty, *Omen Series*.

22. *Chicago Assyrian Dictionary*, vol. A, p. 332; Böck, *Die babylonisch-assyrische Morphoskopie*. Also, an Old Babylonian text (Goetze, *Old Babylonian Omen Texts*, no. 54) lists the meaning of moles and their place on the body.

23. See Kraus, *Texte*; Heessel, *Diagnostic*, pp. 156ff.

24. All dream omens are excerpted from Oppenheim, *Interpretation*. For a discussion of these omens, see also Bottéro, *Mesopotamia*, pp. 115–16.

25. Böck, *Die babylonisch-assyrische Morphoskopie*, p. 113, from *Alamdimmû*, taf. 8.

26. After Böck, *Die babylonisch-assyrische Morphoskopie*, pp. 291–92.

27. Bottéro, *Mesopotamia*, p. 127.

28. Kraus, *Texte*.

29. Reiner, *Astral Magic*, p. 72.

30. *Ibid.*, pp. 72–73; Leichty, "Ritual"; Meissner, "Omnia zur Erkenntnis."

31. Leichty, "Ritual," pp. 239–40.

32. Starr, *Queries*, pp. xxiv–xxxv.

33. Leichty, "Ritual," pp. 237–42.

34. Winter, "Sex" and "The Body of the Able Ruler."

CHAPTER FOUR: DEATH AND THE RULER

1. For discussions of this monument as a victory stele set up to commemorate Naramsin's conquest over the Lullubi, see Frankfort, *Art*; Moortgat, *Die Kunst*; Parrot, *Sumer*; and Strommenger, *Five Thousand Years*. The Stele has also been considered an important indication of the rise of the Akkadian dynasty's imperial ambitions, which are thought to have reached their apogee with the reign of Naramsin. See Collon, *Ancient Near Eastern Art*, p. 76; Amiet, *L'art d'A-gadé*, pp. 29–32. For its aspects of landscape and composition, see Winter, "Trees"; Nigro, "Osservasioni"; Amiet, "Victory Stele" and *L'art d'Agadé*, pp. 29–32, 93–95, 128; Morgan, *Recherches*, pp. 106 and 144.

2. For Badiou on the Event as a rupture of linear time, see *Ethics*. The discussion of sovereign power here relies on Foucault, *Discipline and Punish* and Agamben, *Homo Sacer* and *State of Exception*.

3. Winter, "Sex."

4. Michalowski, "Memory," p. 89.

5. Cooper, "Curse." See also Glassner, *La chute d'Akkadé* and *Chroniques mésopotamiennes*.

6. As Winter argues in "Sex."

7. In this formulation, I follow Agamben's argument that the laws most archaic stratum is "at every point indistinguishable from magic." See Agamben, *Remnants*, p. 79.

8. Agamben, *Homo Sacer*, p. 6.

9. Van De Mieroop, "History," p. 60. The Sumerian title generally translated as king is LUGAL (literally, great man). The Victory Stele of Naramsin refers to him as "the god Naramsin, the mighty or powerful," but there is a break here, so the title "king" may have been used also.

10. Amiet, "Victory Stele," p. 166.

11. After Frayne, *Sargonic*, p. 144.

12. Postgate, *Early Mesopotamia*, pp. 249–50.

13. Frankfort, *Art*, p. 43.

14. Bahrani, *Graven Image*, pp. 138–48.

15. Foster, "The Sargonic Victory Stele."

16. Foucault, *Discipline and Punish*.

17. Agamben, *Homo Sacer*.

18. Foucault, *Discipline and Punish*, p. 48.

19. The closest image to this act is perhaps that of Ishtar with her foot on a lion, subduing it. This image first appears in seal carvings of the Akkadian period, and as far as I am aware, the earliest extant example is the seal at the Oriental Institute of the University of Chicago [A27903]. Boehmer, *Die Entwicklung*, taf. 32, no. 382. It is interesting that the starburst emblem in this seal is very similar to the one in the Victory Stele of Naramsin. The other images of deities' battles from the glyptic arts of the Akkadian period do not show the act of standing upon the dead and dying. These gods have legs raised with foot against opponent in acts of struggle (*ibid.*, taf. 28, nos. 327, 332, 343, 351). I think this iconography is fundamentally different; Ishtar's control of the lion is a far closer parallel to Naramsin's image. In any case, there is no predecessor to the act as it is depicted in the Victory Stele of Naramsin. By the early second millennium BC, this had become the iconography of the war god, Nergal.

20. Despite the repeated statement in modern scholarship that the monument stood in Sippar, the city of the sun god, it did not: the epilogue states explicitly that Hammurabi set up this monument in Babylon. It is not clear to me where or when this recurrent mistake originated in the scholarly literature.

21. Bottéro argues that the monument was not a law code in that it is not a complete set of laws. *Mesopotamia*, pp. 156–84.

22. In the iconography of Mesopotamian art, one might expect to see an interceding deity between the worshiper and the god rather than this kind of direct interaction.

23. Bottéro, *Mesopotamia*, p. 158.

24. Pascal, *Pensées*, p. 46.

25. Agamben, *State of Exception*, p. 38.

26. Giambattista Vico, *De antiquissima Italorum sapienta*, quoted in *ibid.*, p. 17.

27. For a translation of the Code of Hammurabi, see Roth, *Law Collections*, pp. 71–142.

28. For the ritual of the triumph, see Versnel, *Triumphus*.

29. Gombrich, "Art for Eternity," *Story of Art*, ch. 2.

30. Frankfort, *Art*, p. 43.

31. Groenewegen-Frankfort, *Arrest*, pp. 163–65. The use of landscape and the idea of naturalism as a break in tradition have been seen as indications of an ethnic change from Sumerian to Semitic forms of representation. But it is not necessary to look to ethnic difference. The changes in the conception of kingship and power better explain this stylistic shift. Naturalism or a realist style is the strongest tool of ideology, and so is a favored style in the Akkadian and Neo-Assyrian arts.

32. A great deal of work remains to be done in this area before we can really come to understand the remarkable invention of the monument for eternity, and the even more influential invention of the public monument. This invention has not been fully appreciated for its extraordinary innovation, perhaps because public monuments with inscriptions later became such a common ideological device, especially in the modern West.

33. Badiou, *Ethics*.

34. Ellis, *Foundation Deposits*.

35. Excerpted from a prism inscription of Ashurbanipal, Piepkorn, *Historical Prism Inscriptions*, pp. 87–88 (translation emended).

36. Hansen, "New votive Plaques"; Boese, *Altmesopotamische Weihplatten*.

37. Egypt is the other place that merits closer examination for the development of such ideas in order to consider the possibility of cultural exchange in the notions of monument and monumentality as they related to the invention of writing and the conception of future time, but that must remain a subject for a later study. The Victory Stele of Naramsin also uses iconography of kingship, absolute kingship, and empire. This was new for Mesopotamia, although it already existed in Egypt in a developed way. The king was a god — not a manifestation of a god on earth, like Horus and the pharaoh, but a separate deity. He was godlike in himself, in his own body. Egypt may be the source of the iconography of kingship, although not directly of the Victory Stele of Naramsin.

Chapter Five: The Image of My Valor

1. Khalil Ismail, "Eine Siegesstele," p. 105.

2. Edzard, "Altbabylonische," provided a partial transliteration and commentary on some passages; Khalil Ismail and Cavigneaux, "Dadušas," provide the complete transliteration and translation. The translation I provide here is based on both transliterations, with some emendations. I am very grateful to Eckart Frahm, Kathryn Slanski, and especially Marc Van De Mieroop for going over the transliterations with me. Thanks also to Donald P. Hansen, who went over an equally close reading of the image with me. Another translation and commentary appeared in Charpin, *Mesopotamien*.

3. A good example of this motif is the well known hematite seal of Ana-sin-taklaku, servant of Zimrilim of Mari (c. 1770–1760 BC) currently in the Musée du Louvre, Paris.

4. Bahrani, *Graven Image*.

5. Buccellati, "Through a Tablet."

6. Bahrani, *Graven Image*, pp. 138–45; see also ch. 4 here.

7. For an in-depth discussion of the stele as a public monument and an early form of narrative representation, see Winter, "After the Battle"; for the text and historical context of the battle, see Cooper, *Presargonic Inscriptions* and *Reconstructing History*, pp. 33–39.

8. Parrot, *Tello*, p. 95; Winter, "After the Battle," p. 13.

9. Winter, "After the Battle," p. 14.

10. Cooper, *Presargonic Inscriptions*, p. 34.

11. On Eannatum and Enmetena's legal and ethical justifications of war in relation to modern concepts of international laws of war, see Altman, "Tracing the Earliest Recorded Concepts."

12. Cooper, *Presargonic Inscriptions*, p. 54. Enmetena text La. 5.1.

13. Altman, "Tracing the Earliest Recorded Concepts," p. 163; Cooper, *Presargonic Inscriptions*, p. 84.

14. Cooper, *Presargonic Inscriptions*, p. 37.

15. Foucault, *Discipline and Punish*, p. 33.

16. Luckenbill, *Ancient Records*, p. 5.

17. Grayson, *Assyrian Rulers*, pp. 151 and 199.

CHAPTER SIX: THE ART OF WAR

1. Virilio stresses this point in a number of his publications; see, for example, the interview with Sylvère Lotringer in *Pure War*.

2. For the aesthetic strategies of power, see Benjamin, *Illuminations*, p. 241, and Marin, *Portrait of the King*.

3. Transliteration in Borger, *Beiträge*, p. 54; translation in Luckenbill, *Ancient Records*, p. 363. See also Borger, *Beiträge*, p. 197, British Museum text 134609 for similar activities.

4. In addition to this image of the removal of the gods dating to the reign of Tiglath-Pileser III, from Nimrud, such scenes were depicted on Neo-Assyrian wall reliefs, for instance, at the Southwest Palace at Nineveh (Barnett, Bleibtreu, and Turner, *Sculptures*, pls. 143, 451, 453). The removal of architectural sculpture and the demolition of statues can also be seen in various reliefs, such as the one of Tiglath-Pileser III at Nimrud (Layard, *Monuments*, pl. 67A; Barnett and Falkner, *Sculptures*, pp. xvi and 17 and pl. 8).

5. Jacobsen, *Harps*, pp. 447–84.

6. Michalowski, *Lamentation*, pp. 63–64 (translation emended).

7. Starr, *Queries*, pp. 236–37 (translation emended).

8. *Ibid.*, pp. 238–39 (translation emended).

9. Bahrani, *Graven Image*, pp. 174–79; Foster, *Before the Muses*, pp. 383–86.

10. Luckenbill, *Ancient Records*, pp. 642–43; Borger, *Die Inschriften Asarhaddons*, pp. 12–13; Oded, *War, Peace, and Empire*, p. 127.

11. For an illustration, see Barnett and Falkner, *Sculptures*, pp. xvi and 17 and pl. 8, and Layard, *Monuments*, pl. 67A.

12. Livingstone, *Mystical and Mythological*, p. 222.

13. Grayson, *Assyrian and Babylonian Chronicles*, pp. 84.4.17–18. and 126.2. 21–22; Waters, *Survey*, pp. 42–43.

14. Borger, *Die Inschriften Asarhaddons*, p. 25; Waters, *Survey*, p. 45.

15. Parpola, *Letters from Assyrian and Babylonian Scholars*, p. 296 no. 359.

16. Foster, *Before the Muses*, pp. 888–89.

17. Bahrani, "Assault" and *Graven Image*.

18. Thomasen, *Luxury*, p. 157.

19. *Ibid.*, Luckenbill, *Ancient Records*, p. 227.

20. Thomasen, *Luxury*, p. 161, Russell, *Final Sack*, p. 241.

21. For the uncanny blurring of real king and portrait-image and the rituals that brought the image to life, see Bahrani, *Graven Image,* p. 200. See also Bahrani, "Assault," for the practices of image abduction in war and the significant practice of placing curse formulas on statues. I remain unconvinced by the assertion that curse formulas are meaningless for Mesopotamian culture, made by a number of scholars working on other areas of Mesopotamian inscriptions — for example, legal documents (Roth, "*ina*," p. 5) and scientific texts (Rochberg, *Heavenly Writing*, p. 116). It was precisely because the ubiquitous curses on sculpture and monuments had been ignored and dismissed as meaningless that art historians were unable to come to terms with the performative power of images in Mesopotamian Antiquity.

22. For Ashurbanipal texts, see Borger, *Beiträge*, pp. 69 and 249; for Ashurnasirpal, see Grayson, *Assyrian Rulers*, pp. 151 and 199; for Ashur-Dan II, see Parpola, *Assyrian Prophecies*, p. 4.

23. For references in the Assyrian inscriptions to impaled bodies, see Luckenbill, *Ancient Records*, vol. 1, pp. 472, 478, 480, 499, 585, 605, 776 and vol. 2, pp. 830 and 846. For references to skins on walls, see *ibid.*, vol. 1, pp. 441 and 443, and vol. 2, pp. 773 and 844. For references to severed heads, see *ibid.*, vol. 1, pp. 221, 445, 463, 480, 559, 605, and vol. 2, p. 254.

24. *Ibid.*, vol. 2, p. 815; *Liverani*, "Ideology."

25. Piepkorn, *Historical Prism Inscriptions*, p. 74.

26. For an in-depth study of Assyrian practices of deportation in war, see Oded, *Mass Deportations*, especially the translation quoted on p. 42.

27. The omens are in the omen compendium *šumma izbu*, edited by Leichty, *Omen Series*, pp. 39, 104, 115.

28. Gelb, "Prisoners"; Oded, *Mass Deportations*, p. 1.

29. Luckenbill, *Ancient Records*, p. 7.

30. Piepkorn, *Historical Prism Inscriptions*, p. 48.

31. Oded, *Mass Deportations*, p. 35.

32. *Ibid.*, pp. 37–38.

33. *Ibid.*, pp. 52–53; Gelb, "Prisoners," p. 92.

CHAPTER SEVEN: OMENS OF TERROR

1. For the text edition of *Queries to the Sun God* from the State Archives of Assyria series, see Starr, *Queries*. For earlier oracles, see Finet, "La place du divin," and Lambert, "Questions." *Tāmītus* addressed to Adad or Šamaš could be performed by private persons, not just the king. In the ritual, The owner is represented by a piece of clothing taken from a garment and also identified by the name. These aspects of identity are submitted to the god in order to indicate the identity of the questioner.

2. Starr, *Queries*, pp. 7–8 (translation emended).

3. *Ibid.*, p. 70 (translation emended).

4. *Ibid.*, p. 98 (translation emended).

5. Jeyes, *Old Babylonian Extispicy*, pp. 31ff.

6. From the series *Šumma ālu* (if a city), see Guinan, "Divination" and Freedman, *If a City Is Set*.

7. *CAD B*, 124. See Reiner, *Astral Magic*, p. 64. For Mari, see Durand, *Archives*, pp. 3–80.

8. British Museum 124548 and 124914. For Sargon reliefs of priests at camp, see Botta and Flandin, *Monument*, p. 14.

9. Gudea Cylinder B inscription, B8, 23; quoted in Livingstone, *Mystical and Magical*, p. 60.

10. British Museum 47463; trans. in Livingstone, *Mystical and Magical*, pp. 49–61.

11. *Ibid.*, p. 50.

12. *Ibid.*, pp. 56–57.

13. *Ibid.*, p. 60.

14. Dalley, "Ancient Mesopotamian," p. 415.

15. See Pongratz-Leisten, Deller, and Bleibtreu (eds.), "Götterstreitwagen."

16. Black and Green, *Gods, Demons, and Symbols*, p. 52.

17. Oded, *War, Peace, and Empire*, p. 15.

18. For a discussion of the ritual of the substitute king, see Bottéro, *Meso-potamia*, pp. 138–55; Bahrani, *Graven Image*, pp. 129–31 and 173–74; and Par-pola, *Assyrian Prophecies; Letters from Assyrian and Babylonia Scholars; and Letters from Assyrian Scholars*.

19. Girard, *Violence*.

20. Parpola, *Letters from Assyrian and Babylonian Scholars*, p. 155 no. 189. For the letters regarding interpretation, see pp. 44 and 121–22.

21. The bibliography on the Assyrian court scholars is extensive in the spe-cialized Assyriological literature, but see *ibid.* and Rochberg, *Heavenly Writing*, pp. 209–36.

22. Rochberg, *Heavenly Writing*, p. 209.

23. Bonatz describes the battle as a hunt for heads in his anthropological-archaeological study "Ashurbanipal's Headhunt."

24. Luckenbill, *Ancient Records*, p. 396 (translation emended).

25. Barnett, Sculptures, pls. xxv and xxvi; Weissert, "Royal Hunt," pp. 339–58; Bonatz, "Ashurbanipal's Headhunt"; Reade, "Religious Ritual."

26. Quoted in Oppenheim, *Ancient Mesopotamia*, p. 285.

27. Emile Benveniste, *Indo-European Language and Society*, trans. Elizabeth Palmer (Coral Gables, FA: University of Miami Press, 1973), p. 188. Quoted in Agamben, *Homo Sacer*, p. 66.

28. Agamben, *Homo Sacer*, p. 107. In Agamben's analysis of this ancient Roman juridico-theological category, *homo sacer* is one who may be killed (that is, killing him is permissible and is not homicide) but not sacrificed (that is, he is neither a sacrificial victim, nor one who cannot be killed).

29. This despite numerous assertions in modern scholarship that the king in ancient Near Eastern art is always larger than life and dominates pictorial scenes. There is no discrepancy in size between the Mesopotamian king and his subjects like the equivalence that can be observed in images of the Egyptian pharaoh in the New Kingdom war reliefs. The early Victory Stele of Naramsin is quite unusual in its colossal image of the divine king. As a rule, Mesopotamian art did not rely on size differences in the iconography of the king's image.

30. On magical and apotropaic figurines and foundation figures from the earlier periods, see Braun-Holzinger, "Apotropaic Figures" and *Figürliche Bronzen*; Gurney, "Babylonian Prophylactic Figures"; and Woolley, "Babylonian Prophylactic Figures." On Assyrian magical figurines, see Green, "Lion-Demon" and "Neo-Assyrian Apotropaic Figurines."

31. For the iconography, meaning, and function of demons and guardian figures in Neo-Assyrian art, see Ataç, "'Underworld Vision'"; Ornan, "Expelling Demons"; Wiggermann, *Mesopotamian Protective Spirits;* Engel, *Darstellungen*; and Kölbe, *Die Reliefprogramme religiös-mythologischen Charakters.*

32. Ataç, "'Underworld Vision.'"

33. These remarks are so common in the scholarship of Assyriology that I will not list specific authors here. Oded, *War*, lists some of the authors who hold this view in the introduction, n. 3.

34. See Porter (ed.), *Ritual and Politics*. In the introduction, Porter states that "public rituals have a far-reaching impact on political attitudes and behaviors" (*ibid.*, p. 1). She adds that rituals serve "to hold groups together at times of crises or change [and] to reinforce group identity." See also Mehmet-Ali Ataç, review of *Ritual and Politics in Ancient Mesopotamia*, by Barbara Nevling Porter, *Bryn Mawr Classical Review*, 2006.01.10.

35. The situation is not unlike the current documentation of the American war in Iraq. At this point, the main sources are news reports informed by press releases from the U.S. government Public Affairs office in Baghdad, or by government press conferences in Washington D.C. That limit on information does not make it impossible to observe the increasing reliance on the biopolitical and juridico-theological logic of the war.

Chapter Eight: The Essence of War

1. The date of the text is disputed. See Foster, *Before the Muses*, pp. 880–911 for the full text; see also Cagni, *Poem*.

2. Foster, *Before the Muses*, pp. 882–83.

3. *Ibid.*, pp. 895–96.

4. *Ibid.*, p. 902.

5. *Ibid.*, p. 903 (translation emended).

6. Although the poet states that the composition is for Erra, in my opinion this does not glorify but indicates dread of the power of war, and an appeasement of Erra.

7. Deleuze and Guattari, *Thousand Plateaus*.

8. Caillois, *Man and the Sacred*.

9. See the definition in Deleuze and Guattari, *Thousand Plateaus*, pp. 360–61.

10. Agamben, *Homo Sacer*, p. 6.

11. Dumézil, *Mitra-Varuna*.

12. Foucault, *Discipline and Punish*, p. 48.

13. Freedman, *If a City Is Set*, pp. 19, 69, 81, 161, 167–83 (translation emended).

14. Luckenbill, *Ancient Records*, p. 185.

15. The images of war that we have observed since 2004 are indeed ideological, but that does not mean that they are always coercive. It does not mean that the only response to them is repulsion and fear or that terror is their only aim. Certainly terror and fear are tools of the state, but such images are also for the pleasure of the viewer, for gloating. Images of war serve the mindless group mentality of "us against them," "the good guys and the bad guys," according to the terminology of today's war.

16. As we saw in the case of the inscription on the monument of Dadusha (in ch. 5), the formal and technical aspects of sculpture did not go unobserved by the ancient viewers.

17. Reconsideration of the aesthetic dimension of these works of art requires a movement away from the standard textbook explanation of all such images as propagandistic tools of coercive despotism. The works of art that most explicitly display violence and torture, the Assyrian palace reliefs, are not for public consumption. As an explanation for how these were nevertheless propaganda, it has been suggested that the Assyrian reliefs may have been copied and displayed on public monuments, alternatively, they may have been aimed at the vassal governors of neighboring and annexed states, who had to be kept in check.

Such foreign vassals would have seen the reliefs when they came to the Assyrian palace to pay their respects and bring tribute to the Assyrian king. Both these explanations are unsatisfactory, however. These reliefs were made neither with the coercion of the general public in mind nor simply out of fear of vassal princes. It is far more likely that the reliefs were made for the palace's magical efficacy as the center of the court and for posterity. According to sources from Antiquity, the construction of the palace required not only master builders and their workforce but also priest consultants, exorcists, and makers of apotropaic figurines. In addition, of course, it required sculptors and stonemasons to carve the walls with images. Since this was court art, the primary audience consisted of the king and courtiers, not masses that needed to be convinced of the king's right to wage war. The palace reliefs are works of art made for visual pleasure, for viewing in the palace, whether copies were made for public display or not, and whatever their influence on state visits was.

18. Spivey, *Enduring Creation*, pp. 35–36. For more on the Roman games, see Coleman, "Fatal Charades"; Futrell, *Blood*; and Kyle, *Spectacles*.

19. Another detail of the Assyrian war reliefs must be considered here in relation to more recent events: images of torture. The military perpetrators at Abu Ghraib not only considered the acts amusing but also took photographs for pleasure, a thrill, and personal amusement. The practice of torture today — for example, at Guantánamo Bay's Camp X-Ray — is made known to us but kept hidden at the same time. Why is this practice, that the modern perpetrators claim is torture for the sake of gaining information, practiced in secret places, the existence of which is nevertheless publicly known, glances of which reach our newspapers and television screens daily? Torture is a statement of victory in and of itself. It is a symbol of triumph and power over the body of the other. It is no mere technique of war but a statement and signal of absolute power. Torture summarizes state terror and absolute sovereign power as displayed through an act of control over the body and life of the other. This act brings the victim close to death but keeps him in a life that is a prolonged death but not quite the release of death itself.

20. Starr, *Queries*; Eph'al, "Ways and Means."

Bibliography

Adams, Robert McC. *Paths of Fire: An Anthropologist's Inquiry into Western Technology*. Princeton, NJ: Princeton University Press, 1996.

Adorno, Theodor. "Beitrage zur Ideologienlehre." In *Gesammelte Schriften*: Ideologie. Frankfurt: Suhrkamp, 1972.

Agamben, Giorgio. *Homo Sacer: Sovereign Power and Bare Life*. Trans. Daniel Heller-Roazen. Stanford, CA: Stanford University Press, 1998.

——. *Remnants of Auschwitz: The Witness and the Archive*. Trans. Daniel Heller-Roazen. New York: Zone Books, 1999.

——. *State of Exception*. Trans. Kevin Attell. Chicago: University of Chicago Press, 2005.

Althusser, Louis. "Ideology and Ideological State Apparatuses: (Notes Towards an Investigation)." *Lenin and Philosophy, and Other Essays*. Trans. Ben Brewster. London: New Left Books, 1971, 127–86.

Altman, Amnon. "Tracing the Earliest Recorded Concepts of International Law: The Early Dynastic Period in Southern Mesopotamia." *Journal of the History of International Law* 6, no. 2 (2004): 153–72.

Amiet, Pierre. *L'art d'Agadé au Museé du Louvre*. Paris: Editions des Museés Nationaux, 1976.

——. "Victory Stele of Naramsin." In Prudence Oliver Harper, Joan Aruz, and Françoise Tallon (eds.), *The Royal City of Susa: Treasures from the Louvre Museum*. New York: The Metropolitan Museum of Art, 1992, 166–68.

Annus, Amar. *The God Ninurta in the Mythology and Royal Ideology of Ancient Mesopotamia*. Helsinki: Neo-Assyrian Text Corpus Project, University of Helsinki, 2002.

Asher-Greve, Julia M. "Reading the Horned Crown," *Archiv für Orientforschung* 42–43 (1995–96): 181–89.

Ataç, Mehmet-Ali. "The 'Underworld Vision' of the Ninevite Intellectual Milieu." In Collon and A. George (eds.), *Nineveh*, 67–76.

Badiou, Alain. *Ethics: An Essay on the Understanding of Evil*. Trans. Peter Hallward. London: Verso, 2001.

Baer, Ulrich. *Spectral Evidence: The Photography of Trauma*. Cambridge, MA: MIT Press, 2002.

Bahrani, Zainab. "Assault and Abduction: The Fate of the Royal Image in the Ancient Near East." *Art History* 18, no.3 (1995): 363–82.

——. *The Graven Image: Representation in Babylonia and Assyria*. Philadelphia: University of Pennsylvania Press, 2003.

——. "The King's Head." In Collon and George (eds.), *Nineveh*, 115–19.

——. *Women of Babylon: Gender and Representation in Mesopotamia*. London: Routledge, 2001.

Baines, John. "Literacy and Ancient Egyptian Society." *Man* n. s. 18, no.3 (1983): 572–99.

Bänder, Dana. *Die Siegesstele des Naramsîn und ihre Stellung in Kunst- und Kulturgeschichte*. Idstein, Germany: Schulz-Kirchner, 1995.

Barker, Francis. *The Culture of Violence: Tragedy and History*. Chicago: University of Chicago Press, 1993.

Barnett, Richard D. *Sculptures from the North Palace of Ashurbanipal at Nineveh (668–627 B.C.)*. London: British Museum, 1976.

Barnett, Richard D., Erika Bleibtreu, and Geoffrey Turner. *Sculptures from the Southwest Palace of Sennacherib at Nineveh*. London: British Museum, 1998.

Barnett, Richard D., and Margarete Falkner. *The Sculptures of Assur-nasir-apli II (883–859 B.C.), Tiglath-pileser III (745–727 B.C.), Esarhaddon (681–669 B.C.) from the Central and South-West Palaces at Nimrud*. London: British Museum, 1962.

Barthes, Roland. *Image, Music, Text*. Trans. Stephen Heath. New York: Hill and Wang, 1977.

——. *Mythologies*. Tran. Annette Lavers. New York: Hill and Wang, 1972.

——. "The Reality Effect." *The Rustle of Language*. Trans. Richard Howard. New York: Hill and Wang, 1986, 141–48.

——. "Semiology and Medicine." *The Semiotic Challenge*. Trans. Richard Howard. New York: Hill and Wang, 1988, 202–213.

Bataille, Georges. *The Accursed Share: An Essay on General Economy*. Trans. Robert Hurley. New York: Zone Books, 1988–91.

——. *Erotism: Death and Sensuality*. Trans. Mary Dalwood. San Francisco: City Lights Books, 1986.

Beaulieu, Paul-Alain. *The Reign of Nabonidus, King of Babylon, 556–539 B.C.* New Haven, CT: Yale University Press, 1989.

Benhabib, Seyla. "The Critique of Instrumental Reason." In Žižek, *Mapping Ideology*, 66–92.

Benjamin, Walter, "Critique of Violence." *Reflections: Essays, Aphorisms, Autobiographical Writing*, Ed. Peter Demetz. New York: Schocken, 1978, 277–300.

——. *Illuminations*. Ed. Hannah Arendt. Trans. Harry Zohn. New York: Schocken Books, 1968.

——. "On the Mimetic Faculty." *Reflections: Essays, Aphorisms, Autobiographical Writing*. Ed. Peter Demetz. New York: Schocken, 1978, 333–36.

Bersani, Leo, and Ulysse Dutoit. *The Forms of Violence: Narrative in Assyrian Art and Culture*. New York: Schocken, 1985.

Black, Jeremy A., and Anthony Green. *Gods, Demons, and Symbols of Ancient Mesopotamia: An Illustrated Dictionary*. London: British Museum, 1992.

Bleibtreu, Erika. "Grisly Assyrian Record of Torture and Death." *Biblical Archaeology Review* 17, no.1 (1991): 52–61.

——. "Standarten auf neuassyrischen Reliefs und Bronzetreibarbeiten." *Baghdader Mitteilungen* 23 (1992): 347–66.

Bloch, Maurice. *Political Language and Oratory in Traditional Society*, New York: Academic Press, 1975.

Böck, Barbara. *Die babylonisch-assyrische Morphoskopie*. Vienna: Institut für Orientalistik der Universität Wien, 2000.

Boehmer, Rainer Michael. *Die Entwicklung der Glyptik während der Akkad-Zeit*. Berlin: Walter de Gruyter, 1965.

Boese, Johannes. *Altmesopotamische Weihplatten: Eine sumerische Denkmalsgattungen des 3.Jahrtausends v. Chr*. Vol. 6. Berlin: Untersuchungen zur Assyriologie und Vorderasiatischen Archäologies, 1971.

Bonatz, Dominik. "Ashurbanipal's Headhunt: An Anthropological Perspective." In Collon and George (eds.), *Nineveh*, 93–103.

Bond, Brian and Ian Roy. *War and Society*. London: Croom Helm, 1976.

Börker-Klähn, Jutta. *Altvorderasiatische Bildstelen und vergleichbare Felsreliefs*. Mainz, Germany: Zabern, 1982.

——. "Die Reichsakkadische Kunst und Agypten." *Wiener Zeitschrift für die Kunde des Morgenlandes* 74 (1982): 57–94.

Borger, Rykle. *Beiträge zum Inschriftenwerk Assurbanipals*. Wiesbaden, Germany: Harrassowitz, 1996.

——. *Die Inschriften Asarhaddons, Königs von Assyrien*. Osnabrück, Germany: Biblio-Verlag, 1956.

Botta, Paul Emile, and Eugène Flandin. *Monument de Ninive*. Paris: Imprimerie nationale, 1849–50.

Bottéro, Jean. *Mesopotamia: Writing, Reasoning, and the Gods*. Trans. Zainab Bahrani and Marc Van De Mieroop. Chicago: University of Chicago Press, 1992.

——. "Symptômes, signes, écritures en Mésopotamie ancienne." In Jean-Pierre Vernant (ed.), *Divination et rationalité*. Paris: Seuil, 1974, 70–196.

Braun-Holzinger, Eva Andrea. "Apotropaic Figures at Mesopotamian Temples in the Third and Second Millennia." In Tzvi Abusch and Karel van der Toorn (eds.), *Mesopotamian Magic*, Groningen, Netherlands: Styx, 1999, 149–72.

——. *Figürliche Bronzen aus Mesopotamien*. Munich: C.H. Beck, 1984.

Brinkman, John A. "Unfolding the Drama of the Assyrian Empire." In Parpola and Whiting (eds.), *Assyria 1995*, 1–16.

Buccellati, Giorgio. "Through a Tablet Darkly." In M. Cohen (ed.), *The Tablet and the Scroll*. Bethesda, CDL Press, 1993, 58–71.

Budge, E.A.Wallis. *Assyrian Sculptures in the British Museum*. London: British Museum, 1914.

Cagni, Luigi. *The Poem of Erra*. Malibu, CA: Undena, 1977.

Caillois, Roger. *Man and the Sacred*. Trans. Meyer Barash. Urbana: University of Illinois Press, 2001.

Certeau, Michel de. *Heterologies: Discourse on the Other*. Trans. Brain Massumi. Minneapolis: University of Minnesota Press, 1987.

——. *The Practice of Everyday Life*. Trans. Steven Rendall. Berkeley: University of California Press, 1984.

Charpin, Dominique. "Chroniques bibliographiques: 3: Donnés nouvelles sur la région du petit zab au XVIII siécle." *Revue d'assyriologie et d'archéologie orientale* 98 (2004): 151–78.

——. "Une décollation mystérieuse." *Nouvelles assyriologiques brèves et utilitaires* 59 (1994): 51–52.

Charpin, Dominique, Dietz Otto Edzard, and Marten Stol. *Mesopotamien: Die altbabylonische Zeit*. Fribourg, Switzerland: Academic Press, 2004.

Chicago Assyrian Dictionary (CAD). *Assyrian Dictionary of the Oriental Institute of the University of Chicago*. Eds. A.L. Oppenheim, Erica Reiner, et al. Chicago: University of Chicago, 1956–.

Cifarelli, Megan. "Gesture and Alterity in the Art of Ashurnasirpal II of Assyria." *Art Bulletin* 80, no. 2 (1998): 210–28.

Clausewitz, Carl von. *On War*. Trans. J.J. Graham. Harmondsworth: Penguin, 1968.

Colbow, Gudrun. *Die kriegerische Istar: Zu den Erscheinungsformen bewaffneter Gottheiten zwischen der Mitte des 3. und der Mitte des 2. Jarhtausends*. Munich: Profil, 1991.

Coleman, K.M. "Fatal Charades: Roman Executions Staged as Mythological Enactments." *Journal of Roman Studies* 80 (1990): 44–73.

Collon, Dominique. *Ancient Near Eastern Art*. Berkeley: University of California Press, 1995.

——. *Catalogue of Western Asiatic Seals in the British Museum: Cylinder Seals, Akkadian, Post Akkadian, Ur III Periods*. London: British Museum, 1982.

———. "Depictions of Priests and Priestesses in the Ancient Near East." In Kazuko Watanabe (ed.), *Priests and Officials in the Ancient Near East*. Heidelberg: Universitätsverlag C. Winter, 1999, 17–46.

Collon, Dominique, and Andrew George (eds.), *Nineveh*. London: British School of Archaeology in Iraq, 2005.

Cooper, Jerrold S. *The Curse of Agade*. Baltimore: Johns Hopkins University Press, 1983.

———. *Presargonic Inscriptions*. New Haven, CT. American Oriental Society, 1986.

———. *Reconstructing History from Ancient Inscriptions: The Lagash-Umma Border Conflict*. Malibu, CA: Undena, 1983.

Curtis, John, and Julian Reade. *Art and Empire: Treasures from Assyria in the British Museum*. New York: Metropolitan Museum of Art, 1995.

Dalley, Stephanie, "Ancient Mesopotamian Military Organization." In Sasson (ed.), *Civilizations of the Ancient Near East*, vol. 1, pt. 4, 413–22.

———. *Myths from Mesopotamia: Creation, the Flood, Gilgamesh, and Others*. Oxford: Oxford University Press, 1989.

Davis, Whitney. Review of *The Forms of Violence: Narrative in Assyrian Art and Culture*, by Leo Bersani and Ulysse Dutoit, *American Journal of Archaeology* 92, no. 1 (1988): 133–36.

Deleuze, Gilles, and Félix Guattari. *A Thousand Plateaus: Capitalism and Schizophrenia*. Trans. Brian Massumi. Minneapolis: University of Minnesota Press, 1987.

Derrida, Jacques. *Of Grammatology*. Trans. Gayatri Chakravorty Spivak. Baltimore: Johns Hopkins University Press, 1976.

Dolce, Rita. "The 'Head of the Enemy' in the Sculptures from the Palaces of Nineveh: An Example of 'Cultural Migration'?" In Collon and George (eds.), *Nineveh*, 121–32.

DuBois, Page. *Torture and Truth*. New York: Routledge, 1991.

Dumézil, Georges. *Mitra-Varuna: An Essay on Two Indo-European Representations of Sovereignty*. Trans. Derek Coltman. New York: Zone Books, 1988.

Durand, Jean-Marie. *Archives épistolaires de Mari*, Vol. 1 pt. 1. Paris: Recherche sur les civilisations, 1988.

Durkheim, Emile. *The Elementary Forms of the Religious Life*. Trans. Joseph Ward Swain. New York: Free Press, 1965.

Edzard, Dietz Otto. "Altbabylonische Literatur und Religion." In D. Charpin, D.O. Edzard, and M. Stol (eds.), *Mesopotamien: die altbabylonische Zeit*. Orbis Biblicus et Orientalis 160/4. Göttingen: Vandenhoeck & Ruprecht; Fribourg: Academic Press, 2004, 550–55.

Elkins, James. *Pictures of the Body: Pain and Metamorphosis*. Stanford, CA: Stanford University Press, 1999.

Ellis, Richard S. *Foundation Deposits in Ancient Mesopotamia*. New Haven, CT: Yale University Press, 1968.

Engel, Burkhard J. *Darstellungen von Dämonen und Tieren in assyrischen Palästen und Tempeln nach den schriftlichen Quellen*. Mönchengladbach, Germany: Hackbarth, 1987.

Eph'al, Israel. "Ways and Means to Conquer a City." In Parpola and Whiting (eds.), *Assyria 1995*, 49–53.

Fales, Frederick M. "Preparing for War in Assyria." In Jean Andreau, Pierre Briant, and Raymond Descat (eds.), *Economie antique: La guerre dans les économies antiques*. Saint-Bertrand-de-Comminges, France: Musée archéologique départemental, 2000, 35–62.

Falkenstein, Adam, and Wolfram von Soden. *Sumerische und akkadische Hymnen und Gebete*. Zurich: Artemis, 1953.

Farber, Walter. "Die Vergöttlichung des Naram-Sins." *Orientalia* 52 (1983): 67–72.

Farber Flügge, Gertrud. *Der Mythos Inanna und Enki unter besonderer Berücksichtigung der Liste der me*. Rome: Biblical Institute Press, 1973.

Feldman, Allen. *Formations of Violence: The Narrative of the Body and Political Terror in Northern Ireland*. Chicago: University of Chicago Press, 1991.

——. "Memory Theaters, Virtual Witnessing, and the Trauma-Aesthetic." *Biography* 27, no. 1 (2004): 163–202.

Feldman, Marian. "Nineveh to Thebes and Back: Art and Politics Between Assyria and Egypt in the Seventh Century BCE." In Collon and George (eds.), *Nineveh*, 141–50.

Finet, A. "La place du divin dans la société de Mari." In *La divination en*

Mésopotamie ancienne et dans les régions voisines. Paris: Presses universitaires de France, 1966, 87–93.

Finkel, Irving L. "Adad-apla-iddina, Esagil-kin-apli, and the Series SA.GIG." In Erle Leichty, Pamela Gerardi, Abraham Sachs, and Maria deJ. Ellis (eds.), *A Scientific Humanist: Studies in Memory of Abraham Sachs.* Philadelphia: Samuel Noah Kramer Fund, 1988, 143–59.

Foster, Benjamin. *Before the Muses: An Anthology of Akkadian Literature,* 3rd ed. Bethesda, MD: CDL Press, 2005.

——. "The Sargonic Victory Stele from Telloh." *Iraq* 47 (1985): 15–30.

Foucault, Michel. *Discipline and Punish: The Birth of the Prison.* Trans. Alan Sheridan. New York: Vintage, 1977.

——. *The History of Sexuality.* Vol. 1, *An Introduction.* Trans. Robert Hurley. New York: Pantheon, 1978.

——. "Of Other Spaces." Trans. Jay Miskowiec. In Nicholas Mirzoeff (ed.), *The Visual Culture Reader.* London: Routledge, 1998, 237–44.

Frahm, Eckart. "Royal Hermeneutics: Observations on the Commentaries from Ashurbanipal's Libraries at Nineveh." In Collon and George (eds.), *Nineveh,* 45–50.

Frankfort, Henri. *The Art and Architecture of the Ancient Orient.* Harmondsworth: Penguin, 1954.

——. *Kingship and the Gods: A Study of Ancient Near Eastern Religion as the Integration of Society and Nature.* Chicago: University of Chicago Press, 1948.

Frayne, Douglas. "Naramsin." *Reallexicon der Assyriologie und vorderasiatischen Archäologie* 9 (1999): 169–74.

——. *Sargonic and Gutian Periods, 2334–2113 B.C.* Toronto: University of Toronto Press, 1993.

Frazer, James. *The Golden Bough: A Study in Magic and Religion.* London: Macmillan, 1913.

Freedman, Lawrence (ed.), *War.* Oxford: Oxford University Press, 1994.

Freedman, Sally M. *If a City Is Set on a Height: The Akkadian Omen Series Šumma ālu ina melê sakin.* Philadelphia: Distributed by the Samuel Noah Kramer Fund, the University of Pennsylvania Museum, 1998.

Freud, Sigmund. "The Moses of Michelangelo." *Standard Edition of the Complete Psychological Works of Sigmund Freud*. Ed. James Strachey. Trans. Alix Strachey. Vol. 13. London: Hogarth Press, 1958, 211–38.

——. *The Uncanny*. Trans. David McLintock. New York: Penguin, 2003.

Futrell, Alison. *Blood in the Arena: The Spectacle of Roman Power*. Austin: University of Texas Press, 1997.

Gadd, Cyril John. *Ideas of Divine Rule in the Ancient East*. London: Oxford University Press, 1948.

Gamboni, Dario. *The Destruction of Art: Iconoclasm and Vandalism since the French Revolution*. London: Reaktion, 1997.

Gelb, I.J. "Prisoners of War in Early Mesopotamia." *Journal of Near Eastern Studies* 32, no. 1/2 (1973): 70–98.

Gell, Alfred. *Art and Agency: An Anthropological Theory*. Oxford: Clarendon, 1998.

Gerardi, Pamela. "Epigraphs and Assyrian Palace Reliefs: The Development of the Epigraphic Text." *Journal of Cuneiform Studies* 40, no. 1 (1988): 1–35.

Gernet, Louis. *The Anthropology of Ancient Greece*. Trans. John Hamilton and Blaise Nagy. Baltimore: Johns Hopkins University Press, 1981.

Giddens, Anthony. "The Nation-State and Violence." *Social Theory and Modern Sociology*. Stanford, CA: Stanford University Press, 1987, 166–83.

Ginzburg, Carlo. "Morelli, Freud, and Sherlock Holmes: Clues and Scientific Method." In Umberto Eco and Thomas A. Sebeok (eds.), *The Sign of Three: Dupin, Holmes, Peirce*. Bloomington: Indiana University Press, 1983, 81–118.

Girard, René. *Violence and the Sacred*. Trans. Patrick Gregory. Baltimore: Johns Hopkins University Press, 1977.

Glassner, Jean-Jacques. *La chute d'Akkadé: L'événement et sa mémoire*. Berlin: Reimer, 1986.

——. *Chroniques mésopotamiennes*. Paris: Les Belles Lettres, 1993.

——. *The Invention of Cuneiform. Writing in Sumer*. Trans. and Eds. Zainab Bahrani and M. Van De Mieroop. Baltimore: The Johns Hopkins University Press, 2003.

——. "The Use of Knowledge in Ancient Mesopotamia." In J. Sasson (ed.),

Civilizations of the Ancient Near East. New York: Scribners, 1995, 1815–24.

Goetze, Albrecht. *Old Babylonian Omen Texts*. New Haven, CT: Yale University Press, 1947.

Gombrich, Ernst. *Art and Illusion*: A Study in the Psychology of Pictorial Representation. London: Phaidon, 1962.

——. *The Story of Art*. New York: Phaidon, 1956.

Goody, Jack. *The Power of the Written Tradition*. Washington, DC: Smithsonian Institution Press, 2000.

——. *Representations and Contradictions: Ambivalence Towards Images, Theatre, Fiction, Relics, and Sexuality*. Oxford: Blackwell, 1997.

Grayson, A. Kirk. *Assyrian and Babylonian Chronicles*. Winona Lake, IN: Eisenbrauns, 2000.

——. "Assyrian Civilization." In John Boardman (ed.), *The Cambridge Ancient History*. Vol. 3, part 2, *The Assyrian and Babylonian Empires and Other States of the Near East, from the Eighth to the Sixth Centuries BC*. Cambridge: Cambridge University Press, 1991, 194–229.

——. *Assyrian Rulers of the Early First Millennium BC I (1114–859 BC)*. Toronto: University of Toronto Press, 1991.

——. "Assyrian Warfare." In John Boardman (ed.), *The Cambridge Ancient History*. Vol. 3, pt. 2, *The Assyrian and Babylonian Empires and the Other States of the Near East, from the Eighth to the Sixth Centuries B.C.* Cambridge: Cambridge University Press, 1991, 217–21.

Green, Anthony. "The Lion-Demon in the Art of Mesopotamia and Neighbouring Regions" *Baghdader Mitteilungen* 17 (1986): 141–254.

——. "Neo-Assyrian Apotropaic Figurines." *Iraq* 45 (1983): 87–96.

Groebner, Valentin. *Defaced: The Visual Culture of Violence in the Late Middle Ages*. Trans. Pamela Selwyn. New York: Zone, 2003.

Groenewegen-Frankfort, Henriette Antonia. *Arrest and Movement: An Essay on Space and Time in the Representational Art of the Ancient Near East*. London: Faber and Faber, 1951.

Guinan, Ann. "Divination." In William W. Hallo (ed.), The Context of Scripture. Vol. 1. Leiden: Brill, 1997, 421–26.

———. "A Severed Head Laughs." In Leda Jean Ciraolo and Jonathan Lee Seidel (eds.), *Magic and Divination in the Ancient World*. Leiden: Brill and Styx, 2002, 7–40.

Gurney, Oliver Robert. "Babylonian Prophylactic Figures and Their Rituals." *Annals of Archaeology and Anthropology* 22 (1935): 31–96.

Hall, Harry Reginald. *Babylonian and Assyrian Sculpture in the British Museum*. Paris: G. van Oest, 1928.

Hallo, W.W. "Texts, Statues, and the Cult of the Divine King." In John Adney Emerton (ed.), *Congress Volume: Jerusalem*, Leiden: Brill, 1988, 54–66.

Hansen, Donald P. "New Votive Plaques from Nippur." *Journal of Near Eastern Studies* 22, no. 3 (1963): 145–66.

———. "Through the Love of Ishtar." In Lamia al Gailani Werr *et al.* (ed.), *Of Pots and Plans: Papers on the Archaeology and History of Mesopotamia and Syria Presented to David Oates in Honour of his 75th Birthday*. London: NABU, 2002, 91–112.

Heessel, Nils P. *Babylonisch-assyrische Diagnostik*. Münster, Germany: Ugarit-Verlag, 2000.

Hirsch, H. "Eannatum von Lagash und Sargon von Agade." In *Studies Presented to A. Leo Oppenheim*. Chicago: University of Chicago Oriental Institute, 1964, 136–39.

Hubert, Henri, and Marcel Mauss. *Sacrifice: Its Nature and Function*. Trans. W.D. Halls. Chicago: University of Chicago Press, 1964.

Ibn al-Faqīh al-Hamadhānī, Ahmad ibn Muhammad. *Kitāb al-buldān*. Beirut: ʿĀlam al-Kutub, 1996.

Ibn Khaldun. *The Muqqadimah: An Introduction to History*, 2nd ed. Trans. Franz Rosenthal. Princeton, NJ: Princeton University Press, 1967.

Jacobsen, Thorkild, *The Harps that Once —: Sumerian Poetry in Translation*. New Haven, CT: Yale University Press, 1987.

———. *The Treasures of Darkness: A History of Mesopotamian Religion*. New Haven, CT: Yale University Press, 1976.

Jeyes, Ulla. *Old Babylonian Extispicy: Omen Texts in the British Museum*. Istanbul: Nederlands historisch-archaeologisch Instituut te Istanbul, 1989.

Kaelin, Oskar. *Ein assyrisches Bildexperiment nach ägysptischem Vorbild: Zu Planung und Ausführung der "Schlacht am Ulai."* Münster: Ugarit-Verlag, 1999.

Kant, Immanuel. "Zum ewigen Frieden." *Sämtliche Werke.* Vol. 5, *Moralische Schriften.* Ed. Grand Duke Wilhelm Ernst. Leipzig: Insel Verlag, 1927, 684–85.

Khalil Ismail, Bahija. "Eine Siegesstele des Königs Daduša von Ešnunna." Wolfgang Meid and Helga Trenkwalder (eds.), *Im Bannkreis des Alten Orients: Studien Zur Sprach- und Kulturgeschichte des Alten Orients und seines Ausstrahlungsraumes.* Innsbruck: Innsbrucker Beiträge zur Kulturwissenschaft, 1986, 105–108.

Khalil-Ismail, Bahija, and Antoine Cavigneaux. "Dadušas Siegesstele IM 95200 aus Ešnunna: Die Inschrift." *Baghdader Mitteilungen* 34 (2003): 129–57.

Keel, Othmar. *Das Recht der Bilder gesehen zu werden: Drei Fallstudien zur Methode der Interpretation altorientalischer Bilder.* Fribourg, Switzerland: Universitätsverlag, 1992.

Kienast, Burkhardt. "Naram-Sin mit dINANNA." *Orientalia* 59, no. 2 (1990): 196–203.

Klengel, Horst. "Krieg, Kriegsgefangene." *Reallexicon der Assyriologie* 6 (1980–83): 241–46.

Koch-Westenholz, Ulla. *Babylonian Liver Omens: The Chapters Manzazu, Padanu, and Pan Takalti of the Babylonian Extipicy Series Mainly from Assurbanipal's Library.* Copenhagen: Museum Tusculanum Press, 2000.

Köcher, F. and A.L. Oppenheim. "The Old Babylonian Omen Text VAT₅7525." *Archiv für Orientforschung* 18 (1957–58): 62–80.

Kolbe, Dieter. *Die Reliefprogramme religös-mythologischen Charakters in neuassyrischen Palästen: Die Figurentypen ihre Benennung und Bedeutung.* Frankfurt am Main, Germany: Lang, 1981.

Kraus, Fritz Rudolph, "Ein Sittenkanon in Omenform." *Zeitschrift für Assyriologie* 43 (1936): 77–113.

——. *Texte zur babylonischen Physiognomatik. Archiv für Orientforschung Beitieft* 3 (1939).

Kyle, Donald G. *Spectacles of Death in Ancient Rome.* London: Routledge, 1998.

Lambert, W.G. "Donations of Food and Drink to the Gods in Ancient Meso-potamia." In Quaegebeur (ed.), *Ritual and Sacrifice in the Ancient Near East*, 191–201.

———. "The God Aššur." *Iraq* 45 (1983): 82–86.

———. "Questions Addressed to the Babylonian Oracle: The Tamitu Texts." In Jean-Georges Heintz (ed.), *Oracles et prophéties dans l'Antiquité*. Paris: De Boccard, 1997, 85–98.

Layard, Austen Henry. *Discoveries in the Ruins of Nineveh and Babylon*. London: Murray, 1853.

———. *The Monuments of Nineveh: From Drawings Made on the Spot*. London: Murray, 1849.

———. *A Second Series of the Monuments of Nineveh*. London: Murray, 1853.

Leichty, Erle. *The Omen Series Šumma Izbu*. Locust Valley, NY: J.J. Augustin, 1970.

———. "Ritual, 'Sacrifice,' and Divination in Mesopotamia." in Quaegebeur (ed.), *Ritual and Sacrifice in the Ancient Near East*, 237–242.

Littauer, M.A., and J.H. Crouwel. *Wheeled Vehicles and Ridden Animals in the Ancient Near East*. Leiden: Brill, 1979.

Liverani, Mario. "2084: Ancient Propaganda and Historical Criticism." In Jerrold S. Cooper and Glenn M. Schwartz (eds.), *The Study of the Ancient Near East in the Twenty-first Century*. Winona Lake, IN: Eisenbrauns, 1996, 283–90.

———. "The Ideology of the Assyrian Empire." In Mogens Trolle Larsen (ed.), *Power and Propaganda: A Symposium of Ancient Empires*. Copenhagen: Akademisk Forlag, 1979, 297–317.

———. "Messages, Women, and Hospitality: Inter-tribal Communication in Judges 19–21." *Myth and Politics in Ancient Near Eastern Historiography*. Ed. Zainab Bahrani and Marc Van De Mieroop. Ithaca, NY: Cornell University Press, 2004, 160–92.

———. *Uruk: The First City*. Ed. and trans. Zainab Bahrani and Marc Van De Mieroop. London: Equinox, 2006.

Livingstone, Alastair. *Mystical and Mythological Explanatory Works of Assyrian and Babylonian Scholars*. Oxford: Clarendon, 1986.

Luckenbill, Daniel David. *Ancient Records of Assyria and Babylonia*. Chicago: University of Chicago Press, 1926.

Malbran-Labat, Florence. *L'armée et l'organisation militaire de l'Assyrie d'après les letters des Sargonides trouvées à Ninive*. Geneva: Droz, 1982.

Marcus, Michelle I. "Art and Ideology in Ancient Western Asia." In Sasson (ed.), *Civilizations of the Ancient Near East*, vol. 4, pt. 10, 2487–2502.

——. "Geography as Visual Ideology: Landscape, Knowledge, and Power in Neo-Assyrian Art." In Mario Liverani (ed.), *Neo-Assyrian Geography*. Rome: Università di Roma, Dipartimento di scienze storiche, archeologiche e antropologiche dell'Antichita, 1995, 193–202.

Marcuse, Herbert. *The Aesthetic Dimension: Toward a Critique of Marxist Aesthetics*. Boston: Beacon, 1978.

Marin, Louis. *Portrait of the King*. Trans. M.M. Houle. Minneapolis: University of Minnesota Press, 1981.

Marx, Karl, and Friedrich Engels. *The German Ideology*. Amherst, NY: Prometheus Books, 1998.

Mayer, Walter. *Politik und Kriegskunst der Assyrer*. Münster: Ugarit-Verlag, 1995.

Mayer, Werner. *Untersuchungen zur Formensprache der babylonischen Gebetschwörungen*. Rome: Biblical Institute Press, 1976.

Meissner, Bruno. "Omina zur Erkenntnis der Eingeweide des Opfertieres." In *Archiv fur Orientforschung* 9 (1933–34): 118–22.

Michalowski, Piotr. *The Lamentation over the Destruction of Sumer and Ur*. Winona Lake, IN: Eisenbrauns, 1989.

——. "Memory and Deed: The Historiography of the Political Expansion of the Akkad State." In Mario Liverani (ed.), *Akkad: The First World Empire: Structure, Ideology, Traditions*. Padua: Sargon, 1993, 69–90.

Miglus, P.A. "Die Siegesstele des Königs Dadusa von Esnunna und ihre Stellung in der Kunst Mesopotamiens und der Nachbargebiete." In R. Dittman, C. Eder, and B. Jacobs (eds.), *Altertumwissenschaften im Dialog. Festschrift für Wolfram Nagel zur Vollendung seines 80. Lebensjahres*. Münster: Alter Orient und Altes Testament 306, 2003, 397–420.

Mirzoeff, Nicholas. *Watching Babylon: The War in Iraq and Global Visual Culture.* London: Routledge, 2005.

Mitchell, W.J. Thomas. *What Do Pictures Want?: The Lives and Loves of Images.* Chicago: University of Chicago Press, 2005.

Moortgat, Anton. *The Art of Ancient Mesopotamia: The Classical Art of the Near East.* Trans. Judith Filson. London: Phaidon, 1969.

Morandi, D. "Stele e statue reali assire: Localizzazione, diffusione e implicazioni ideologiche." *Mesopotamia* 23 (1988): 105–56.

Morgan, Jacques de. *Recherches archéologiques.* Vol. 7. Paris: Mémoires de la Délégation en Perse, 1905.

Nietzsche, Friedrich Wilhelm. *On the Genealogy of Morals.* Trans. Walter Kaufmann and R.J. Hollingdale. New York: Vintage, 1967.

Nigro, Lorenzo. "Osservasioni sullo schema compositivo della stele di Naram-Sin." *Contributi e materiali di Archeologia Orientale* 4 (1992): 60–100.

———. "The Two Steles of Sargon: Iconology and Visual Propaganda at the Beginning of Royal Akkadian Relief." *Iraq* 60 (1998): 85–102.

———. "Visual Role and Ideological Meaning of the Enemies in the Royal Akkadian Relief." In Proseck'y (ed.), *Intellectual Life of the Ancient Near East,* 283–97.

Nissen, Hans J., Peter Damerow, and Robert K. Englund. *Archaic Bookkeeping: Early Writing and Techniques of Economic Administration in the Ancient Near East.* Chicago: University of Chicago Press, 1993.

Oded, Bustenay. *Mass Deportations and Deportees in the Neo-Assyrian Empire.* Wiesbaden, Germany: Reichert, 1979.

———. *War, Peace, and Empire: Justifications for War in Assyrian Royal Inscriptions.* Wiesbaden, Germany: Reichert, 1992.

Oppenheim, A. Leo. *Ancient Mesopotamia: Portrait of a Dead Civilization.* Chicago: University of Chicago Press, 1977.

———. *The Interpretation of Dreams in the Ancient Near East, with a Translation of an American Dream-Book.* Philadelphia: American Philosophical Society, 1956.

Ornan, Tallay. "Expelling Demons at Nineveh: The Visibility of Benevolent

Demons in the Palaces of Nineveh." In Collon and George (eds.), *Nineveh*, 83–92.

———. *The Triumph of the Symbol: Pictorial Representation of Deities in Mesopotamia and the Biblical Image Ban*. Fribourg, Switzerland: Academic Press Fribourg, 2005.

Paley, Samuel M. *King of the World: Ashur-nasir-pal II of Assyria, 883–859 B.C.* New York: Brooklyn Museum, 1976.

Parpola, Simo. *Assyrian Prophecies*. Helsinki: University of Helsinki Press, 1997.

———. *Letters from Assyrian and Babylonian Scholars*. Helsinki: University of Helsinki Press, 1993.

———. *Letters from Assyrian Scholars to the Kings Esarhaddon and Assurbanipal. 2 vols*. Kevelaer, Germany: Butzon & Becker, 1970–83.

Parpola, Simo, and Robert M. Whiting (eds.). *Assyria 1995*. Helsinki: University of Helsinki Press, 1997.

Parrot, André. *Tello: Vingt campagnes de fouilles (1877–1933)*. Paris: Albin Michel, 1948.

———. *Sumer, the Dawn of Art*. Trans. Stuart Gilbert and Stuart Emmons. New York: Golden Press, 1961.

Pascal, Blaise. *Pensées*. Trans. A.J. Krailsheimer. Harmondsworth: Penguin, 1966.

Paterson, Archibald. *Assyrian Sculptures: Palace of Sinacherib*. The Hague: Nijhoff, 1915.

Peirce, Charles Sanders. *Collected Works*. Eds. C. Hartshorne and P. Weiss. Cambridge, MA: Harvard University Press, 1931–58.

———. "Logic as Semiotic: The Theory of Signs." In J. Buchler (ed.), *The Philosophy of Peirce: Selected Writings*. London, Routledge, 1940.

Piepkorn, Arthur Carl. *Historical Prism Inscriptions of Ashurbanipal*. Chicago: University of Chicago Press, 1933.

Pittman, Holly. "The White Obelisk and the Problem of Historical Narrative in the Art of Assyria." *Art Bulletin* 78, no. 2 (1996): 334–55.

Place, Victor, and Félix Thomas. *Ninive et l'Assyrie*. 3 vols. Paris: Imprimerie impériale, 1867–70.

Pongratz-Leisten, Beate. *Herrshaftswissen in Mesopotamien: Formen der Kommu-*

nikation zwischen Gott und König im 2. und 1. Jahrtausend v. Chr. Helsinki: Neo-Assyrian Text Corpus Project, 1999.

——. "The Interplay of Military Strategy and Cultic Practice in Assyrian Politics." In Parpola and Whiting (eds.), *Assyria 1995*, 245–52.

Pongratz-Leisten, Beate, Karlheinz Deller, and Erika Bleibtreu (eds.). "Götterstreitwagen und Götterstandarten: Götter auf dem Feldzug und ihr Kult im Feldlager." Special issue, *Baghdader Mitteilungen* 23 (1992).

Porter, Barbara Nevling. *Images, Power, Politics: Figurative Aspects of Esarhaddon's Babylonian Policy.* Philadelphia: American Philosophical Society, 1993.

——. (ed.). *Ritual and Politics in Ancient Mesopotamia.* New Haven, CT: American Oriental Society, 2005.

Postgate, J.N. *Early Mesopotamia: Society and Economy at the Dawn of History.* London: Routledge, 1992.

——. "Royal Ideology and State Administration in Sumer and Akkad." In Sasson (ed.), *Civilizations of the Ancient Near East*, vol. 1, pt. 4, 395–411.

Pritchard, James Bennett (ed.). *Ancient Near Eastern Texts Relating to the Old Testament with Supplement.* Princeton, NJ: Princeton University Press, 1969.

Proseck'y, Jiri (ed.). *Intellectual Life of the Ancient Near East.* Prague: Oriental Institute, 1998.

Quaegebeur, Jan (ed.). *Ritual and Sacrifice in the Ancient Near East.* Louvain, Belgium: Peeters, 1993.

——. "Religious Ritual in Assyrian Sculpture." In Porter (ed.), *Ritual and Politics in Ancient Mesopotamia*, 7–32.

——. "Ninive (Nineveh)," *Reallexikon der Assyriologie* 9, nos. 516 (2000): 388–433.

——. *Assyrian Sculpture.* London: British Museum, 1983.

Reade, Julian E. "The Architectural Context of Assyrian Sculpture." *Baghdader Mitteilungen* 11 (1980): 75–87.

——. "Ideology and Propaganda in Assyrian Art." In Mogens Trolle Larsen (ed.), *Power and Propaganda: A Symposium on Ancient Empires.* Copenhagen: Akademisk Forlag, 1979, 329–43.

——. "Narrative Composition in Assyrian Sculpture." *Baghdader Mitteilungen* 10 (1979): 52–110.

———. "Sargon's Campaigns of 720, 716, and 715 B.C.: Evidence from the Sculptures." *Journal of Near Eastern Studies* 35, no. 2 (1976): 95–104.

———. "The Neo-Assyrian Court and Army: Evidence from the Sculptures." *Iraq* 34, no. 2 (1972): 87–112.

Reiner, Erica. *Astral Magic in Babylonia*. Philadelphia: American Philosophical Society, 1995.

———. "Fortune-Telling in Mesopotamia." *Journal of Near Eastern Studies* 19, no. 1 (1960): 23–35.

Rittig, Dessa. *Assyrisch-babylonische Kleinplastik magischer Bedeutung vom 13.–6. Jh.v. Chr.* Munich: Uni-Druck, 1977.

Rochberg, Francesca. *The Heavenly Writing: Divination, Horoscopy, and Astronomy in Mesopotamian Culture*. Cambridge: Cambridge University Press, 2004.

Roth, Martha T. "*ina amat* DN$_1$ *u* DN$_2$ *lišlim*." *Journal of Semitic Studies* 33 (1988): 1–9.

———. *Law Collections from Mesopotamia and Asia Minor*, 2nd ed. Atlanta, GA: Scholars Press, 1997.

Russell, John Malcolm. *The Final Sack of Nineveh: The Discovery, Documentation, and Destruction of King Sennacherib's Throne Room at Nineveh, Iraq*. New Haven, CT: Yale University Press, 1998.

———. *Sennacherib's Palace Without Rival at Nineveh*. Chicago: University of Chicago Press, 1991.

Salonen, Erkki. *Die Waffen der alten Mesopotamier: Eine Lexikalische und kaltergeschichtlichte Untersuchung*. Helsinki: Societas Orientalis Fennica, 1965.

Sasson, Jack M. (ed.). *Civilizations of the Ancient Near East*. 4 vols. New York: Scribner, 1995.

Sordi, Marta. *I canali della propaganda nel mondo antico*. Milan: Vita e pensiero, 1976.

Spivey, Nigel. *Enduring Creation: Art, Pain, and Fortitude*. Berkeley: University of California Press, 2001.

Starr, Ivan (ed.). *Queries to the Sungod: Divination and Politics in Sargonid Assyria*. Helsinki: University of Helsinki Press, 1990.

Strommenger, Eva. *Five Thousand Years of the Art of Mesopotamia*. Tans. Christina Haglund. New York: Abrams, 1964.

Thomasen, Alison Karmel. *Luxury and Legitimation. Royal Collecting in Ancient Mesopotamia*. Aldershot: Ashgate, 2005.

Todorov, Tzvetan. *Theories of the Symbol*. Trans. Catherine Porter. Ithaca, NY: Cornell University Press, 1982.

Uehlinger, Christoph. "Clio in a World of Pictures: Another Look at the Lachish Reliefs from Sennacherib's Southwest Palace at Nineveh." *Journal for the Study of the Old Testament* 363 (2003): 221–305.

Van De Mieroop, Marc. *A History of the Ancient Near East, c. 3000–323 B.C.* Oxford: Blackwell, 2003.

——. "Hammurabi's Self Presentation." In Heather D. Baker, Eleanor Robson, and Gábor G. Zólyomi (eds.), *Your Praise Is Sweet: A Memorial Volume for Jeremy Black from Students, Colleagues and Friends*. Oxford: Griffith Institute, forthcoming.

Vanstiphout, Herman. "The nth Degree of Writing at Nineveh." In Dominique Collon and Andrew George (eds.), *Nineveh: Papers of the XLIXe Rencontre Assyriologique Internationale, London, 7–11 July 2003*. Vol. I. London: British School of Archaeology in Iraq, 2005.

Versnel, H.S. *Triumphus: An Inquiry into the Origin, Development and Meaning of the Roman Triumph*. Leiden: Brill, 1970.

Virilio, Paul, and Sylvère Lotringer. *Pure War*. Trans. Mark Polizotti. New York: Semiotext(e), 1983.

Wafler, Markus. *Nicht-Assyrer neuassyrischer Darstellungen*. Neukirchen-Vluyn, Germany: Neukirchener, 1975.

Walzer, Michael. *Just and Unjust Wars: A Moral Argument with Historical Illustrations*. Harmondsworth: Penguin, 1980.

Watanabe, Chikako Esther. "The 'Continuous Style' in the Narrative Schemes of Assurbanipal's Reliefs." In Collon and George (eds.), *Nineveh*, 103–14.

Waters, Matthew W. *A Survey of Neo-Elamite History*. Helsinki: Neo-Assyrian Text Corpus Project, 2000.

Weidner, Ernst Friedrich. "Assyrische Beschreibungen der Kriegs-Reliefs

Aššurbânaplis." *Archiv für Orientforschung* 8 (1932–33): 175–203.

Weissert, Elnathan. "Royal Hunt and Royal Triumph in a Prism Fragment of Ashurbanipal." In Parpola and Whiting (eds.), *Assyria 1995*, 339–58.

Westenholz, Joan Goodnick. *Legends of the Kings of Akkade: The Texts*. Winona Lake, IN: Eisenbrauns, 1997.

Wiggermann, F.A.M. *Mesopotamian Protective Spirits: The Ritual texts*. Groningen, Netherlands: Styx & PP Publications, 1992.

Williams, Raymond. *Keywords: A Vocabulary of Culture and Society*. New York: Oxford University Press, 1976.

——. *Marxism and Literature*. Oxford: Oxford University Press, 1977.

Winter, Irene J. "After the Battle Is Over: The Stele of the Vultures and the Beginning of Historical Narrative in the Art of the Ancient Near East." In Herbert L. Kessler and Marianna Shreve Simpson (eds.), *Pictorial Narrative in Antiquity and the Middle Ages*. Washington, DC: National Gallery of Art, 1985, 11–32.

——. "The Body of the Able Ruler: Toward an Understanding of the Statues of Gudea." In H. Behrens et al. (eds.), *Dumu E-Dub-ba-a: Studies in Honor of Åke Sjöberg*. Philadelphia, University of Pennsylvania Museum Press, 1989, 573–83.

——. "Art in Empire: The Royal Image and the Visual Dimensions of Assyrian Ideology." In Parpola and Whiting (eds.), *Assyria 1995*, 359–81.

——. "Royal Rhetoric and the Development of Historical Narrative in Neo-Assyrian Reliefs." *Studies in Visual Communication* 7 (1981): 2–38.

——. "Sex, Rhetoric and the Public Monument: The Alluring Body of Naram-Sîn of Agade." In Natalie Boymen Kampen with Bettina Bergman (eds.), *Sexuality in Ancient Art: Near East, Egypt, Greece, and Italy*. New York: Cambridge University Press, 1996.

——. "Tree(s) on the Mountain: Landscape and Territory on the Victory Stele of Naram-Sîn of Agade." In Lucio Hilano (ed.), *Landscapes: Territories, Frontiers and Horizons in the Ancient Near East*. Padua, Italy: Sargon, 1999, 63–72.

Woolley, C. Leonard. "Babylonian Prophylactic Figures." *Journal of the Royal Asiatic Society* (1926): 689–713.

Žižek, Slavoj. *Iraq: the Borrowed Kettle*. London and New York: Verso, 2004.

——. *Mapping Ideology*. London: Verso, 1994.

——. *The Plague of Fantasies*. London: Verso, 1997.

——. *The Sublime Object of Ideology*. London: Verso, 1989.

——. *The Ticklish Subject: The Absent Centre of Political Ontology*. London: Verso, 1999.

——. *Welcome to the Desert of the Real! Five Essays on September 11 and Related Dates*. London and New York: Verso, 2002.

——. *Iraq: the Borrowed Kettle*. London and New York: Verso, 2004.

Index

divination and, 18; ethnographic and historical representation of, 53; inorganic objects associated with, 78; integrated into machinery of power, 213–15; king's body, 104, 107, 120, *121, 122, 123*; as locus of existential identity, 77–78; mantic body, 17–18; omens and, 48, 89; oneiromancy and, 92–94; physiognomy, 91–96; political economy of power and, 16; portrait as nonorganic body, 96, *97, 98*–99, *100*; power over life and death, 113–14; *salmu* (bodily substitute) and, 174; signification and, 75; of soldiers, 108–109; as text, 76–78, 98–99; of vanquished enemy, 132, 133.
Borders, measuring of, 152.
Bottéro, Jean, 60, 61, 62, 83.
Bunu-Ishtar of Arbil, 137, 139; decapitation of, 140; defeat of, 141, 142, 146, 154.

Caillois, Roger, 9.
Cartesian duality, 77.
Charles I, king of England, 120, *121*.
Charles I (Van Dyck), 120, *121*.
Chiasmus, 68, 91, 126.
China, 11.
Christianity, 192.
Cities/city-states, 13, 104, 105, 147; destruction of, 181, 203–204; identity in monuments, 160; just war and, 152; lamentations for, 211–12; as locus of identity, 180; patron gods of, 165, 183–84.
Civilians, war and, 11.
Civilization, 9–10, 210, 211.
Class, dominant, 66.
Clausewitz, Carl von, 9, 12.
Codex Hammurabi, 20, 51, 114–15, *116–17,* 118–20, 124; Dadusha stele compared with, 137; intersection

of body and power in, 215; as war booty, 173.
Collateral damage, 11.
Colossi, 52.
Connoisseurship, 54, 58.
Crassus (Plutarch), 49–50.
Cuneiform script/texts, 40, 42, 60, 63, 103, 132.
Curse formulas, 201, 202, 237 n.21.
Curse of Agade, The, 103.
Cylinder seals/texts, 40–48, 114, 137, 147, 154.

Dadusha, stele of, 133, *134–35,* 136–47, 164.
Death, 18–19, 92, 147; destruction of monuments and, 166; in Eannatum of Lagash stele, 147, 150, 151, 154; of a king, 35, 198–99; by mythology in Roman arena, 222; naked corpses, 150; political economy of, 50; torture and, 19, 155; Victory Stele of Naramsin and, 107, 109, 110, *111,* 112–14, 124.
Deconstruction, Derridean, 61.
Deleuze, Gilles, 207, 212, 225 n.3.
Delphic oracle, 92.
Deportation, 163, 164, *177,* 178, 217.
Derrida, Jacques, 61.
Despotism/dictatorship, 66, 71, 101, 241 n.17.
Différance, Derridean, 63.
Diplomacy, 11, 152.
Discipline and Punish (Foucault), 16, 113.
Disease, 83–84, 91, 95.
Display, 13, 15, 21.
Divination, 13, 17; body and, 76, 89; Etruscan and Roman, 89; as origin of semiotics, 58–59; representation and, 59–65; signs of the future and, 65; strategies of war and, 18; symptomatology and, 82–83.
Doctrine, 69.

Zone Books series design by Bruce Mau
Typesetting by Archetype
Image placement and production by Julie Fry
Printed and bound by Maple-Vail